CONCORDIA UNIVERSITY

3 4211 00139 9974

W9-ACO-244

# RAVENNA

PHOTOGRAPHS BY Leonard von Matt

# RAVENNA

TEXT BY Giuseppe Bovini

*Translated from the Italian by Robert Erich Wolf*

Harry N. Abrams, Inc., Publishers, New York

KLINCK MEMORIAL LIBRARY
Concordia Teachers College
River Forest, Illinois 60305

The photographs for the colorplates and black-and-white illustrations were almost all made by Leonard von Matt in 1969 especially for this book.

For technical reasons, such as restoration being in progress, some photographs had to come from other sources. Material was kindly placed at our disposal for plates 12, 58, and 59 by Edizione A. Longo, Ravenna; for plates 7, 33-57, 86, and 87 by Azienda Autonoma di Soggiorno e Turismo di Ravenna, Ente Provinciale per il Turismo, Ravenna, and Istituto dell'Università di Bologna di Antichità Ravennati, Ravenna (photographs by Villani, Bologna, and Trapani, Ravenna); for plate 73 by Deutsches Archäologisches Institut, Rome.

Library of Congress Cataloging in Publication Data

Bovini, Giuseppe.
    Ravenna.

    Bibliography: p. 212
    1. Art—Ravenna. I. Matt, Leonard von, illus.
II. Title.
N6921.R3B62        709'.45'47        72-4832
ISBN 0-8109-0431-4

Library of Congress Catalogue Card Number: 72-4832
Copyright 1971 in West Germany by Verlag M. DuMont Schauberg, Cologne
All rights reserved. No part of the contents of this book may be reproduced without the written permission of the publishers
Harry N. Abrams, Incorporated, New York

Printed and bound in West Germany

107407

# Contents

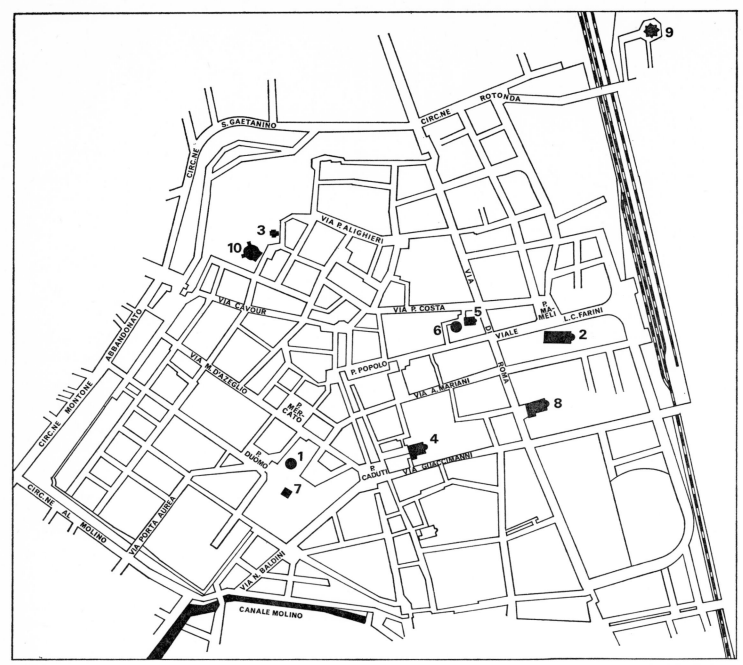

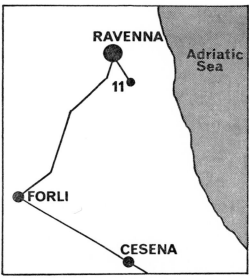

# The City in History

## The Geographical Position of Ravenna

Today the countryside that surrounds Ravenna on all sides is pancake-flat and extraordinarily fertile and luxuriant. In ancient times, though, there was nothing like this broad ring of green. From its beginning, Ravenna consisted of a group of sandy ridges lapped on one side by the Adriatic Sea and hemmed in on the other three by marshes.

The region we now call Ravenna grew up along a long curving chain of sand dunes heaped up almost a thousand years before our era. The sandy ridge began in the north, at the southernmost branch of the Po River, and reached almost to present-day Cervia about fourteen miles or so south of today's Ravenna. The general contours were approximately those of the old forest road now called the Strada del Bosco. In the course of the centuries the several arms of the Po, during their annual flooding, left behind silt and detritus which pushed back the waterline of the sea and gave rise to a new arc of dunes somewhat farther to the east, along a line which was later to become a Roman road, the Strada Romea. This second ridge began to take shape some centuries before the birth of Christ and must certainly have been more or less fully established by the first imperial era, though neither then nor in the immediately following centuries was it entirely unbroken. There were places where the Adriatic succeeded in pushing through this new cordon of dunes, and Procopius, writing in the sixth century A.D., reported that the water was no farther than two stadia—something like 1,300 feet—from the inhabited area.

In the Middle Ages and even later, the process of deposition continued along the coastline in front of the easternmost line of dunes with the result that, today, the sea is more than three miles from the center of the city.

## The Birth of a City

As with so many other very ancient cities, so too the origins of Ravenna are not known with certainty. Its beginnings are hidden in the obscurities of time, and myth and legend have shrouded them even more. Dionysius of Halicarnassus, the Greek historian of the first century B.C., dated the foundation of the city at "seven generations before the Trojan War," but we know nothing for certain either for or against this, just as we know nothing about the first inhabitants. Strabo, the Greek geographer who was born about 64

B.C. and died about A.D. 24, claimed that they were of Greek stock, from Thessalia. However, the fifth-century Byzantine historian Zosimus insisted that they were Pelasgians, and a century later Jordanes called them *Ainetoi*, which is probably to be read as a Byzantine corruption of *(V)eneti*.

It is not impossible that even in historical times the city may have been inhabited (or, more likely, occupied) by the Etruscans for a brief time at least. Strabo states that the Thessalians could not bear the violent attacks and vexations of the Tyrrhenians—and *Tyrrhenoi* was the name the Greek writers used for the Etruscans—and so they abandoned Ravenna to the Umbrians and returned to their original homelands.

At the beginning of the twentieth century W. Schulze proposed that the suffix -*na* or -*nna* in the name Ravenna was proof of its Etruscan origin. Today, however, scholars are much more cautious, having since learned that the suffix was not the exclusive property of the Etruscans and can be found in various other linguistic strata.

Whatever the case may be, the presumed presence of the Etruscans in the city, even for a brief period, is by no means proven by the fact that certain objects have been unearthed there which are unquestionably Etruscan in workmanship, notably some small bronze votive offerings and a lovely statuette (now in the Museum of Antiquities in Leiden), the latter a very archaic and decidedly Ionian-looking warrior with an Etruscan inscription on his right flank. Since these are small objects and easy to transport, they may well have been brought in by exchange or importation and certainly constitute no proof of an Etruscan presence in the city. In any case, no archaeological stratum corresponding to an Etruscan Ravenna has so far been unearthed. This may be because it lies buried at a very considerable depth or because the confines of the Etruscan settlement may not have coincided with those of the Roman, and hence of the modern, city and so have still to be discovered. In short, then, this remains another of Ravenna's mysteries.

Still, if there ever was an Etruscan occupation of the city it was most likely of brief duration. But there is nothing to be found in the ancient historical tradition to lend credence to the hypothesis. To the contrary, in fact, since the early historians made much of the Umbrians, who did actually push as far as the Po within historical times. When Pliny described Ravenna as a *Sabinorum oppidum* (a Sabine settlement), he was not in error as some modern writers have argued. His statement is easily explained by the fact that, according to Dionysius of Halicarnassus, there was an ethnical affinity between Sabines and Umbrians.

## The Roman Conquest

Nor do we know exactly when Rome took over the city. Strabo says that Ravenna became a Roman colony, but in point of fact it seems to have escaped the usual colonizing process because Cicero, in an oration of 68 B.C., tells us that the population of Ravenna was, juridically, *foederatus* (a confederate of Rome). That status may have had both geographical and economic grounds, the city being surrounded by noncultivable marshlands and therefore without interest to the early Romans, who expected their colonies to be able to provide them with agricultural produce.

For all that it lacked any real hinterland or anything that could be called a real territory, Ravenna nevertheless constituted a strategic bastion of very considerable importance. Its location permitted it to control long stretches of the roads linking the north and south of the peninsula, and this made it to all intents and purposes impossible to seize, the more so since it was isolated from the mainland by the easily defended swamps and marshes around it and was at the same time in immediate contact with the open sea, whence it could receive provisions and reinforcements.

It has been supposed that the first stimulus to Ravenna's maritime development came from the Roman consul Marius (c. 155–86 B.C.) because Plutarch, the Greek historian of the first and second centuries of our era, mentions that the people of Ravenna erected a marble statue in his honor. Whatever the fact, we do know that the first Roman fleet whose presence in Ravenna is attested for certain was that of Caecilius Metellus Pius, who, as Sulla's legate, disembarked there in 82 B.C.

Two medieval documents from the end of the twelfth century also mention a port connected with Caius Julius Caesar, but the absence of any earlier testimony makes it impossible to take this as fact or even as basis for conjecture. This does not, however, rule out the possibility that, for military purposes, some work may have been done on the port by Caesar when he selected Ravenna as his headquarters during his negotiations with the Senate and used it as a base from which to launch his seizure of Rimini and then, in 49 B.C., to cross the Rubicon (the stream lies a mere eighteen miles or so south of Ravenna) and thereafter march on Rome.

## The Creation of the Port of Classis

We know from Suetonius and Tacitus that the port of Classis just outside the city owed its great development to the Emperor Augustus. Recognizing the importance of the site for the defense of the Adriatic and the water routes to the Near East, where the army of Ravenna maintained *vexillationes* or advance detachments, Augustus chose to make it the seat, together with Misenum, of an efficient and experienced praetorian fleet. We are told by Dion Cassius, the Roman historian of the second to third centuries A.D., and, following him, by the Byzantine Jordanes in the sixth century, that the fleet comprised no fewer than 240 or 250 ships, from quinqueremes to light warships, which were always ready to intervene immediately wherever needed in accord with a principle to which Augustus adhered and which was defined by the fourth-century A.D. Latin military theorist Vegetius, in his *Epitoma rei militaris*, as "*in rebus bellicis celeritas amplius solet prodesse quam virtus*" (in war swift action counts for more than bravery).

To accommodate such a fleet, a new port was created at Classis (now Classe) some two and one-half miles south of the city. A vast basin was dredged out in the zone where the most recent chain of dunes had begun to separate off from the older cordon along the shore. Probably the natural conformation of the place was responsible for the choice of Ravenna as a port which could offer a safe base for the Adriatic fleet without at the same time involving too much expense, although as a rule the Romans preferred to create their ports by diverting water into an inland site rather than by the great cost and effort of dredging them out of the open sea.

The Founder of the Empire did not stop with the construction of a great military port at Ravenna. He foresaw the need to link it with the southern arm of the Po by means of a broad canal, the Fossa Augusta, about which Pliny wrote. As described by Apollinaris Sidonius in the second half of the fifth century, the canal divided into two arms, one running around the city walls as an additional defense, the other flowing through the town itself as an aid to commerce and transport. It may be that what Augustus's engineers actually did was to transform some natural stream of the lagoon into a *fossa* (a navigable channel), and perhaps also straighten its course.

From that time on, Ravenna was to know the busy ring of the shipbuilders' hammers. There is graphic evidence of this in a tall funeral stele (now in the Museo Nazionale di Antichità in the city) which shows a *faber navalis* (a ship's carpenter), one Publius Longidienus, who is portrayed, ax in hand, at work building a new ship.

The decline of the power of Rome and the neglect of the port by the often-changing new masters of Ravenna led to the slow and, one might say, silent disappearance of all the structures of the immense harbor, from its entrance to the anchorages, from wharves to workshops, all of them buried under a thin but tightly packed layer of bluish sand and under a more compact bank of detritus and clayey alluvium. Even the great high lighthouse that Pliny admired soon collapsed to disappear beneath a small dune heaped up over and around it by the windblown sand; then the dune itself vanished as the terrain around it rose higher and higher through the centuries until all was level.

With the steady receding of the waterline and the neglect of the man-made basin, the port, by the sixth century A.D., must have been only in part usable, much of it having already been silted up. We have the picturesque description by Jordanes, who writes that there where once were seen tall trees—masts—from which hung sails, now in his time there were fertile fields from whose masts —trees—dangled apples, the wondrous fruit. So it is today still. Where blue-green water shimmered before the town of Classis, as we can still see it in a mosaic in Sant'Apollinare Nuovo (plate 61),

there now stretch fields that alternate crops of grain and sugar beets. Where ships of every type once floated we hear not surf but the roar and clatter of plowing and reaping machines.

Sometimes, indeed rather often, long-buried ancient monuments or settlements bequeath their names to certain localities and thus can be said to live on there where they once rose, though it be only through the echo of a name. So it is that the port of Ravenna survives, however vaguely, in the denomination *in Classe* attached since the Early Middle Ages to the splendid basilica erected shortly after the middle of the sixth century on the site of the venerated tomb of the sainted Bishop Apollinaris, who had been first to propagate the faith in Ravenna. And there is another echo in the name borne since the early twelfth century by another church there, Santa Maria in Porto Fuori, commemorated by Dante as "*casa di Nostra Donna in sul lito Adriano*" (the house of Our Lady on the Adriatic shore; *Paradiso*, XXI, 122–23).

## A Growing City in the First Centuries of the Empire

In the time of Augustus, Ravenna was still traversed by various watercourses, and its houses, according to Strabo, had to be built on piles. The tides regularly swept inland and scoured the mud of the river bottoms and kept the air clean and fresh. The city itself was scattered over many small islets linked by bridges or ferries and had a truly unique physiognomy.

With an ever-expanding population spreading beyond its earlier confines, Ravenna also took to beautifying itself with fine sculpture such as the magnificent marble relief in the Museo Nazionale depicting members of the Julian-Claudian imperial house. Datable around the middle of the first century A.D., its fine and accurate workmanship suggests that it must have been executed in Rome or at least done by skilled stonecarvers from abroad.

Like the other ancient municipal settlements, the *oppida* of the Roman world, Ravenna too had a quadrangular ground plan. Only the northeast side escaped in part from the usual rectilinear regularity since it followed the contours defined by two watercourses. It was usual for gates in the walls of a *municipium romanum* to be flanked by cylindrical towers, and one of these has survived in fairly good state in Ravenna, the so-called Salustra not far from the apse of the present cathedral. Two similar towers once crowned the Porta Aurea, the double-arched city gate built in A.D. 43 under Claudius, and although they no longer exist we know what they looked like from the medieval seal of the city and from drawings by such Renaissance architects as Giuliano da Sangallo and Andrea Palladio.

Not far from the Porta Aurea rose the Temple of Apollo and the Amphitheater, but nothing remains of these today, nor of the Circus or the Capitol.

At the beginning of the second century A.D., Trajan ordered an aqueduct to be built for the city which, according to Martial, lacked proper drinking water. The aqueduct collected water from the vicinity of Teodorano in the Apennines and brought it to Ravenna by a route more or less paralleling the course of the Ronco River.

The city grew in importance, its population increased, and it soon spread beyond the original *oppidum municipale*. Once the fleet became established in the great new port, the urban agglomeration extended not only to Classis but even to the neighboring suburb of Caesarea.

## Christianity Comes to Ravenna

The *Passio Sancti Apollinaris*, a more or less legendary account written probably in the sixth century, attributes the introduction of Christianity into Ravenna to Apollinaris, a native of Antioch, said to have been consecrated bishop by no less than Saint Peter himself and dispatched by him to spread the good tidings among the seamen and merchants of Classis. This would date the beginnings of Christianity in Ravenna within the first century A.D. and therefore well within apostolic times.

Such an early dating suggests all too clearly that the sixth-century hagiographer was consciously aiming to exalt the figure of the first bishop of Ravenna or at least to confer greater distinction, greater prestige, and greater glory on the origins of the Church in his city. For their part, modern historians concede that Apollinaris came from the East but assure us that it was only toward the end of the second century that he went to Ravenna to spread the Word. It should be kept in mind that the earliest bishop of Ravenna whose dates and historical existence can be attested with any certainty is Saint Severus, who was no less than the eleventh successor to Apollinaris, and we would have had no record of him had he not represented his diocese at the Council of Sardica (the present-day Sofia) in 343–44. For none of his predecessors is there any secure chronological evidence, and none of them underwent martyrdom, not even Apollinaris, though he, through his steadfastness in the propagation of the faith, has been awarded the distinction of Saint and Confessor.

At the close of the second century and throughout the following two centuries the Christian community of Classis and Ravenna had their own burial grounds not far from the port zone, as we know from the various Christian funerary epigraphs unearthed there, the earliest of which can be seen in the Archiepiscopal Museum (the Museo Arcivescovile) of the city.

## Capital of the Roman Empire of the West

At the start of the fifth century, in 402 to be precise, because of the threat of invasion by the Visigoth King Alaric, the Roman Emperor Honorius followed the counsel of his adviser Stilicho and, for reasons of security and strategy, abandoned his seat in

Milan and transferred his court to Ravenna. The city on the Adriatic presented great advantages as an imperial residence in times of uncertainty. The marshes around it made it all but impregnable, while at the same time it could easily receive reinforcements, arms, and provisions by way of the sea from the eastern part of the Empire. The choice of Ravenna proved well-founded. When Alaric again descended on Italy in 408 he thought better of trying to take the new capital and proceeded instead against Rome.

As seat of the Roman Empire of the West, Ravenna lost its look of a modest provincial center to assume the splendor appropriate to an imperial residence. In the course of the fifth century magnificent civil and religious edifices were built, among them the basilica of San Lorenzo in Caesarea, admired even by Saint Augustine, and the great cathedral erected by Bishop Ursus on a five-aisled basilican plan such as had already been used in the Basilica Maior in Milan. Subsequently an octagonal baptistery whose superb mosaics we can still admire today was built alongside the cathedral. The plan of the babtistery was later modified by Bishop Neon, to whom we owe the Basilica Apostolorum, now called San Francesco.

Upon the death of Honorius, his sister Galla Placidia ruled the Empire from Ravenna in the name of her young son Valentinian III. It was she who built the churches of San Giovanni Evangelista and Santa Croce as well as the small cruciform chapel she may have intended as her own mausoleum. If that was her wish, it was not realized. The august sister of Honorius died in 450 while in Rome and was buried there. But her monument survives, and its mosaics never fail to convey an impression of solemnity because of the atmosphere of mysterious enchantment they emanate.

In Galla Placidia's time the bishop of Ravenna was Saint Peter Chrysologus, who earned his laudatory cognomen as a learned and elegant orator: *aureus sermicinator* ("he of the golden speech"). He was one of the greatest of Ravenna's bishops, with something of the same prestige in his time as Saint Ambrose enjoyed in Milan in the last quarter of the fourth century. It was during his episcopate, about 430, that certain churches in the Emilian region, those of Forlì, Imola, Bologna, Modena, and Voghenza, split off from the metropolitan jurisdiction of Milan and set themselves up as an autonomous group subject to the authority of the bishop of Ravenna while at the same time remaining suffragan to Rome.

After the death of the imperial regent Galla Placidia in Rome on November 27, 450, Italy was invaded by the Huns. The last sovereigns of the Western Empire would continue to reside in Ravenna, but thenceforth they were to be no more than pale shadows of a power whose decline nothing would or could prevent. And Ravenna too could not help but go under in the debacle of the Empire. After visiting it in 467, Apollinaris Sidonius wrote to his friend Candidianus: "Ravenna is no more than a swamp where all the forms of life show themselves as the inverse of what they should be: where walls fall and water stands, towers crash down and ships sit immobile in the bay, where the invalids stroll about and the physicians take to their beds, where baths freeze over and houses burn, the living die of thirst and the dead float swollen in the water, where thieves keep vigil and judges slumber, priests turn themselves into usurers and Syrians sing psalms, beggars go about armed and soldiers haggle over money like old-clothesmen, where graybeards play at ball and little boys at dice, where the eunuchs study the art of war and the barbarian mercenaries the art of poetry. Think then what manner of city now houses your household gods!"

## The Reign of the Barbarian Kings

In 476, with the deposition of Romulus Augustulus, the Roman Empire of the West was brought to an end. Thereupon Ravenna became the seat of Odoacer, the first of the Barbarians in Italy to bear the title of king.

About 490, preceded by his fame as conqueror after his victories on the Isonzo and Adda rivers and at Venice, the Ostrogoth Theodoric marched on Ravenna at the head of a huge army *(innumerae catervae)*.

For almost three years the city lived in a state of siege. On March 5, 493, Theodoric forced Odoacer to agree to negotiations. The vanquished ruler was assured that his life would be spared and even that he might hope to retain part of his dominions. Ten days later, accused of plotting, he was slain by Theodoric's own hand.

Thereupon the Ostrogoth king became sole ruler and assumed the title of *Dominus*, to which he later added that of *Rex*. He proved a wise and enlightened monarch and encouraged new building, launched major projects to reclaim the marshlands around his capital, and restored Trajan's aqueduct: in the Museo Nazionale there are lead water pipes discovered in 1938 which bear the inscription in raised letters: D(OMI)NVS REX THEODERICVS CIVITAM REDDIDIT.

Among Theodoric's architectural undertakings was his residence, the *Palatium*, of which we can get some idea from the mosaic on the south wall of the nave of Sant'Apollinare Nuovo (plate 62). At the start of this century a good part of the foundations of the edifice were brought to light by Ghirardini, including a large inner courtyard, an ample public hall with apse (the so-called tribunal), and another room with three apses identified as a triclinium.

As an Arian and head of a people who subscribed to that doctrine, Theodoric wished his followers to have their own churches apart from those of the orthodox Catholic natives of the city. Thus there soon rose as a cathedral the Anastasis Gothorum—now the church of Spirito Santo (p. 45)—and alongside it the Baptistery of the Arians, whose cupola is superbly decorated with mosaics (pp. 46–55, plates 15–21).

In proximity to his palace Theodoric built a court church, the splendid basilica originally dedicated to the Savior but now called Sant'Apollinare Nuovo which contains, among other treasures, the earliest mosaic cycle to have survived, a sequence of

twenty-six scenes of the miracles, parables, and Passion of Christ (pp. 77–103, plates 32–68).

In these churches, and in the others that were erected in the territory of Classis, the priests followed the teachings of Arius which were condemned as heretical by the Roman Church. According to those doctrines, only God is "non-generated" and truly divine, and Christ—the *Logos*—is "diverse and dissimilar" to God, not having been born from the living God as Himself a living God but, instead, acquiring His godhead only through adoption and not possessing it by nature and essence.

Yet, all things considered, there was never any serious tension between Arians and Catholics in Ravenna until toward the close of Theodoric's reign when he held Pope John I as prisoner. The pope died in May of 526, just three months before Theodoric himself, and was considered by the Catholics as a *victima Christi*— a life sacrificed for Christ.

The monumental mausoleum Theodoric built for himself has survived. It lies something over a half-mile from the city, and its austere and ponderous bulk, constructed from huge blocks of stone perfectly squared off and fitted together, rises in lonely majesty within a crown of dark cypress trees. The mausoleum is topped by an enormous cupola hewn from a single block of Istrian limestone *(ingens saxum)* which plays a considerable part in the impression one receives of force and dominion, of the stubborn will and hunger for fame that befits a people of great conquerors (pp. 105–110, plates 69–71).

## The Byzantine Conquest

In May of 540 Belisarius, general of Emperor Justinian I of Constantinople, succeeded in entering Ravenna against the resistance of the Goths under the command of Vitiges. Thereby the city passed to the Byzantines and in 544 was made the seat of the prefecture for Italy of the now reunited Eastern and Western empires.

It was only after the Byzantine conquest that two of the most beautiful basilicas in the city were completed: in 548 the octagonal San Vitale, where the mosaic portraits of Justinian and his empress, Theodora, can still be admired (pp. 111–61, plates 72–98), and in 549 Sant'Apollinare in Classe, whose broad and solemn nave is rounded off by a vast apse from which the hieratic image of Saint Apollinaris, the first bishop of the city, looks down on the congregation (pp. 163–75, plates 99–105).

In those years the Byzantines brought to the city the sumptuousness of the East and adorned its edifices with imported marbles already finely worked in the famous workshops of Proconnesus. Among the many objects of inestimable value that were brought into Ravenna from one source or another during that period was an ivory throne, a superb example of the carver's art of the sixth century (pp. 201–209, plates 129–39). It came as a gift to the great and highly capable prelate Archbishop Maximian

of Pola, the first in the West to be awarded the title of *Archiepiscopus*.

About 561, some twenty-one years after Ravenna fell to the Byzantines, Maximian's successor, Archbishop Agnellus, managed to obtain an edict from Emperor Justinian awarding all goods and properties of the Arians to the Catholics. This involved the "*reconciliatio*" to the Catholic Church of all the religious edifices in Ravenna and Classe that had been built by the Arians, a conversion of no small importance to future times since it saved those monuments from possible destruction.

The Goths continued to put up some resistance, but when eventually they were defeated once and for all, Ravenna again became the chief city of the peninsula, the capital to which the governors of the other regions of Italy, the *iudices provinciarum*, were responsible.

But it was at that time too that the Lombards became restless and took steps to extend their conquests to the south of Italy. The prefect Longinus, who had no army outside of Ravenna, entrenched himself in the city; the emperor from the East sent armies to Italy which were led by a commander with unusually great authority. It was thus in the course of the war against the Lombards that the institution of the Exarchate came into being. The first mention we have of this system of rule by a viceroy of the emperor goes back to 584, though it undoubtedly existed *de facto* before that date.

For almost two centuries, until 751, the Exarchs or Imperial Governors ruled the city and ruled it badly. Ravenna declined all too visibly. Its markets and trade dwindled and at last became crippled beyond saving.

## Another Decline and Fall

Shortly before the middle of the eighth century Liutprand, King of the Lombards, seized and plundered Classe, leaving little more than ruins. By the ninth century the chronicler Andreas Agnellus, author of the *Liber pontificalis ecclesiae Ravennatis*, could speak only of the "*destructa Classis*." Ravenna itself had reached the limit of its forces, and the pretense of its archbishops that its Church was independent of Rome was certainly not enough to restore to a moribund city its quondam power and glory.

Only in the time of the Ottonians, from the tenth century on, when the archbishops became great feudal lords of the Holy Roman Empire, did the ancient capital regain something of its past vitality. It was as if Ravenna, true miracle of the Western world and once acclaimed as *felix* and *praecelsa* (fortunate and lofty), had awakened at last from its dreams of a greater past. Then, not long after, it became one of the first cities in Italy to form itself into a commune. Along with this autonomous form of government it created educational institutions at an early date, a *studio*—meaning something in the nature of a university however primitive as yet—and a school of *ars notaria* to train scribes. Later

the government passed into the hands of powerful families. In the fourteenth century the Da Polenta family won out, and among its members Guido Novello has enjoyed special fame for the generous hospitality he extended to Dante Alighieri, who, exiled from Florence ("motherland with little mother love"), died in Ravenna in the night between the thirteenth and fourteenth of September, 1321.

## The Heritage of the Ancient World: Monuments and Mosaics of Early Christian Times

The Christian religious edifices of the fifth and sixth centuries in Ravenna were endowed with solid geometrical forms of crystalline clarity and were conceived in volumetric masses equally impressive if small or large. Yet from outside they all strike one as unpretentious and even humble, and this is because they are built entirely of simple rows of bricks joined by rather high layers of mortar. The warm red-brick color and texture of these broad flat wall surfaces are never interrupted by the sparkle of marble or the pleasing gracefulness of natural stone. Nothing hints even that their interiors glow with priceless and splendid decoration, with the magnificence of the glistening colors—bright as their first day—of mosaics that cover, in whole or part, their walls, vaults, cupolas, even the embrasures of the windows.

Made chiefly of such durable materials as stone, marble, colored glass enamels, and sometimes even mother-of-pearl, mosaic has the advantage over other mediums, and notably over painting, that it can resist and survive the decay and disintegration that the centuries bring. Paintings often bleach out with the passing of time or their color relations become much altered; frescoes are subject to mold or go dark or flake off. Mosaics, however, conserve intact the colors the artist gave them, so that we cannot help but be moved by the magic of their perennial freshness and by the perduring of their original, vital, joyous splendor. No wonder that such a true artist of the Renaissance as Domenico Ghirlandaio could define mosaic as "true painting for all eternity."

Formed by the juxtaposition of myriads and myriads of tiny elements of hard material, the so-called tesserae, each of which constitutes a point or tiny patch of color, the "fabric" of mosaic is spread across broad areas and gives rise to glittering golds, scintillations of silver, flashes of garnet red, trumpet blasts of emerald greens, almost murmuring opalescent whites, the muted tones of the milder blues . . .

In the Ravenna mosaics the tesserae are not disposed on a flat and uniform plane but set at all different angles so that when the light strikes them it is not reflected in continuous beams as in a mirror but is refracted and broken up prismatically into as many chromatic units as there are tiny cubes of mosaic, whence the marvelous play of lights and reflections which make these mosaic surfaces seem to quiver with life, to be ever varied and infinitely changeable. In addition, this irradiation of light over considerable surfaces transforms space itself, transmuting even the most geometrical solid architecture into something almost immaterial and imponderable.

Not a single early writing has passed on to us the names of any of the *magistri imaginarii*, the artists who designed the mosaics, or the *magistri musivarii*, those who executed them, nor do we have any idea even of where they may have come from. There is no doubt, though, that their training must have involved two different traditions, one Hellenistic-Roman, the other Byzantine. It may be that at first they came from Milan when the court moved from there to Ravenna. Then perhaps, at a later time, they may have formed their own school in Ravenna itself, one disposed to welcome influences from Rome but also—like the nearby port of Classis—whatever came to them from the East. But then again, shortly before the middle of the sixth century and after the city fell to the Byzantines, they may have come directly from Constantinople.

What we do know is that, in the troubled and confused period of transition between Late Antiquity and the Middle Ages, Ravenna was traversed by very different and even contradictory currents and lived the life of two quite dissimilar worlds. For all of its varied artistic expressions, Ravenna drew upon both of these worlds, with their separate inspirations and their separate problems.

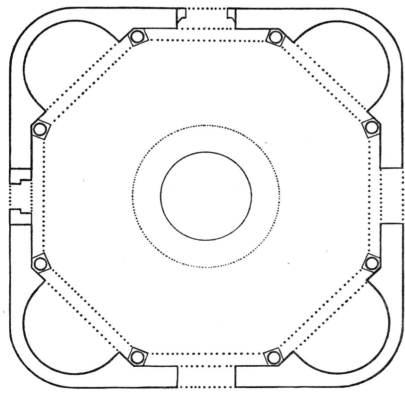

*Baptistery of the Orthodox. Drawing of the exterior*

*Baptistery of the Orthodox. Ground plan (after Perogalli)*

## 1   Baptistery of the Orthodox

*Founded in the first quarter of the fifth century*
*Decorated in the third quarter of the fifth century*

Early in the fifth century Bishop Ursus saw to the building of a grandiose cathedral (unfortunately now destroyed) and soon after, to complement it, an octagonal baptistery located to its north. Both of these had as models similar edifices in Milan. Shortly after the middle of the same century Bishop Neon modified the plan of the baptistery so that the entire interior could be spanned by a single cupola covered with splendid mosaics. In consequence, although its real founder was Ursus, it is often referred to as the Baptistery of Neon.

The imposing building has a diameter of about thirty-six feet, and its walls are solid brick. On the eight sides of its lower zone, now sunk into the ground to a depth of almost ten feet, there originally alternated four apses and four flat walls, each with a door.

In the center of each of the eight walls of the middle zone there is an arched window whose function is not only to admit light but also to relax what would otherwise be a too rigorous architectural plan.

Then, on each of the eight sides of the uppermost zone—perhaps remodeled toward the end of the seventh century—there are two blind arches supported by flat moldings, and each arch resolves at the top into a pair of smaller arches.

A tiled roof of eight sloping triangular segments covers the interior cupola, which was constructed in the Roman manner with a double series of rings of hollow clay tubes shaped like syringes and inserted into each other. These rings diminish in diameter as they ascend to the vault, and in the covering of the crown are replaced by a network of small blocks of very light pumice stone.

The broad and airy interior never fails to produce a profound impression. The polychrome marble inlays (today very much restored), the stuccoes on which now only traces of color remain, the iridescent mosaics gleaming everywhere, all of these are so intimately and harmoniously wedded to the architecture as to make a truly indissoluble unity.

The mosaic decoration of the cupola is arranged in three zones comprising a circular medallion in the summit of the vault surrounded by two broad concentric bands.

In accord with the function of the edifice, the central medallion shows the Baptism of Christ (plate 2). Immersed to the hips in the waters of the Jordan, the entirely nude Savior receives baptism at the hands of Saint John the Baptist, who stands on the rocky bank of the river. From above, the dove of the Holy Spirit descends. Emerging from the stream on the other side of Christ is an elderly

bearded man, nude to the waist, holding a marsh reed with his left hand and, with both hands, a green cloth with which to dry the body of the Redeemer after the rite. A Latin inscription above his head identifies him unequivocally as the personification of the River Jordan.

Looking closely at this mosaic one notices an area where the gold has a much lighter tone. Included in it are the dove, the head of Christ, the upper part of the cross held by the Baptist, the latter's head, and all of his right arm as well as the shallow *patera* (bowl) from which he pours the sacramental water. All of this is the product of a restoration undertaken—rather too drastically in some respects—by the Roman mosaicist Felice Kibel shortly after the middle of the nineteenth century. It was he who arbitrarily placed the bowl in the Baptist's hand although, as we know from all the early representations of this subject, in the original mosaic the saint must have held no object whatsoever but, instead, have laid his right hand directly on Christ's head, exactly as in the analogous scene in the somewhat later mosaics of the Baptistery of the Arians (plate 18) which have been spared this kind of mishandling.

Around this central medallion runs a broad band of mosaic whose dark indigo blue background brightens below to the fresh green of a meadow. The figures of the Twelve Apostles stand out against this, each identified by his name written above his shoulders. Divided into two groups led respectively by Saints Peter and Paul, they step forward slowly, each with his mantle caught up and usually draping the hands in which he holds a symbolic crown. They are separated one from the other by slender tall floriated candelabra rising from bases of acanthus leaves. Each apostle wears either a gold tunic and white pallium or, alternatively, a white tunic and gold pallium, and each head stands out against a loop of a drape that falls in a regular rhythm from the frame around the central medallion. The faces are well characterized and so individual that one can think of them as portraits.

The procession of saints is imprinted with such a cadenced feeling of movement as to seem almost a figurative embodiment of the idea of the *sempiterne rote* (the eternal round of the heavenly spheres) that Dante imagined.

The second ring of mosaics encircles the band with the apostles and is divided into eight architectonic segments separated by candlesticks formed from luxuriant plant motifs. Each segment is made up of three parts. The middle part represents a niche before which is placed, in alternate segments, either a richly decorated throne as symbol of the sovereignty of Christ or an altar upon which lies an open Gospel. To the sides of each throne, in a kind of loggia composed of pillars and ceiling and closed off in front by an openwork half-screen or transenna, are the varicolored plants of the symbolic gardens of Paradise. At either side of each altar, however, the portico shelters an empty chair, and these would seem to allude to those prepared by God to welcome the elect into the many mansions of Heaven: *et ego vado parare vobis locum* (I go to prepare a place for you; John 14:2).

It has been proposed recently that the three zones of decoration in the cupola should not be considered as distinct from each other, however different their content may seem, but, instead, as inseparably linked. They were realized, the argument runs, in terms of the so-called Plotinian or polar perspective, which means that the various elements are to be interpreted as placed in front of each other. Thus the Baptism of Christ should be seen as actually occurring within the circle of apostles offering crowns, and they in turn are to be thought of as circling around in front of the architecture in the outermost band.

Below the cupola, in the zone with the windows, the wall is richly decorated with stucco reliefs done during the episcopate of Bishop Neon (449–75). Besides various purely ornamental motifs they include sixteen figures of prophets in aedicules, two for each wall, along with figured scenes.

Still lower, on and around the eight arches set against the eight walls, there is again mosaic decoration, an exuberant efflorescence of acanthus scrolls in the midst of which, within each pendentive, a small male figure is set against a gold background. However, it is difficult to judge these since a good part of them was redone at the end of the nineteenth century.

1   *Baptistery of the Orthodox. Interior. First quarter of the fifth century*  ▷

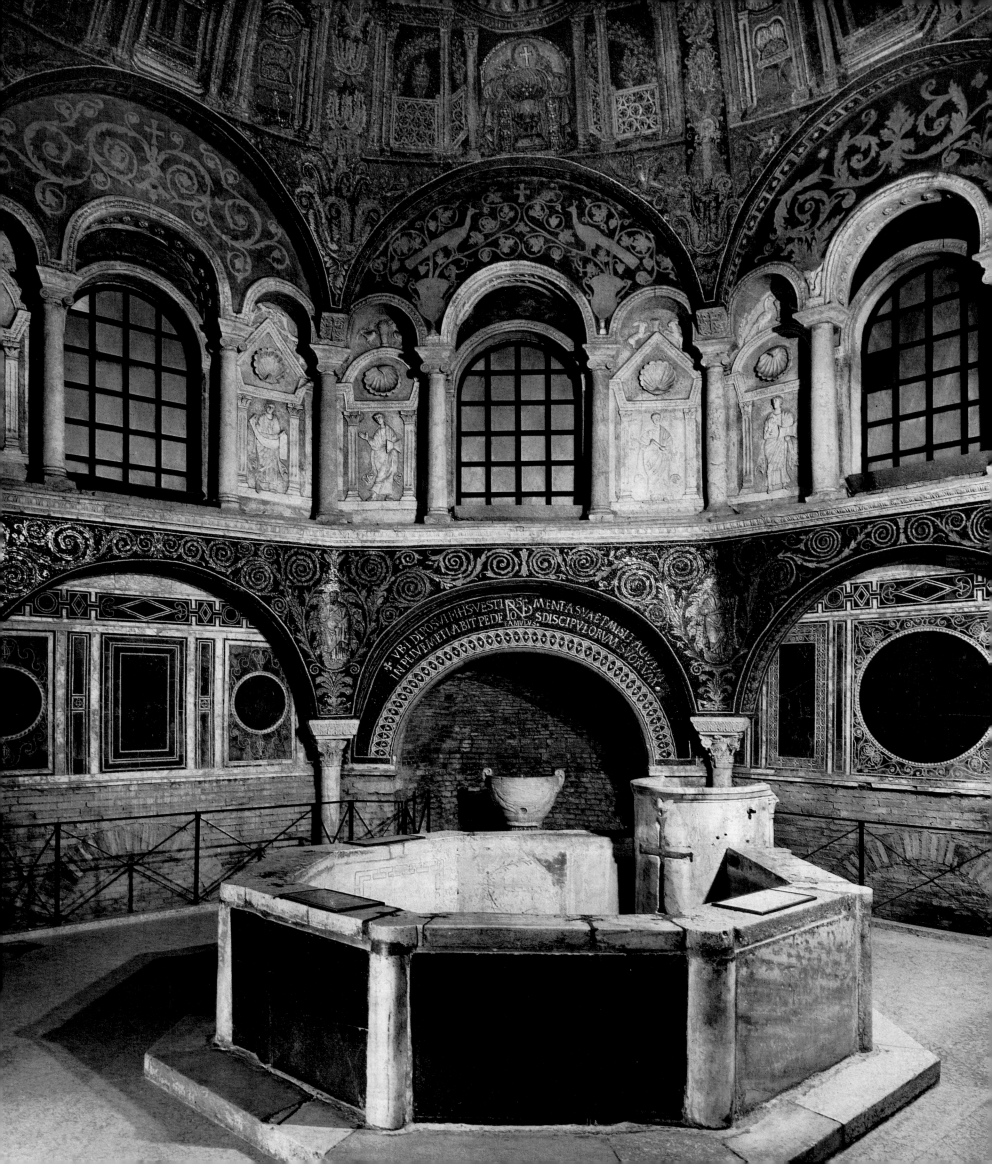

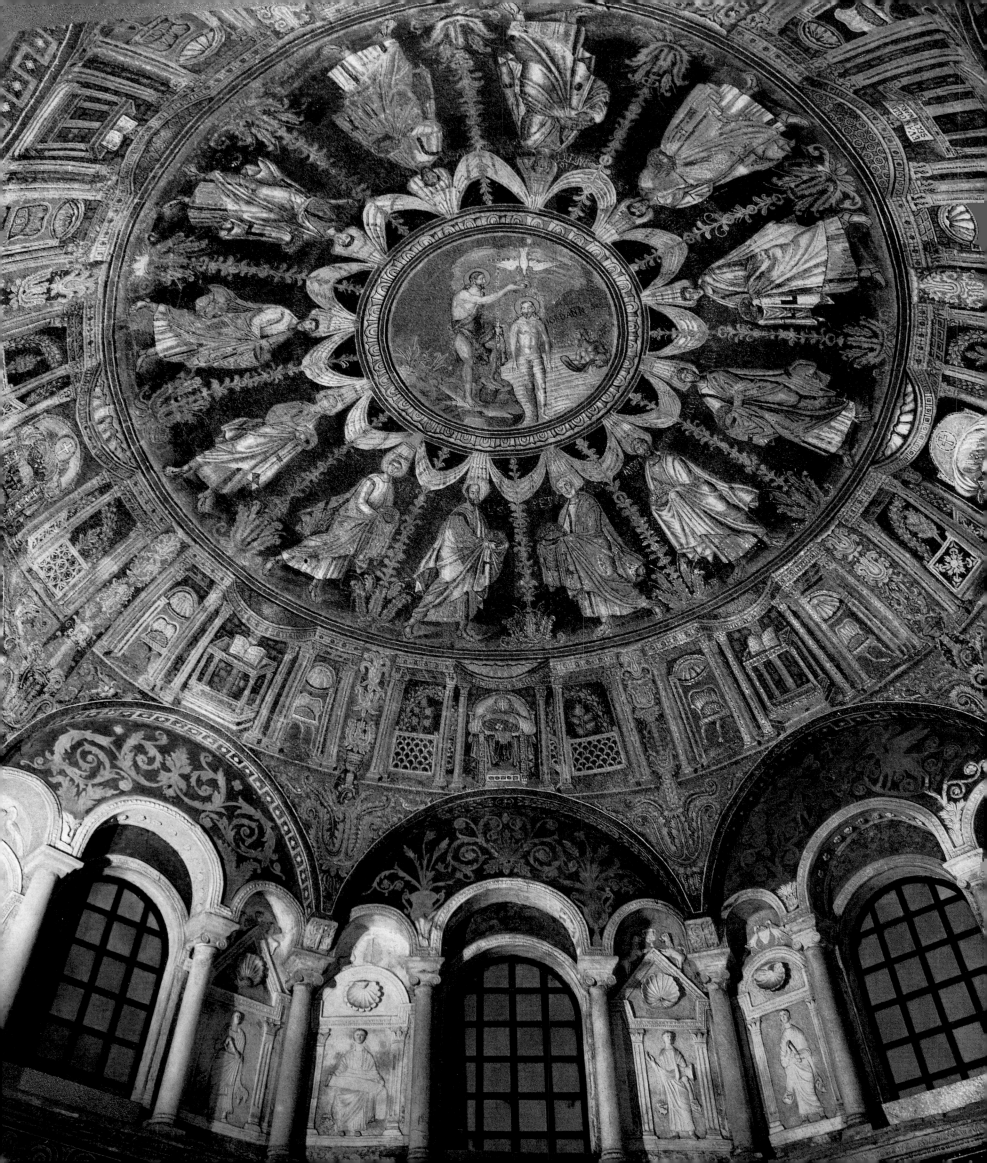

*2 Baptistery of the Orthodox. Cupola mosaic and the stucco decoration in the window zone. Third quarter of the fifth century*

The mosaic decoration of the cupola gives the impression of a great spoked wheel revolving slowly around a central fixed disk. In this way the two concentric bands seem to be infused with a centrifugal motion which makes one think almost that the cupola is tending to descend and broaden out. The chromatic range of the mosaics remains lively and brilliant, the more so in contrast to the stuccoes below them, which have retained scarcely more than a pale tint of their original painted surfaces.

*3   Baptistery of the Orthodox. Detail of the stucco decoration*

Here we have one of the few surviving examples of the art of the ancient *gipsoplastae*—the decorators and artists specializing in sculpture in stucco. Since stucco has nothing like the strength and permanence of marble or stone, its conservation through so many centuries is nothing short of miraculous, even if the colors with which these reliefs were once painted have now mostly faded or flaked away.

Because these reliefs were designed to be set between two zones of mosaic, the modeling of the figures of the prophets was kept relatively flat in order to harmonize or at least remain more or less consistent with the overall two-dimensional mosaic decoration.

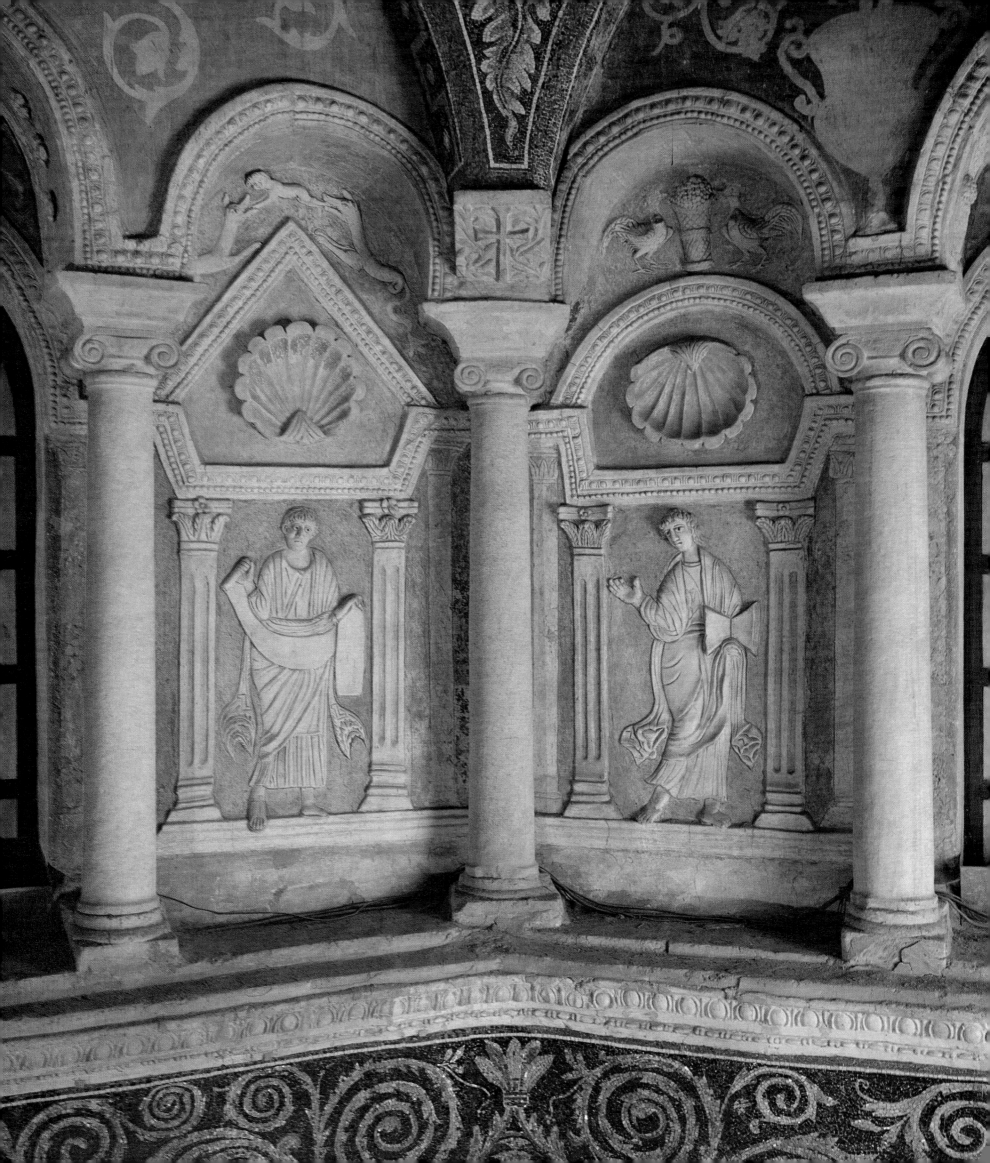

*4  Baptistery of the Orthodox. Detail of the cupola mosaic*

In the first band encircling the medallion at the summit of the
vault we have a circular procession of the Twelve Apostles in the
act of offering to Christ the symbolic crowns they won through
martyrdom in His faith. The second band is made up of eight
architectural structures, open porticoes in whose recessed centers
thrones and chairs alternate. It is noteworthy that, entirely aside
from the symbolic and figurative elements, the decorative
scheme allotted considerable importance to purely ornamental
motifs. Thus, in the upper zone, a drape falls in festoons and,
at regular intervals, there are slender floriated candelabra growing
from clusters of acanthus leaves. These two motifs combine to
separate rhythmically the individual apostles one from the other.
Notable also are the floral motifs in the outermost band which
are superimposed and combined to make an organic decoration
which contrasts with the more rigid architectonic character of the
porticoes they serve to separate.

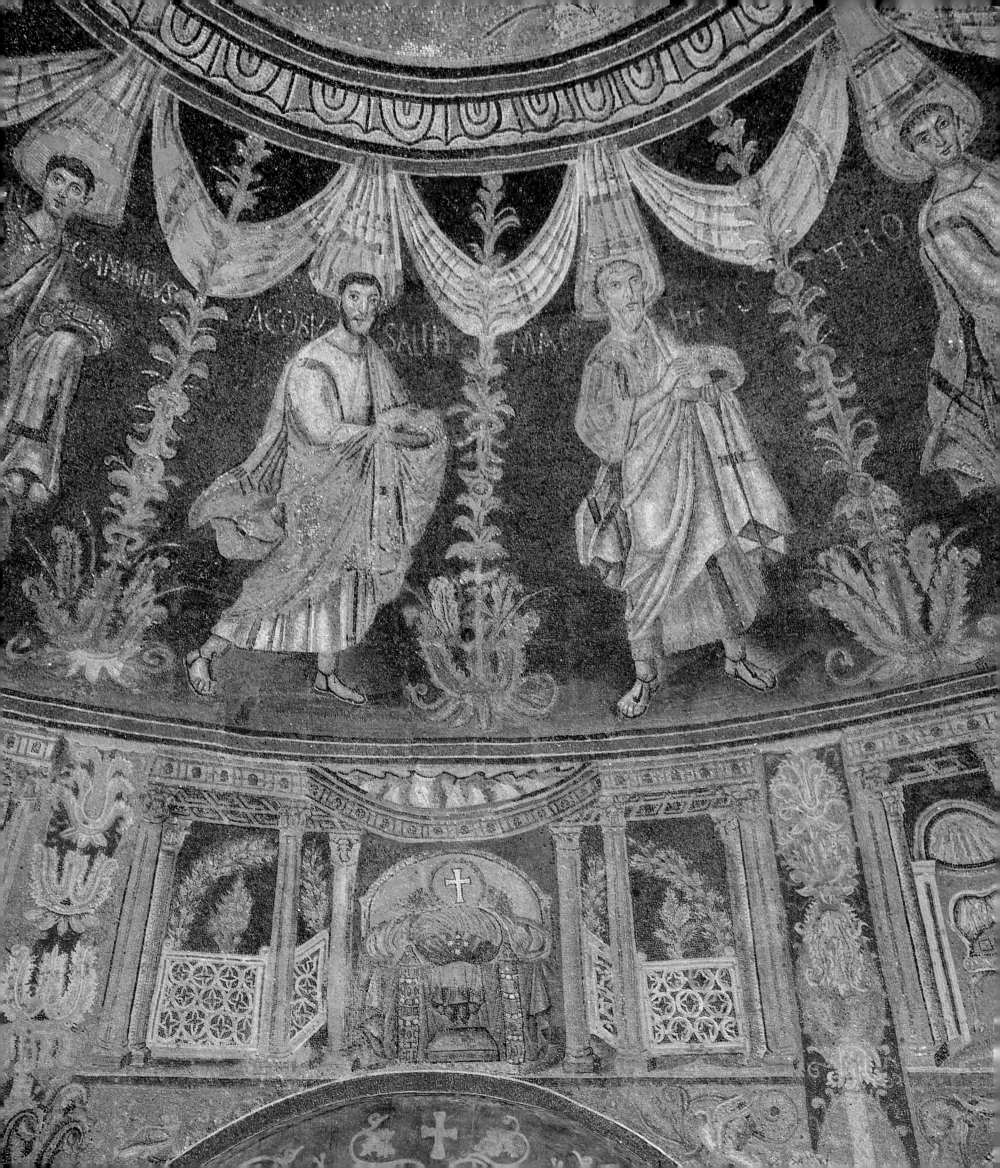

5 *Baptistery of the Orthodox. The Apostle John*

All the apostles are depicted in the act of stepping forward in a slow and hieratic stride. Each is dressed in gold tunic and white mantle, like Saint John here, or, alternately, in white tunic and gold mantle.

The tunics are long and reach almost to the feet and are decorated with two dark *clavi* (broad stripes). On the borders of the mantles there are letters of the alphabet which, contrary to what one might expect, have no ulterior significance and are used only for decorative purposes. As a motif they are not at all uncommon in Ravenna mosaics, and we shall find them again (see plates 15, 21, 60 and 64, among others).

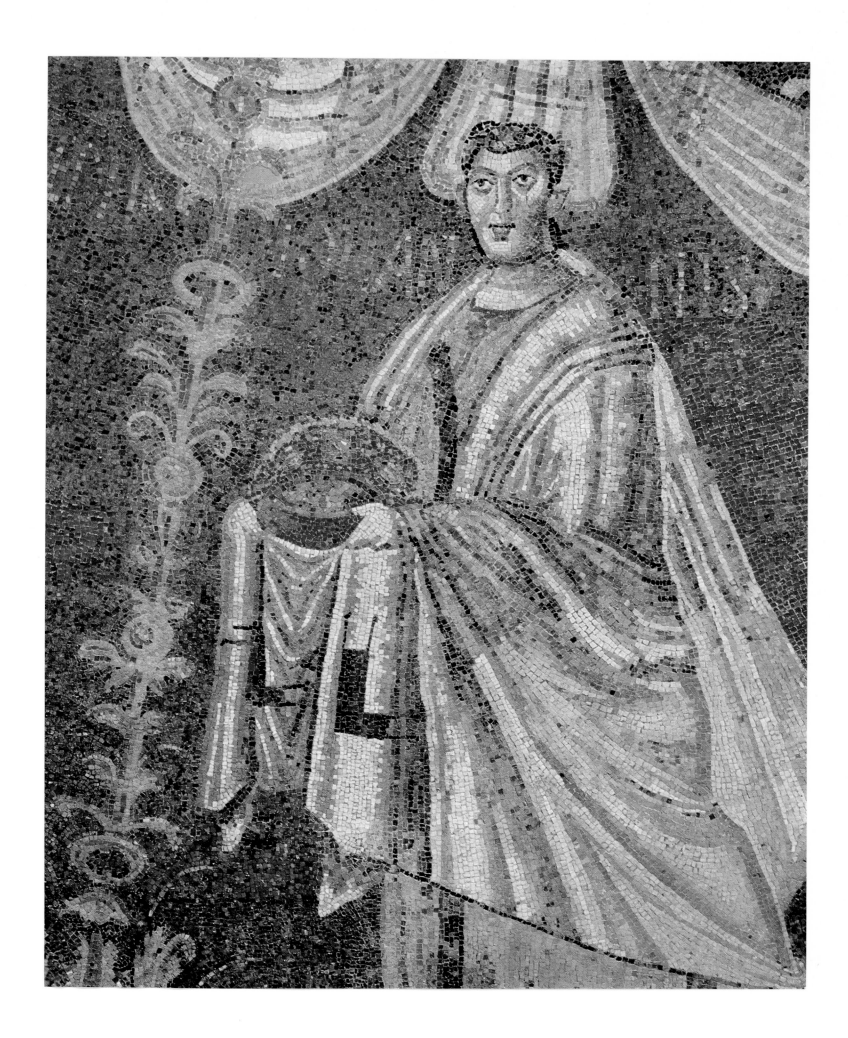

6   *Baptistery of the Orthodox. The Apostle Bartholomew (detail)*

In his hands, usually covered by a drape of the pallium, each apostle holds the incorruptible crown of glory *(immarcescibilis gloriae corona)* he has earned, the splendid circlet of immortality which is the divine reward for his steadfastness in the faith. Here they offer to Christ this divine gift with the evident purpose of glorifying Him and submitting to His sovereignty.

The truly remarkable facial traits of the Twelve seem conceived with perfect respect for individualization and are clear proof that the medieval *pictor imaginarius* who realized them was still following the great lesson of Roman art, whose preferences went decidedly more to the concrete than to the abstract.

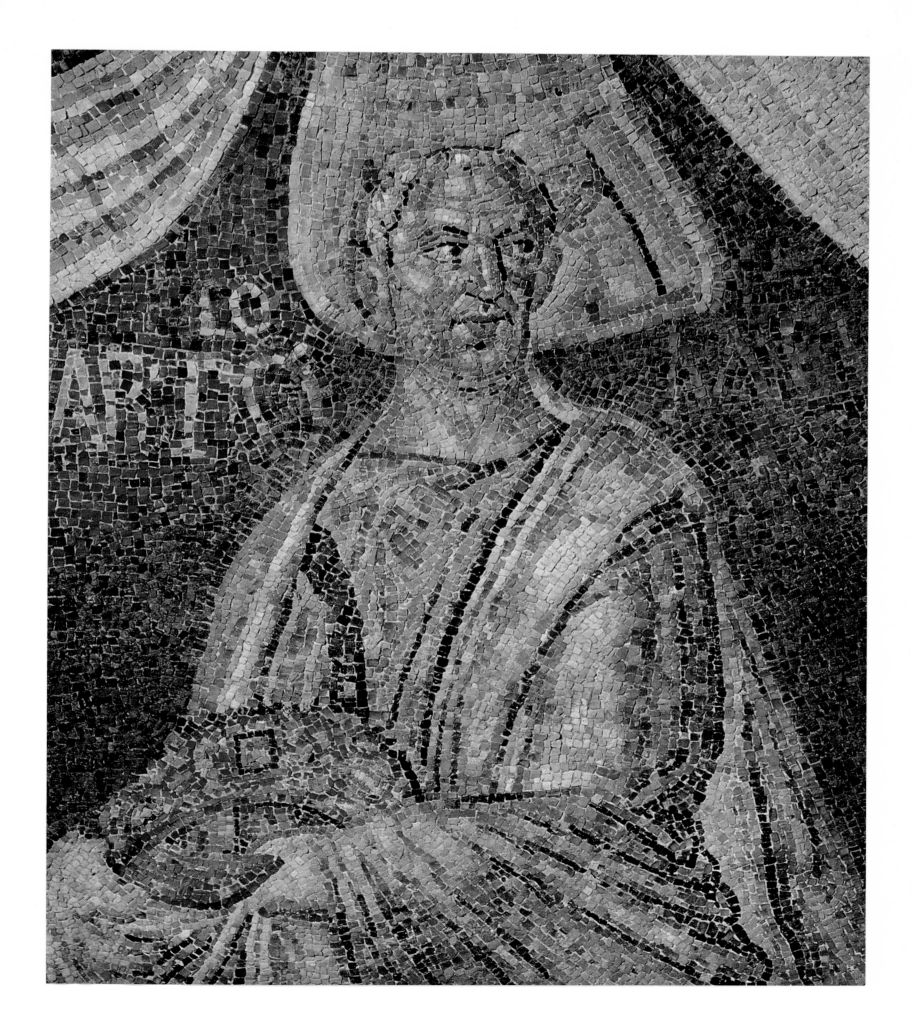

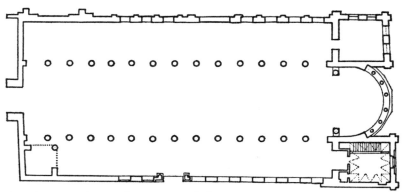

*San Giovanni Evangelista. Facade*

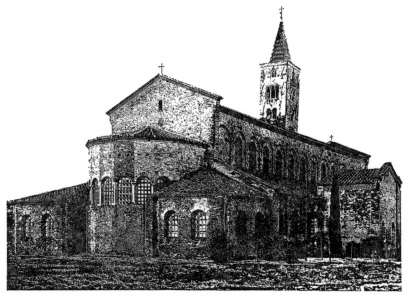

*San Giovanni Evangelista. Ground plan*

*San Giovanni Evangelista. Apse*

## 2 San Giovanni Evangelista

*second quarter of the fifth century*

A mosaic epigraph once visible in the apse of the church and transcribed by the chronicler Andreas Agnellus affirmed that its founder was Galla Placidia herself in fulfillment of a vow made when, on the journey from Constantinople to Ravenna to take over the reins of the Roman Empire of the West in the name of her young son Valentinian III, the ship in which she was travelling was menaced by a frightful tempest. Presumably she set about fulfilling her pledge soon after her safe arrival in Ravenna in 426.

By and large the basilica of San Giovanni Evangelista can be said to look today much as it did in its earliest years, even if, as a result of the bombing raids of 1944, the front elevation, roof, and part of the apse have had to be entirely reconstructed. A more significant alteration, however, involves the ground level, which is now some nine feet higher than the original. The center of the front wall is taken up by an extremely high vestibule added in medieval times, and this too has been entirely reconstructed along the original lines. A square campanile about 138 feet high stands immediately alongside the front and is another addition to the original plan, dating from about the end of the ninth century.

The rear of the basilica, on the outside, is characterized by two structures projecting to either side of the apse. These annexes had specific functions in the primitive church and were the so-called *pastophoria*, the one known as the *prothesis* being used for the presentation of offerings, the other known as the *diaconicon* being reserved to house and store the liturgical furnishings. This marks the first appearance in Ravenna of this sort of annex, and for the prototype one must look to Syria, to the Early Christian church at Firftin built as early as 372.

The apse itself is polygonal on the outside and is ringed by seven windows separated from each other only by plain short columns with simple impost capitals so that, despite the grills and glass, one has the impression of an open airy loggia.

The interior of the church is spacious, measuring no less than 163 feet by 73 feet, and is bright and well lighted. Its nave and aisles are marked off by two rows of marble columns each topped by capitals of classical type. Each capital is in turn surmounted by a pulvin, the special Byzantine type of supplementary impost block inserted between capital and arch, and here these take the form of inverted pyramids adorned with crowns enclosing various Christian symbols.

107407

### 3   The so-called Mausoleum of Galla Placidia

*second quarter of the fifth century*

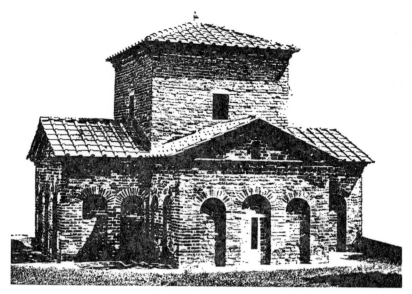

*Mausoleum of Galla Placidia. Exterior*

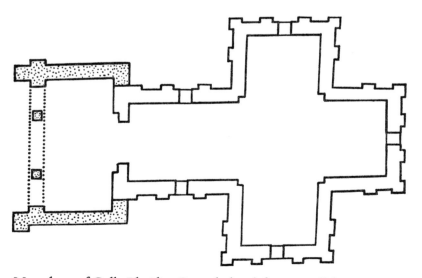

*Mausoleum of Galla Placidia. Ground plan (after Perogalli)*

As early as the ninth century it was taken for granted in Ravenna that Galla Placidia—sister of Emperor Honorius and after his death in 423 regent of the Roman Empire of the West—had been laid to rest in the small cruciform edifice that today stands isolated at the far end of the quiet greensward stretching behind the grandiose church of San Vitale. The early medieval historian of Ravenna, Andreas Agnellus, was more cautious and limited himself to: *"ut aiunt multi"* (as many say), thereby shifting to local tradition all responsibility for the rightness or wrongness of the information.

The historical fact is that Galla Placidia died in Rome in 450, and it is safe to assume that her body was inhumed in the ancestral mausoleum of the Theodosian family to which she belonged, a monument situated near the south side of the old basilica of Saint Peter's and which we know was used in that same year when the regent herself transferred to it the remains of her father, Theodosius I, which had been brought from Constantinople.

Even if Galla Placidia is in fact buried in Rome, this does not rule out the likelihood that she may have wished to build a mausoleum in Ravenna for herself and her family, especially since originally the small building was attached to one side of the narthex of the church of Santa Croce, another of her foundations. At the beginning of the seventeenth century the narthex and front end of that basilica were demolished and some twenty-three feet lopped off the front of it, which explains why the mausoleum is no longer an integral part of the ensemble of Santa Croce but now stands completely apart.

Seen from outside, the mausoleum seems decidedly modest. It certainly lacks the imposing monumentality of Theodoric's burial place, for one thing because, unlike that structure, it was not realized with great blocks of stone carefully squared off but instead with ordinary short thick bricks resting on layers of mortar about three-quarters of an inch high. What is more, in the course of more than fifteen centuries the building has sunk more than five feet and therefore strikes one as especially squat.

The arms of its basic Latin-cross plan are, respectively, forty-one and thirty-four feet long, and their crossing is crowned on the exterior by a modest-sized square tower covering the small cupola of the interior.

Each outside wall of the building, except for the entrance wall, is enlivened by a series of blind arcades whose rhythmic succession confers a certain movement to the individual walls. At the same time these arcades serve structurally as static counterbalance to the outward thrust of the walls that support the barrel vaults covering each arm in the interior.

29

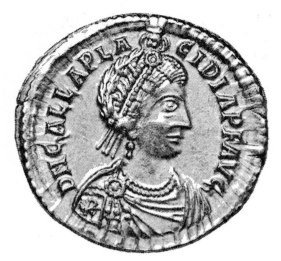

*Solidus of Galla Placidia*
*(obverse). Minted under*
*Valentinian III*

*Solidus with Victory and the Cross*
*(reverse). Minted under*
*Valentinian III*

*Solidus of Constantius III, consort of Galla*
*Placidia. Minted in Ravenna*

On entering, one senses an atmosphere at one and the same time opulent, conducive to meditation, and full of mystic suggestion. On sunny days the room glows with an enchanting topaz-colored light which filters in through the slabs of translucent alabaster used in place of glass for the windows. The light warms up the yellow Siena marble of the high wainscoting running around the entire room, and it gives life and magical reflections to the tiny cubes of mosaic, the gold ones in particular, that entirely cover the cupola, lunettes, vaults, and window embrasures. The architecture itself is virtually transfigured by the chromatic, impalpable atmospheric effulgence streaming from the polychrome walls which, palpitant with glints of light, seem almost to cancel out the spatial limits imposed by the solid structure.

An unexpected and singular effect is produced by contemplating the star-studded sky which fills the concavity of the hemispheric cupola with its intense night-blue background (plate 8). No fewer than 570 eight-pointed stars seem to rotate in concentric circles around the *sancta crux invicta* (never-vanquished holy cross), which, symbol of redemption, shines from the summit of the cupola. It may well have been under the spell of this magical night sky of mosaic that Gabriele D'Annunzio was led to describe Ravenna as a *"glauca notte rutilante d'oro"* (a sea-green night gleaming with gold).

In the four pendentives which spring from a square base to give origin to the cupola one sees, emerging from delicate but swift-blown banks of cloudlets, the four *zodia*, the living creatures who constitute the symbols of the Four Evangelists as described in Revelation 4:6–7, where they are the vehicles for spreading the good tidings to the four distant corners of the world: the eagle (John), the lion (Mark), the winged ox (Luke), and the winged man (Matthew).

In each of the four high arches supporting the cupola there is a pair of apostles who stand beneath a large shell-like canopy.

Only Peter and Paul can be specifically identified since they not only have the somatic traits long familiar in iconographic tradition, but also hold their customary attributes, the key and the *volumen*, or scroll-book, respectively.

On the rear wall the Roman martyr Saint Lawrence is pictured striding forward purposefully to the instrument of his martyrdom, a grill over a blazing fire which occupies the center of the composition. On the left in the same mosaic is a *scrinium* (a small cabinet) whose two shelves hold four books on each of which is written the name of an evangelist as symbol of the four disciples of the faith for which Saint Lawrence too offered his life (plates 7, 14).

The mosaics in the lunettes over the back walls of the two lateral arms are both very much alike. In a forest of green acanthus fronds highlighted with gold and filling the entire arch, two deer approach a pool in the center whose water ripples as if touched by a breeze (plate 13). This is undoubtedly an allusion to Psalm 42: "As the hart panteth after the water brooks, so panteth my soul after thee, O God."

Directly above the entrance is enthroned the Good Shepherd (plates 9–11). Against a background blue as a distant sky, in a landscape skillfully composed of a few trees, bushes, and rocks, the gentle and yet noble figure sits in the midst of a flock of six sheep, all with muzzles turned trustingly toward Him. The exact fulcrum of the composition, Christ is dressed in golden tunic and purplish pallium with a large golden nimbus behind His head. His right hand reaches out to one of the sheep in His humble flock, the other hand holds a cross so tall as to seem almost to unite heaven and earth. It is clear that the whole conception of the figure of the mystic shepherd is indebted to the classical images of Orpheus charming the beasts with his music.

7 *Mausoleum of Galla Placidia. Interior seen from the entrance* ▷

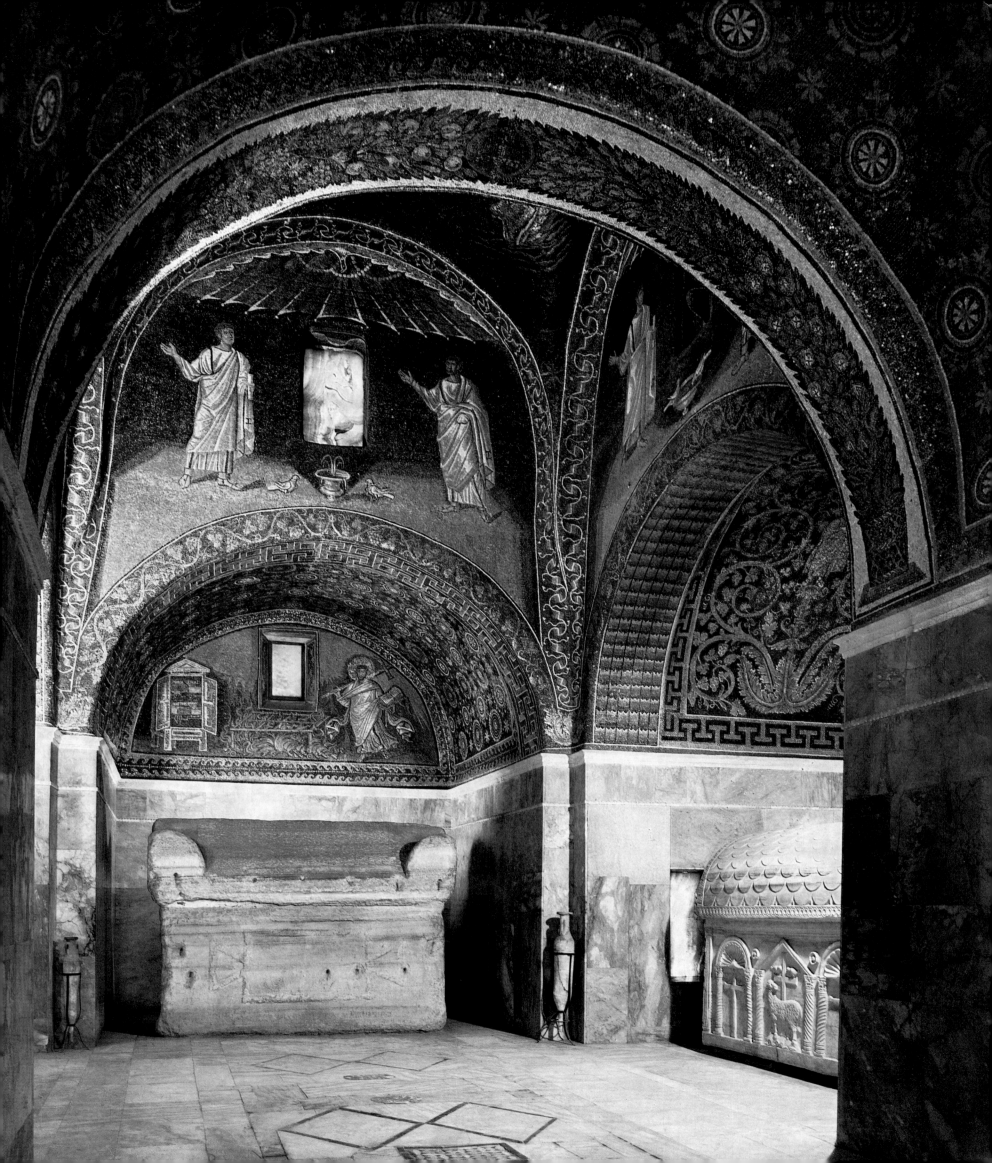

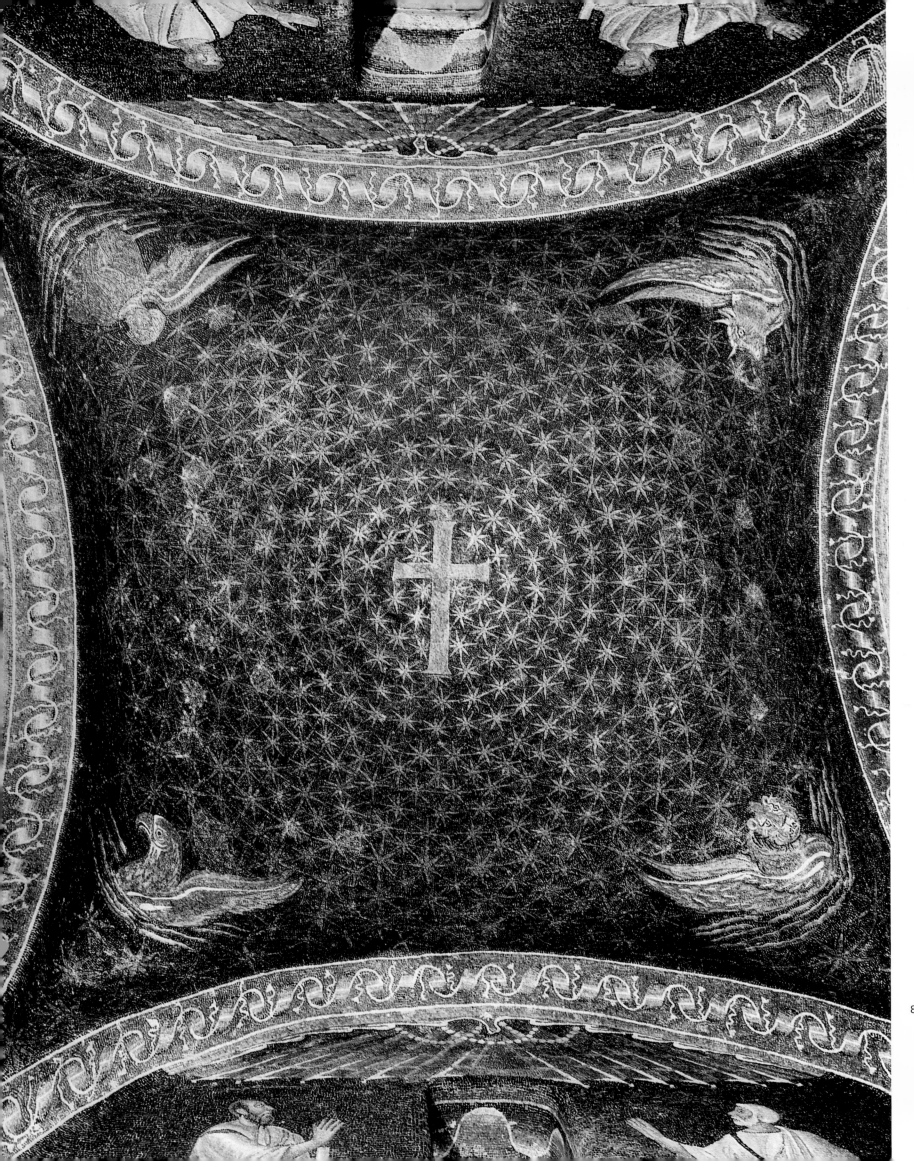

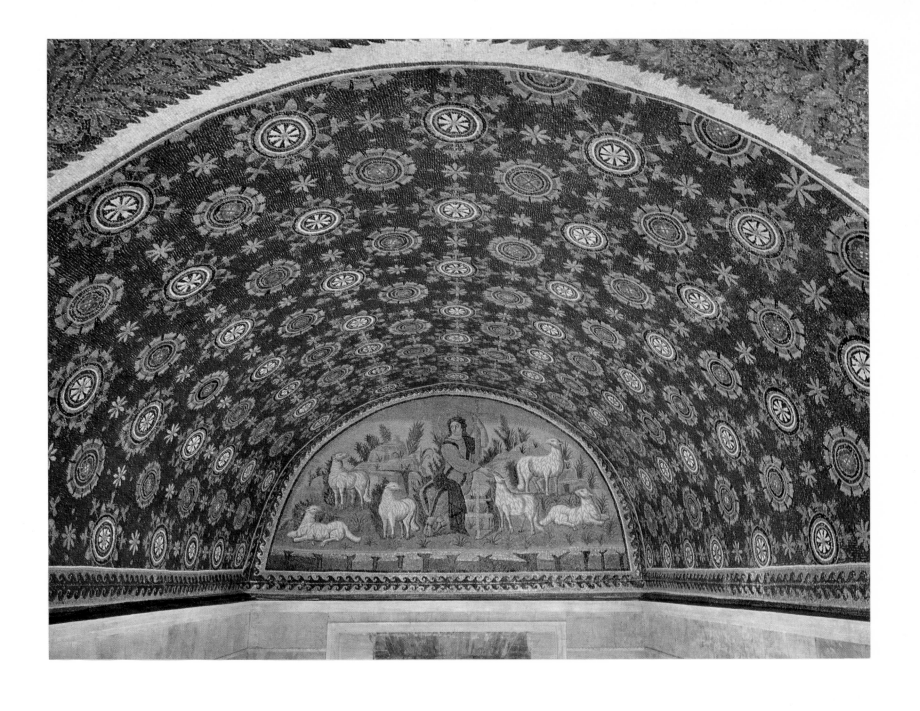

◁ 8  *Mausoleum of Galla Placidia. The cupola viewed from directly*
*below*

9  *Mausoleum of Galla Placidia. The vault and lunette over the*
*entrance*

33

10 *Mausoleum of Galla Placidia. The Good Shepherd*

The Good Shepherd was one of the most popular subjects of Early
Christian art, found over and over again in the catacomb
frescoes and on sarcophagi. He undoubtedly represents Christ
Himself, who, it will be recalled, said: "I am the good shepherd:
the good shepherd giveth his life for the sheep" (John 10:11).
However, in this mosaic there is a notable evolution over earlier
representations, since the Shepherd is not shown as a simple
herdsman in peasant dress but in truly godlike aspect, with regal
garments and a great golden halo gleaming behind His head.

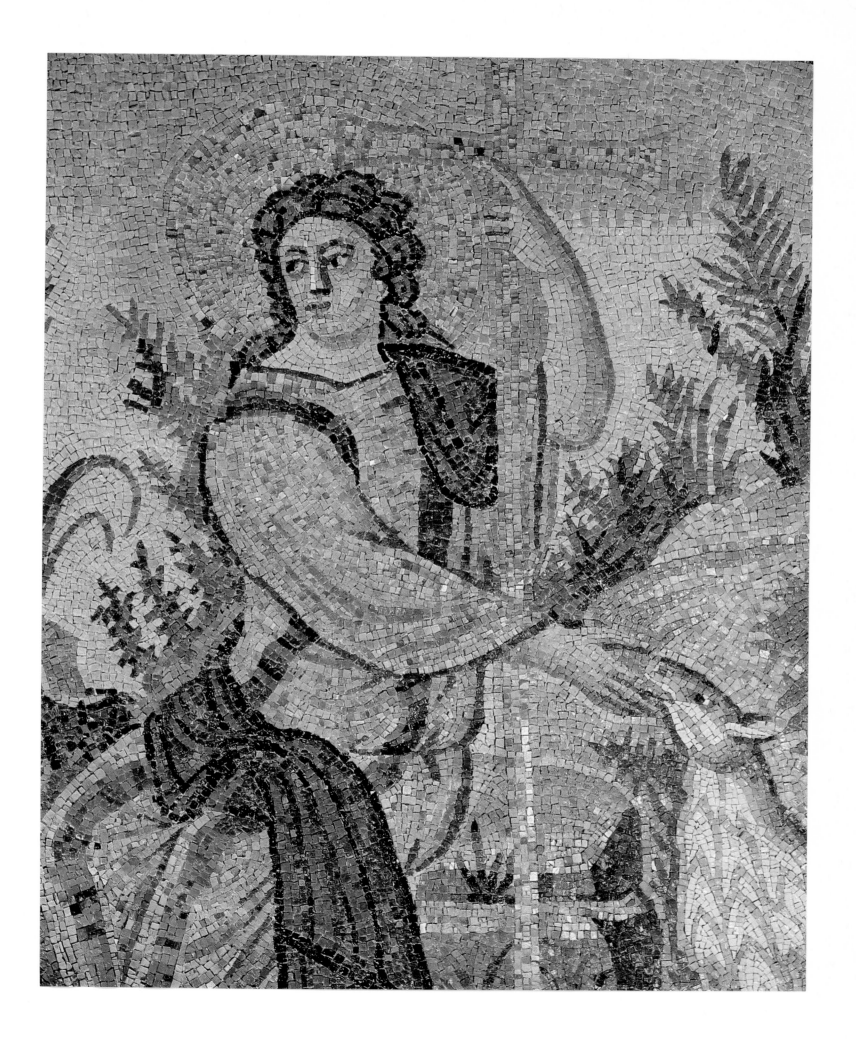

*11 Mausoleum of Galla Placidia. One of the sheep in the flock of the Good Shepherd*

The meek sheep surrounding the Good Shepherd in green pastures suggestive of the gardens of Paradise are not to be understood as symbols of the living faithful but rather of the blessed souls of those who have died and are now taken up into the flock of the elect. This, of course, does not rule out the implication that the living too may hope someday to be welcomed to the Paradise gardens, a concept explicitly expressed in the ancient prayer of the *Commendatio animae:* "In His ever verdant lovely Paradise may Christ, the Son of the living God, permit thee to live and may that true Shepherd count thee among His sheep." Further instances of this symbolism can be seen in plates 101, 103–105, and 115.

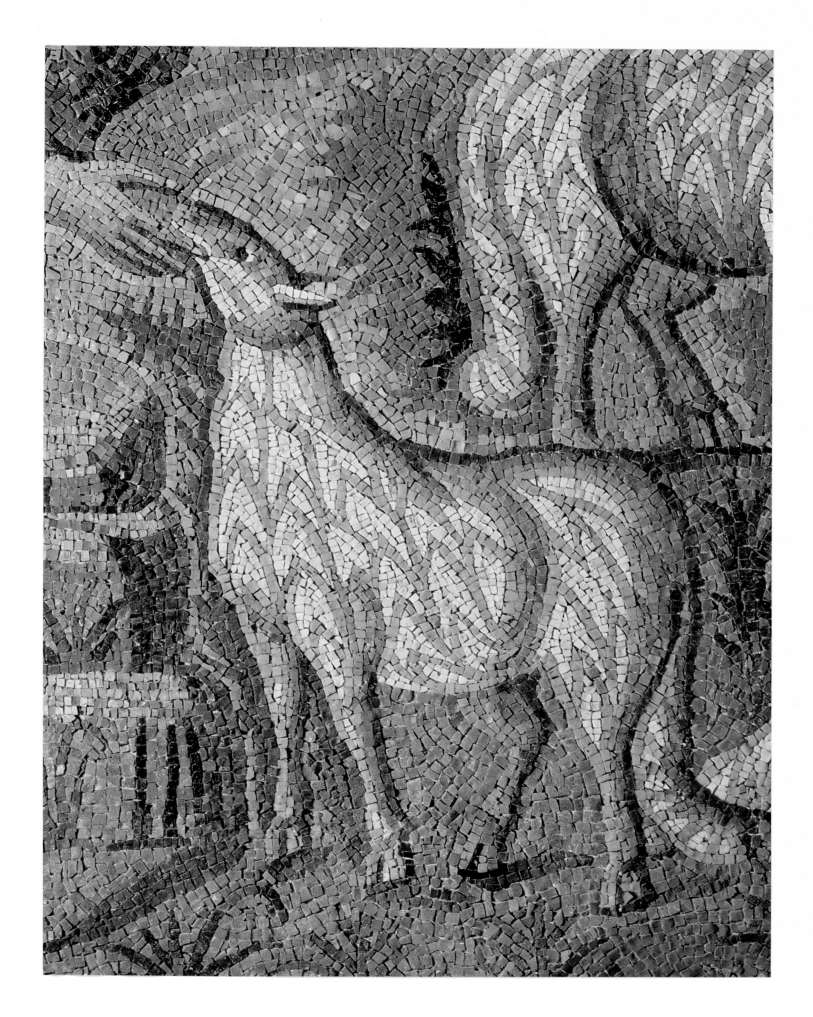

*12   Mausoleum of Galla Placidia. Portion of a fretwork frieze*

Where mosaic is used as extensively as in the Mausoleum of
Galla Placidia there must inevitably be some recourse to simple
nonfigurative decorative motifs. Such motifs are particularly
useful as a way of making representational scenes stand out more
vividly in contrast. This is the case with the brilliantly colored
fretwork frieze using a double Greek-key pattern which runs
along the intrados over the lunette with Saint Lawrence.

   Similar ornamental motifs are frequent in Early Christian and
Byzantine art. Among many others there are the single Greek key
(plates 60–62), stylized waves also known as "running dogs"
(plate 14), undulating ribbons (plates 8, 24), gems and pearls
(plates 22, 104), and lotus blossoms with corolla alternately
upright and inverted. Such motifs offer additional evidence that
the early mosaicists were anything but deficient in imagination and
fantasy and that they utilized their inventions with admirable
taste, making each composition harmonize with the entire
ensemble, each color with the whole range of colors employed.

*13   Mausoleum of Galla Placidia. Mosaics on the barrel vault and the
lunette of a cross-arm*

Besides the Greek-key fret band delimiting the historiated
lunettes, we see here in the foreground a frieze made up of a
supple and graceful trailing vine. The motif covers a good part of
the barrel vault, as we see on the left here where it is treated more
broadly and crystallized into a more symmetrical pattern. However,
unlike other motifs used for friezes, this one is not purely ornamental
but has its own symbolic value within this context. The *pictor
imaginarius* who decided on its use here must have had in mind the
Biblical passage where Christ tells the faithful: "I am the vine,
ye are the branches: He that abideth in me, and I in him, the same
bringeth forth much fruit: for without me ye can do nothing"
(John 15:5). On the other hand, there is nothing at all symbolic
in the purely ornamental swirls of acanthus lushly and harmoniously
overgrowing the field of the lunette where the thirsting deer
draw nigh to the pool.

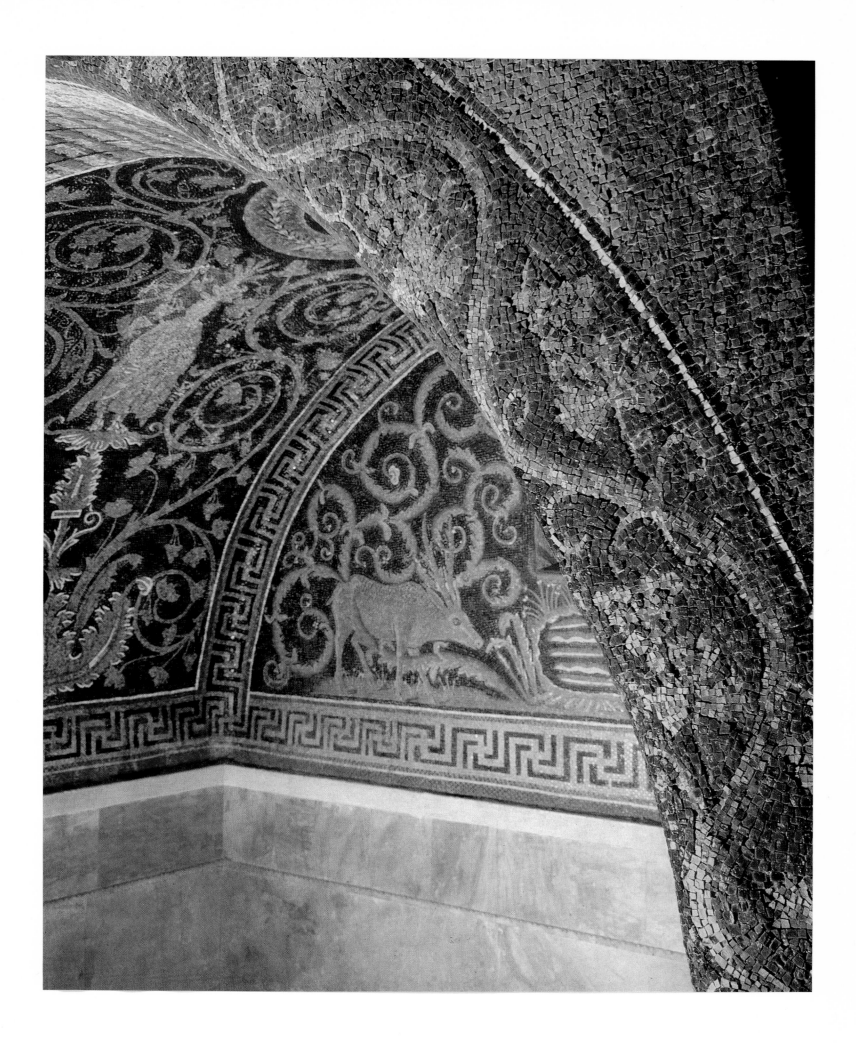

*14   Mausoleum of Galla Placidia. Saint Lawrence*

The image of Saint Lawrence proceeding briskly and without
hesitation toward the predestined instrument of his martyrdom
was intended to remind the faithful of the heroism of the early
martyrs who gave their lives in defense of the faith. When this
mausoleum was built there were still fresh recollections of the
many heroes of the early Church who shed their blood that the
religion of Christ might become known, win proselytes, and
triumph. Saint Cyprian in his tenth Epistle exalts the glorious blood
of the martyrs *(gloriosus martyrum sanguis)*, and says: "*[Ecclesia]
erat ante in operibus fratrum candida: nunc facta est in martyrum cruore
purpurea. Floribus eius nec lilia, nec rosae desunt*"—[the Church]
was once, in the work of the brothers, of purest white; now,
by the blood of the martyrs, it has taken on the color of purple;
for flowers she lacks neither lilies nor roses.

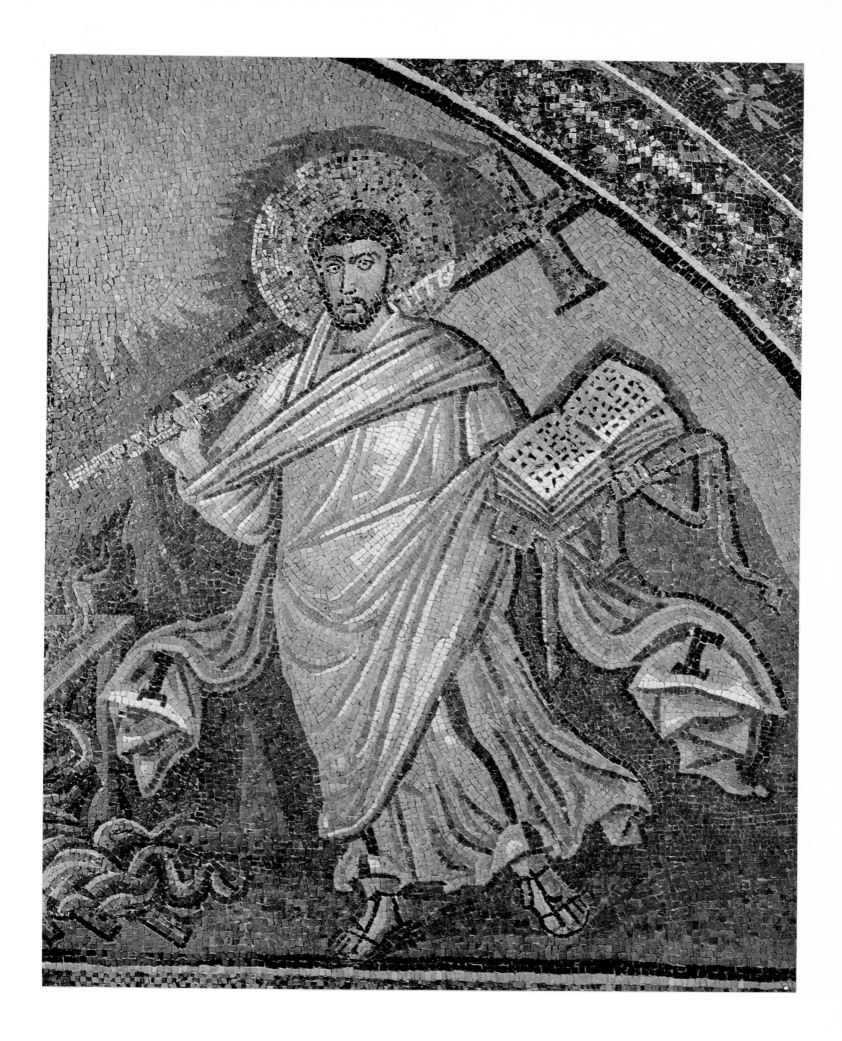

*Basilica Apostolorum. Facade*

*Basilica Apostolorum. Ground plan (after Perogalli)*

## 4 Basilica Apostolorum (now San Francesco)

*third quarter of the fifth century*

The present church of San Francesco was originally dedicated to the apostles. It seems certain that it was founded and completed by Neon, who was bishop of Ravenna from 449 to 475. Agnellus not only explicitly attributed the construction to him but reported a brief one-line mosaic epigraph that could once be read there: DOMINUS NEON EPISCOPUS SENESCAT NOBIS, which would seem to express the wish of the congregation that their beloved bishop might enjoy a long life among them. As for the early mosaic decoration, the ninth-century chronicler remarked that it included images of the Apostles Peter and Paul to either side of a cross.

The Basilica Apostolorum was also known more simply as the church of San Pietro Maggiore, as we know from documents of the first half of the ninth century. However, for almost half of its existence it has been called San Francesco, having been taken over in 1261 by the Minorites of the Franciscan order. It was here in 1321 that the last rites were held for Dante Alighieri, and the poet's body was deposed in a Roman sarcophagus near the portico.

The basilica has conserved little of its original aspect, and the few vestiges of the church that Neon built are now all buried underground. The present appearance goes back only to the tenth and eleventh centuries when a largely new church was built over the ancient outer walls, though the almost 180-foot-high square bell tower is slightly older and dates from the end of the ninth century. Like all the other ancient churches of Ravenna, here too with the passage of time the pavement and columns have been raised, the original level having been no less than eleven feet and nine inches lower than the present one.

Along the upper part of the exterior walls flanking the nave there is a very characteristic though much restored hanging arcade. The interior, about 152 feet by 78 feet, is divided into a nave and two aisles by two rows of twelve columns each. The columns are in veined marble from the island of Proconnesus, and on some shafts one can still make out the seal of the workshop from which they came. For all the extreme simplicity of the architectonic lines, and in spite of the fact that the interior is bare and unadorned, a feeling of mystic spirituality is by no means absent.

There is a perfect equilibrium between closed and open areas, between massive volumes and airy colonnades, and it is harmoniously rounded out by the deep apse in which all the perspective lines of the nave tend to resolve.

The sanctuary is considerably elevated above the nave to accommodate a crypt with numerous columns. It is of the type called *ad oratorio*, specifically designed for prayer, and dates back to shortly before the year 1000. Beneath the crypt, fragments of mosaic pavement from the earlier level of the sanctuary have been unearthed, one of them bearing a Latin inscription referring to the original sepulcher of Bishop Neon.

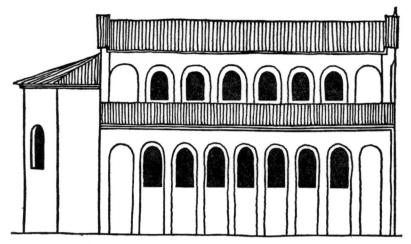

*Anastasis Gothorum. Drawing of the north side (after De Angelis d'Ossat)*

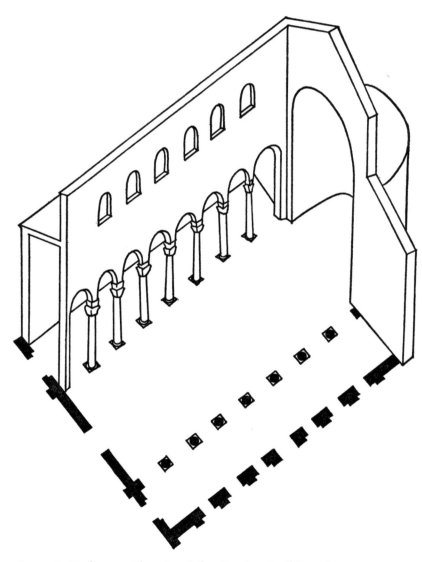

*Anastasis Gothorum. Elevation (after De Angelis d'Ossat)*

## 5    Anastasis Gothorum, the former Cathedral of the Arians (now Spirito Santo)

*end of the fifth century*

Captained by Odoacer, the Herulian chief and, since 476, the first king of Italy, Ravenna withstood the siege of the Goths for two and one-half years. Then, in March of 493 the Ostrogoth King Theodoric succeeded in taking the city and soon after treacherously slew its ruler. Theodoric thereupon took up residence in Ravenna and proceeded to embellish his new capital with numerous new buildings, both civil and religious.

Because his people adhered to the doctrine propounded by the Alexandrian priest Arius (d. 336) which denied the consubstantiality and unity of the three persons of the Trinity, Theodoric preferred them to have their own churches independently of those used by the Catholic natives of Ravenna. The first need was for an Arian *ecclesia matrix*—a mother church or cathedral—and it appears that one was begun immediately after the conquest of the city. The Catholics at the beginning of the fifth century having dedicated their cathedral to the Resurrection of Christ, the Arians followed suit and called theirs the Anastasis Domini.

The old Arian Cathedral has survived in relatively good state, even if in the course of time it has lost its original mosaic decoration and undergone various remodelings and consolidations. Toward the middle of the sixteenth century a portico of graceful arches was added to the front of the church. It was set on eight columns, four of which have spiral fluting in their upper part and were used in early medieval times to support a marble ciborium.

Both outside and inside, the church has retained its original basic architectonic lines, though a coffered ceiling has replaced the original trussed roof, and the floor, together with the columns and doors, has been raised about six feet. Viewed from outside, the apse still has its pentagonal design.

The basilica covers an area of eighty-six and one-half feet by fifty-three feet and is therefore unusually shallow compared with the other churches in Ravenna which characteristically are quite long. Significantly, these somewhat stunted dimensions are much like those of certain churches of the fifth and sixth centuries in Greece and Constantinople. However, their closest resemblance is to a church in Rome which likewise began as an Arian foundation. Now called Sant'Agata in Subura or, more commonly, Sant'Agata dei Goti, it was built by the military commander Flavinus Ricimer some thirty years before the Ravenna Arian Cathedral. Later, in 592, it received its present dedication and name at the hands of Saint Gregory the Great himself.

When the Byzantines conquered Ravenna, the Anastasis Gothorum passed in 561 to the Catholics, who dedicated it to the martyred warrior-saint Theodore of Amasea in Pontus. Finally, in the fifteenth century, it was given its present name and dedication to the Holy Spirit.

## 6  Baptistery of the Arians

*end of the fifth century*

Only a dozen yards or so from the front of his cathedral, Theodoric had a baptistery built for his Arian followers. It is a modest octagonal structure characterized by a plan in which four flat walls alternate with four round apses on its lower part. Originally a kind of outer ambulatory surrounded the building on seven sides, but today no more than a few fragments of its walls survive, though its exact disposition was ascertained by exploratory diggings when the baptistery was restored between 1914 and 1916.

Although the present pavement lies four and one-half feet below the street level, the original floor has been found to have been almost three feet lower still, so that in looking at the building one should keep in mind that something like seven and one-half feet of its height lie concealed below the level of the present structure.

A line of bricks set in sawtooth pattern divides the building into two distinct zones. In its upper part an arched window opens in the center of each of the eight walls. A pyramidal roof with eight sloping sides masks the round brick cupola of the interior.

As we see it now, the interior strikes us as rather cold because for their entire height the walls are completely bare of any decoration whatsoever, though once they too had their mosaics and stuccoes. Only the mosaic in the cupola survives, and happily it has needed repairs and retouching in only a few places.

Here again we have a central medallion surrounded by a broad band (plate 17). The medallion, as one would expect, shows Christ half-immersed in the Jordan and receiving the initiatory sacrament from John the Baptist while a personification of the river looks on.

Around this, as in the Baptistery of the Orthodox, there are the Twelve Apostles. Separated from each other by a stylized palm tree, they stride slowly forward in two groups headed by Saints Peter and Paul respectively. Here too the solemn figures bear the symbolic jeweled crowns in their hands shrouded by the pallia, though the two Princes of the Apostles themselves carry their traditional attributes, the key and the scroll (plates 19, 21).

Peter and Paul meet at either side of a richly decorated throne before which soars a tall cross, a clear allusion to the sovereignty of Christ (plate 20).

Careful examination of the coloring of the tesserae and the style of the figures convinces us that this mosaic was executed in two stages, though both within the reign of Theodoric (493–526). The first would include the entire central disk, the throne, Saint Peter, and Saint Paul with the apostle immediately following him, whereas the other nine apostles would all have been done in a second stage.

*Baptistery of the Arians. Reconstruction of the exterior (after De Angelis d'Ossat)*

*15, 16  Baptistery of the Arians. Two apostles*  ▷

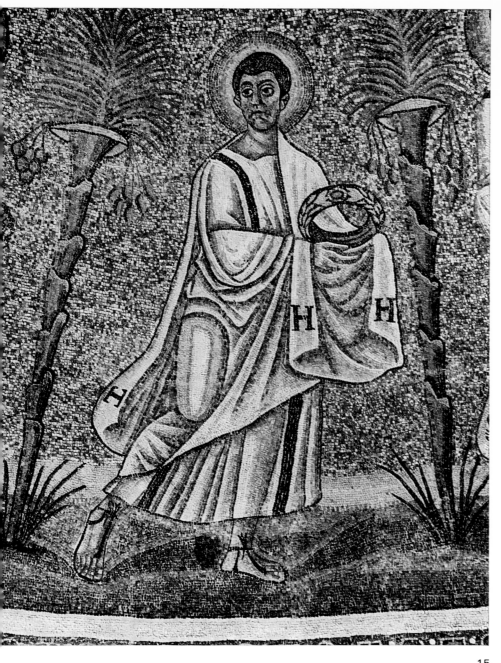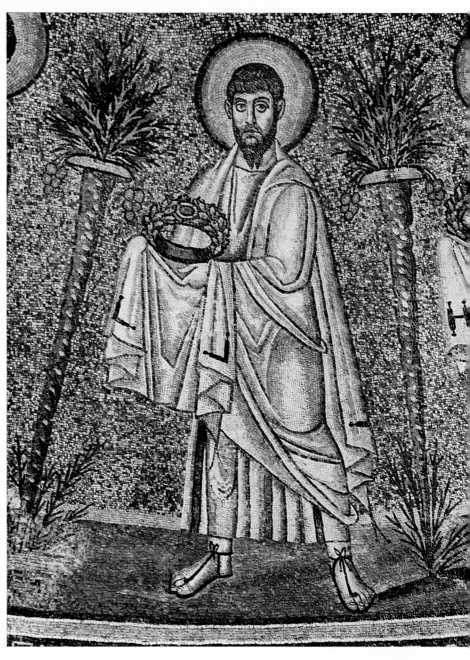

15      16

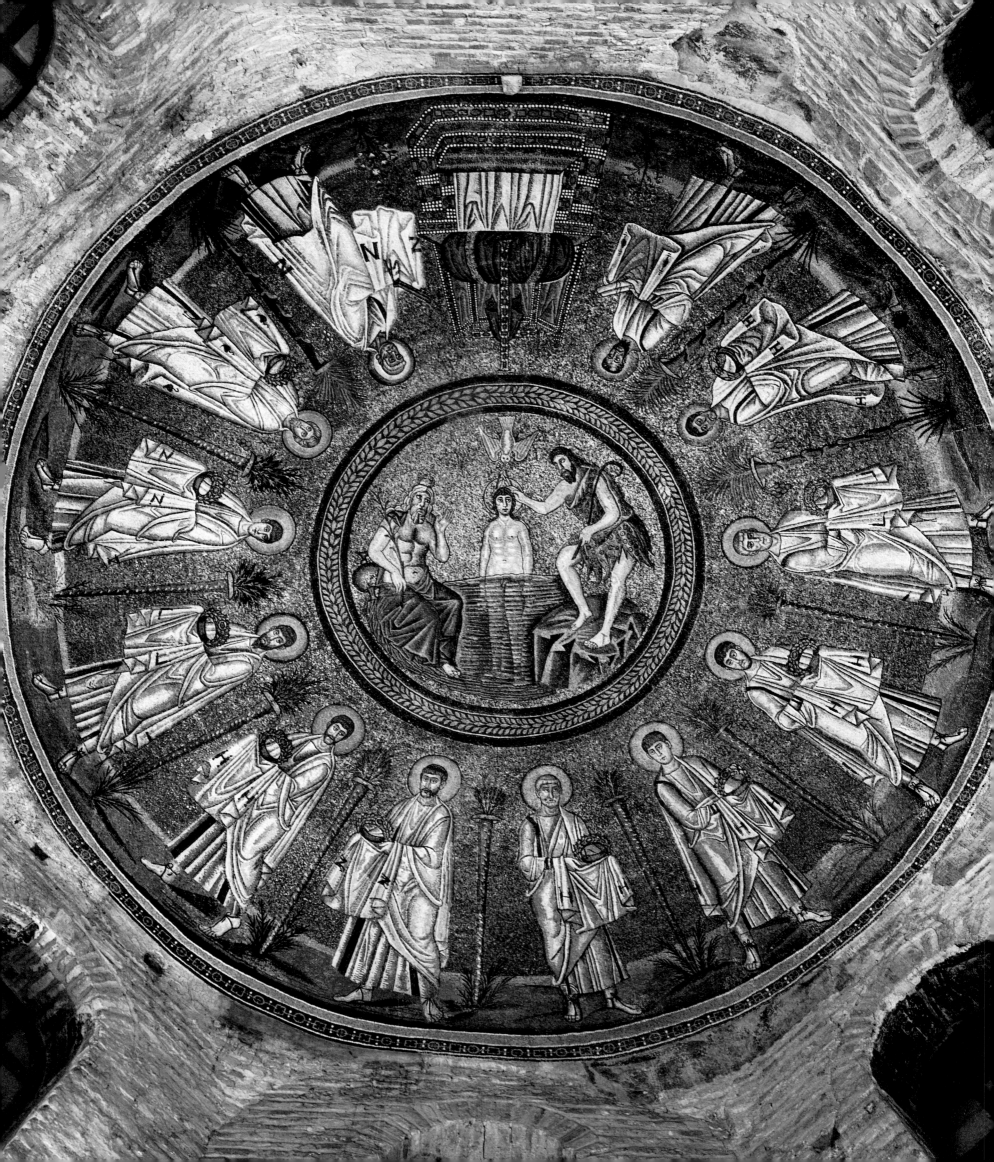

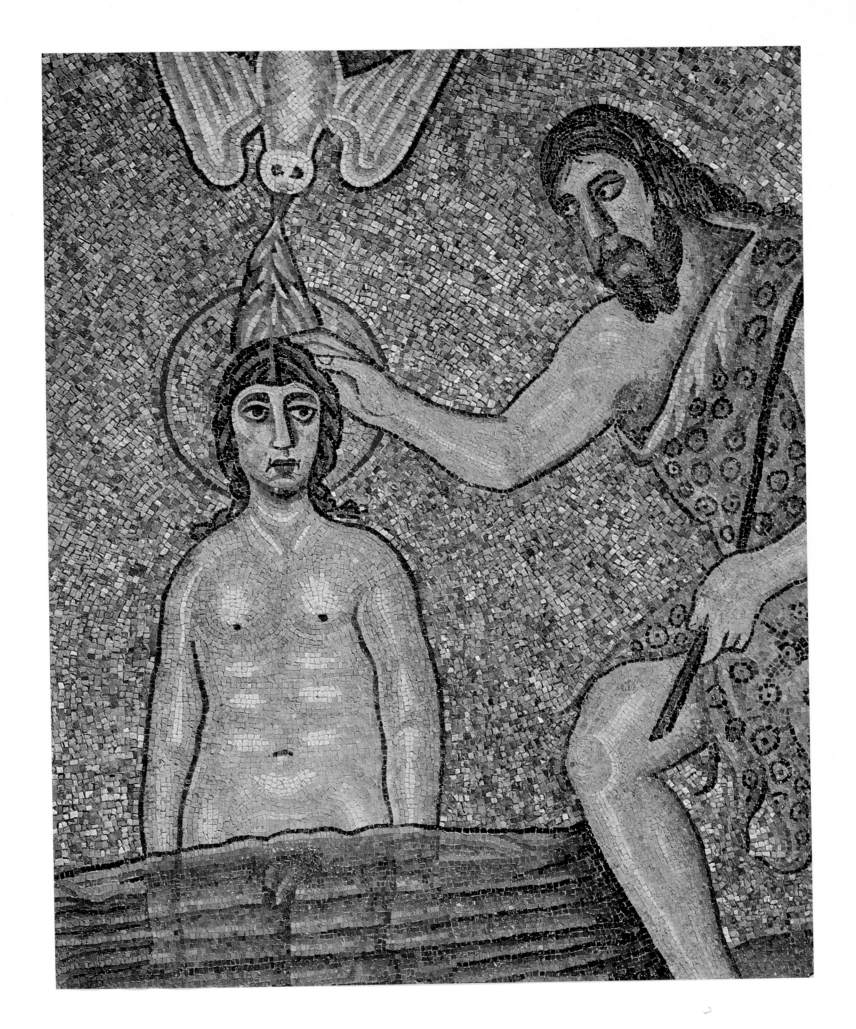

19   *Baptistery of the Arians. Saint Paul (detail)*

As always in Early Christian art, Saint Paul is depicted holding a scroll. There are two possible explanations of this attribute. One has to do with Paul as "doctor" or "teacher" of the Gentiles, the other with the *Lex Dei*, the divine rule which, in the early art of Ravenna and especially on sarcophagi (plates 108, 110), is unequivocally delivered over by Christ to Paul rather than to Peter. Both interpretations may be valid, but because all of the Ravenna sarcophagi with this scene antedate the mosaics in this baptistery, some by as much as fifty and even a hundred years, the second explanation does seem to have more in its favor.

Notice that Paul does not touch the volume of sacred precepts with bare hands but only with his hands covered by the ends of his pallium. We have seen this already in connection with the apostles and their symbolic crowns; it is a gesture of reverence, respect, and submission which Early Christian art must certainly have taken from the practice of *manuum velatio*, obligatory in court ceremonial, where the suppliant could not approach the emperor to offer anything to the august presence or receive anything from him except with hands covered by an edge of the pallium or mantle. The gesture was often depicted on monuments in the East and is likewise frequent in the Ravenna mosaics (compare plates 5, 6, 15, 16, 21, 64, 81, and 83).

◁ ◁ 17   *Baptistery of the Arians. Cupola mosaic*

◁ 18   *Baptistery of the Arians. The Baptism of Christ (detail)*

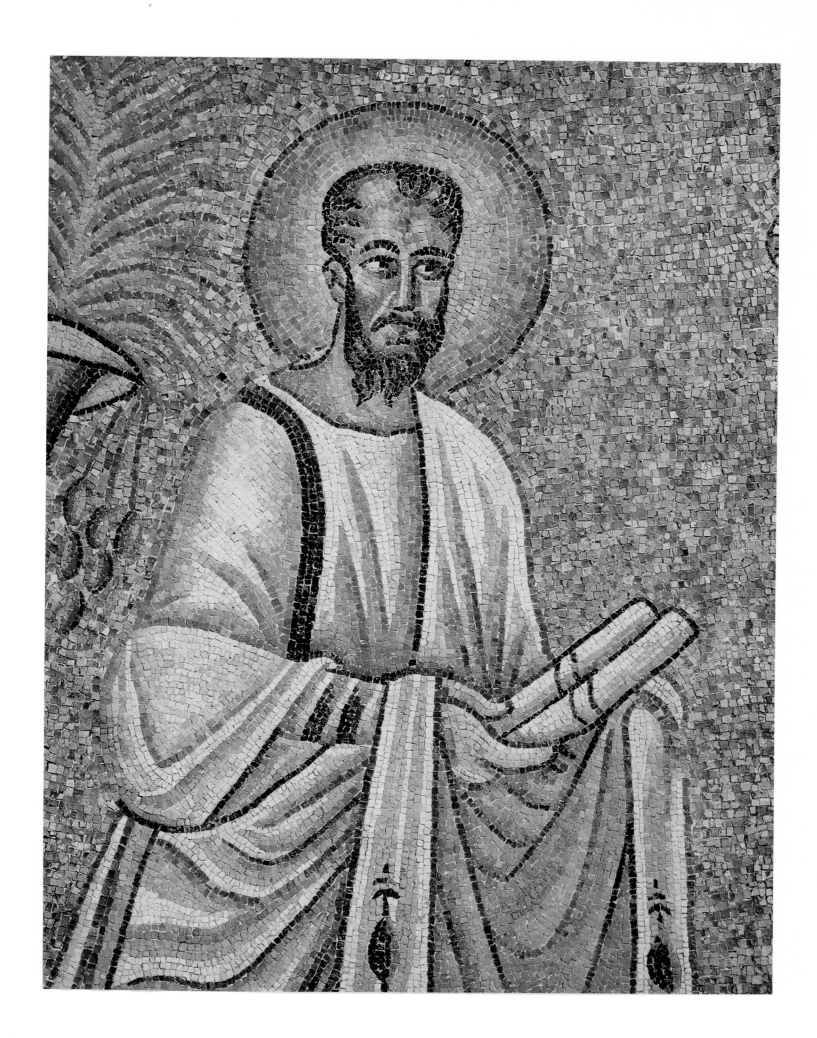

**20  Baptistery of the Arians. The divine throne**

The throne, richly studded with pearls and jewels and surmounted
by a purple cushion before which is suspended a gemmed cross,
is undoubtedly to be understood as a symbol of the throne of God.
However, rather than alluding to the preparation of the throne of
which the Apocalypse speaks in connection with the Last
Judgment, it is more likely that it refers simply to the kingship
of Christ. The latter interpretation is suggested by the fact that
the throne has a truly triumphal character perfectly in keeping
with the *solium regale*—the royal throne—which, beginning with
Diocletian, occasionally replaced the image of the emperor on
Roman coins. The allusion to the sovereignty of Christ would
have been perfectly clear to the contemporaries of the Christian
artists who did these mosaics.

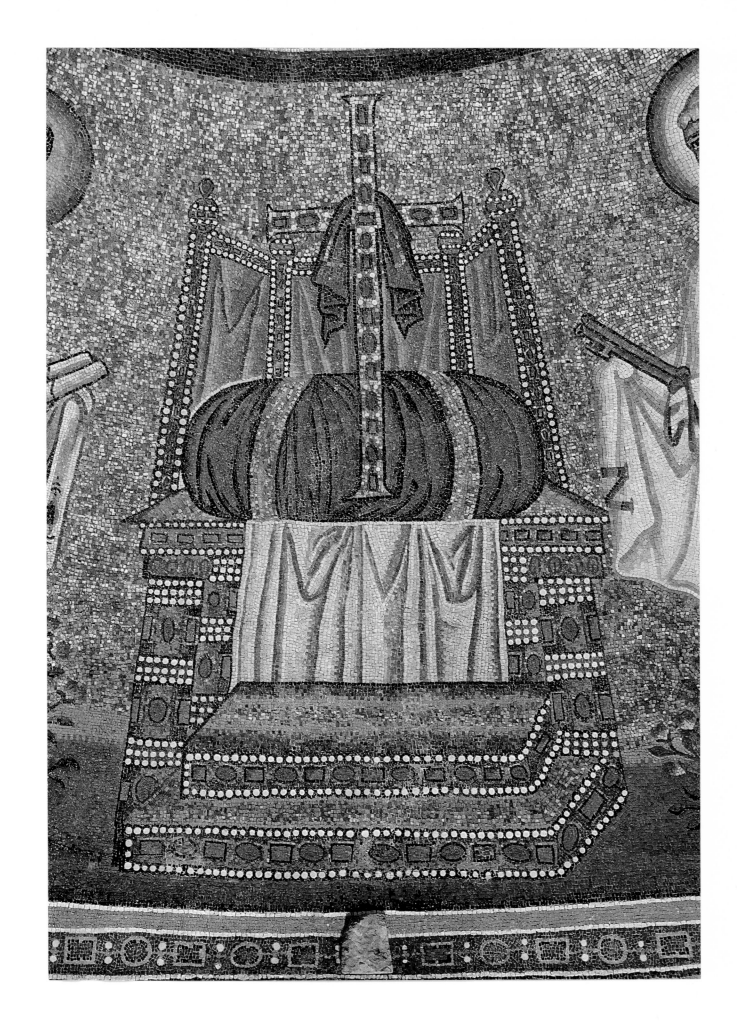

Although here and there in Christian writings of the first centuries one finds some indication of Paul's personal appearance, nothing at all is said about that of Peter. However, in chapter eighteen of the seventh book of the *Historia Ecclesiastica*, written in the fourth century by Eusebius of Caesarea, we read that portraits painted on wooden tablets of those "two lights of the world" could be seen in the Eastern regions even before his time and therefore, presumably, already in the third century. In any case, the Early Christian artists of Rome frequently depicted the Prince of Apostles and almost always with the same distinctive physiognomy well summed up by the Late Byzantine historian Nicephorus Callistus: "face pale and wan, hair and beard curly and thick but not too long, eyes black but with reddish reflections, nose large."

The keys that Peter carries here are the conventional attribute accruing to him as keeper of the gates of Paradise, and in earlier depictions, in Rome as in Ravenna (see plate 108), one sees Christ consigning them to the chief apostle's hands.

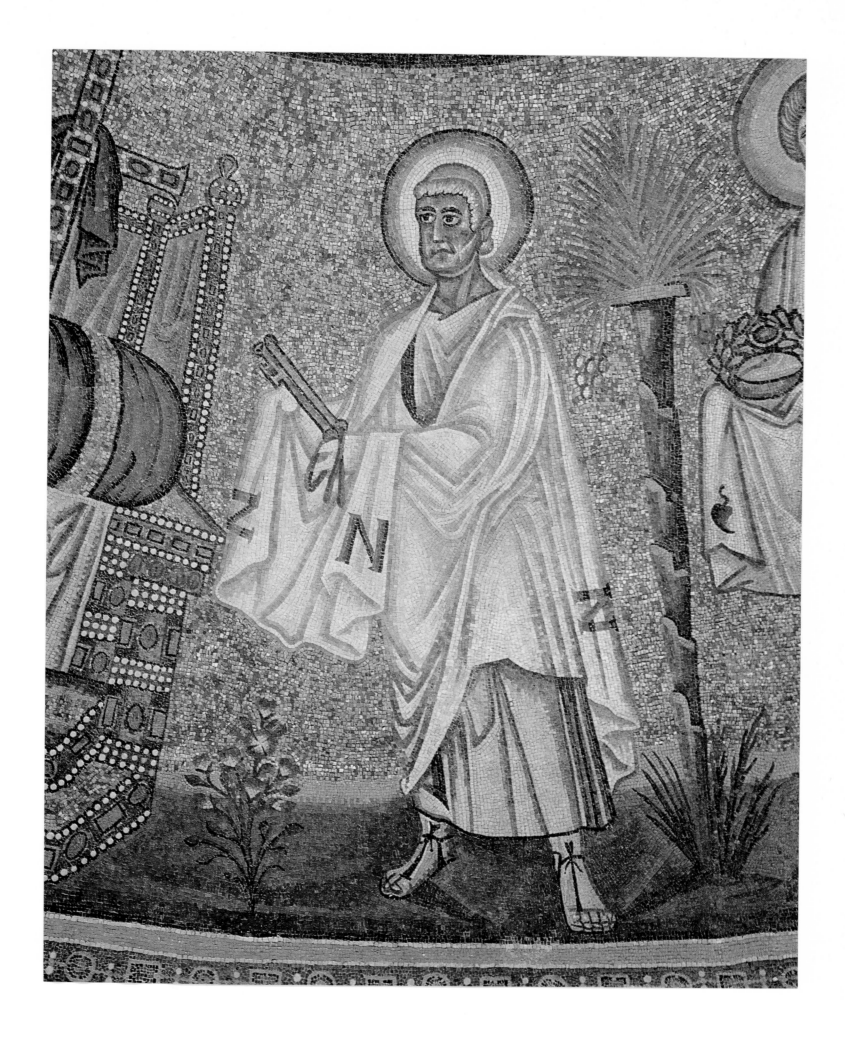

## 7 Archiepiscopal Chapel (formerly the Oratory of Saint Andrew the Apostle)

*end of the fifth and beginning of the sixth century*

Andreas Agnellus attributed the building of what he called the Monasterium Sancti Andreae Apostoli—the chapel in the Archbishop's Palace—to Bishop Peter I (429–49). Modern historians, however, almost all agree that here for once the early chronicler of Ravenna nodded and mistook Peter II (494–519) for his predecessor. Quite recently Paolo Verzone even proposed that, in view of the somewhat later style of the mosaic and stucco decoration, the chapel should be assigned to the bishopic of Peter III (570–78).

This small shrine, encompassed in the much-rebuilt Archbishop's Palace (now a museum), is important as one of the very few ancient *monasteria* (oratories) to have survived in satisfactory condition in Ravenna, and it served for almost fifteen centuries as the private chapel of the bishops of that diocese.

An inscription in twenty Latin hexameters on the walls of the vestibule of the tiny edifice (plate 23) affirms that the *monasterium* was intended by its founder Peter to be used for the administration of the sacrament of confession: here the repentant sinner prostrates himself *ante pedes medici* (before the feet of the physician of the soul).

The oratory is composed of two adjoining small rooms, one a long and narrow oblong narthex, the other a hall in the form of a Greek cross and concluding in an apse. The walls of both are covered with slabs of marble below, with mosaics above.

One enters the vestibule through a door in one of its narrow sides above which is a high lunette filled with a figure of Christ as warrior (plates 23, 24). Impressive as it may be, the lower part of the lunette is almost entirely the work of restorers, who, something over a half-century ago, filled in the missing portions with tempera painted to resemble mosaic.

A large nimbus with a jeweled cross glows behind the head of Christ. He has youthful features and long hair falling behind His back, and the figure is depicted frontally wearing armor and a dark amethyst chlamys, a short mantle fastened with a jeweled clasp at the right shoulder. Across His shoulders the youthful warrior carries a long red cross, and in His left hand He holds a book open to the words: EGO SUM VIA, VERITAS ET VITA (I am the Way, the Truth, and the Life).

The *Christus militans* is portrayed here as *triumphator*. Sufficient fragments of mosaic survived to permit the restorers to see that He was meant to trample underfoot the heads of a lion and a serpent, symbols of power and of evil.

The barrel vault of the vestibule is covered with a mosaic against whose gold ground a motif of four lilies combined in a cross is linked with others to make an overall pattern of diamonds enclosing birds and animals of the most diverse species: doves, partridges, ducks, guinea fowl, parrots, peacocks, and many others.

*Archiepiscopal Chapel. Ground plan (after Gerola)*

57

On the long walls of the vestibule, almost as if supporting the florid decorations of the vault, are four rectangles with dark blue background against which stand out the gold letters of a lengthy inscription (plate 23). The first of the twenty hexameters is especially beautiful in both form and concept: AUT LUX HIC NATA EST AUT, CAPTA, HIC LIBERA REGNAT (the light is either born here or, imprisoned, reigns here in freedom). The words are perfectly applicable to the art of mosaic itself, especially the apposition of *capta* and *libera*, since the essential characteristic of that art is the creation of prodigious effects of luminosity by means of resplendent vitreous cubes which seem to imprison within themselves something of the living light of the sun.

A door in a long wall of the vestibule leads to the oratory proper. There the central area is spanned by a groin vault supported on four large lunettes, the border of each of which consists of a band ornamented with seven medallions. On two of these bands are the *imagines clipeatae* (busts within a shieldlike medallion) of the Twelve Apostles and the Redeemer, while on the other two are those, respectively, of six male saints (in part much restored) and of six female saints, plus a monogram of Christ to complete each band. The air of grave austerity in all of these faces comes above all from the fixity of their gazes, which seem intent on some infinitely remote harmony. This is equally true of the female saints, for all that they are less powerfully depicted. Each of them, except for Saint Felicity, is made especially expressive by the white and luminous aureole of a diaphanous silk veil that falls from her hair.

A slender angel robed in white and with great brown wings lowered and folded behind his back rises within each of the four pendentives of the groin vault. The angels seem almost to levitate above the patch of green meadow beneath their feet, and—virtual caryatids—they raise their arms above them to support the central medallion of the vault, which encloses the monogram of Christ.

In the triangular spaces between the four angel-caryatids, against a gold background and emerging from slender wisps of clouds, are the symbols of the Four Evangelists, each holding a closed volume on whose binding are mounted various gems and white pearls.

When the small half-vault of the apse was restored at the start of this century, it was found to be constructed on an armature of terra-cotta tubes fitted into each other. Here too there is a painted imitation of mosaic in tempera, a night sky studded with stars scattered densely around a golden cross in the center. That the original mosaic had such stars was ascertained by Giuseppe Gerola, who found the very few fragments of them that had survived.

From the thematic point of view, on the basis of the images they contain, one can say that the vestibule represents the Church Militant, the oratory itself the Church Triumphant. The latter concept is especially well expressed by the solemn manner in which the four angels hold up the shield with the monogram of Christ in the presence of the heavenly hierarchies as represented by the Four Evangelists, the Twelve Apostles, and the six male and six female saints.

*22 Archiepiscopal Chapel. Detail of the groin vault and lunettes in the oratory* ▷

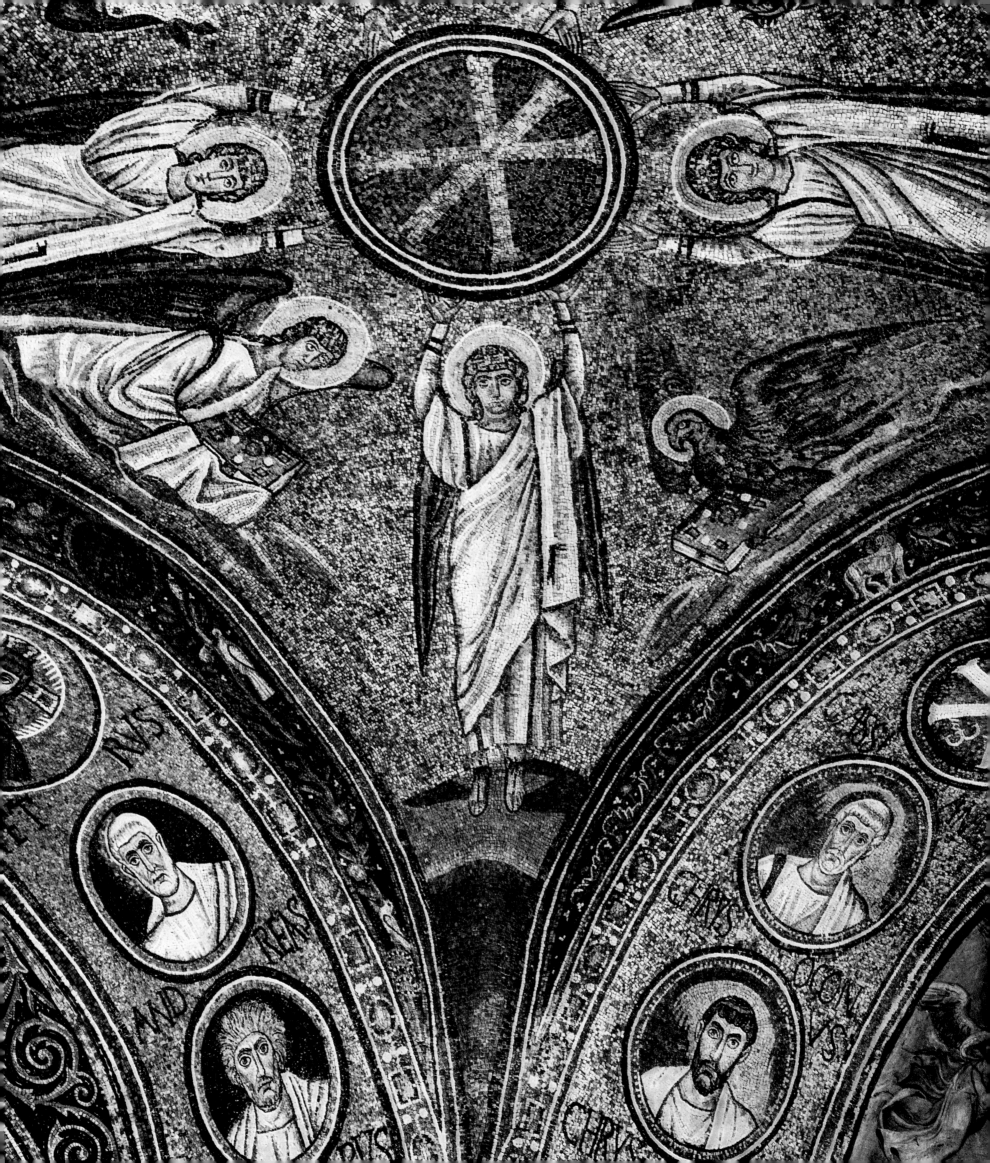

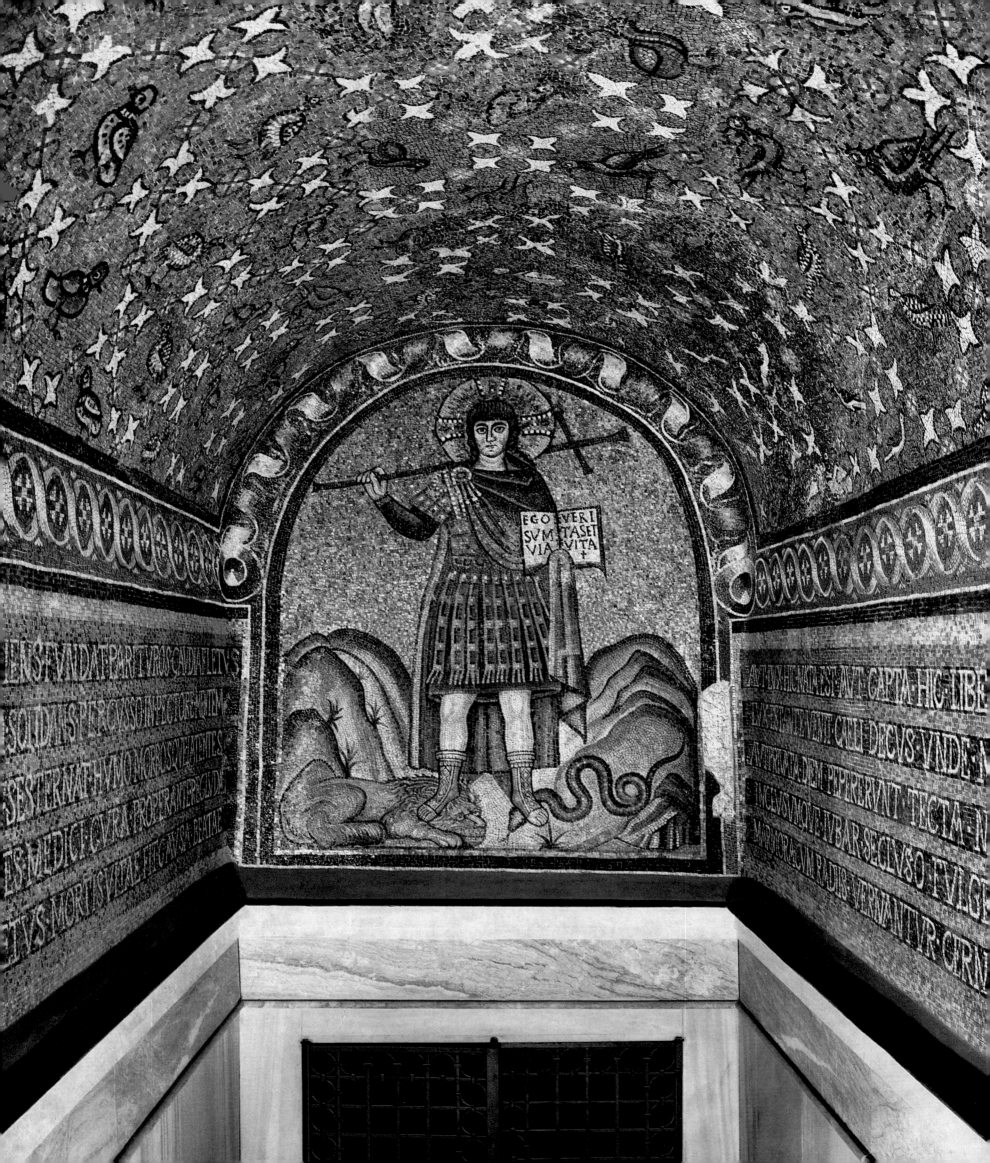

EGO VERI
SVM TAS ET
VIA ET VITA

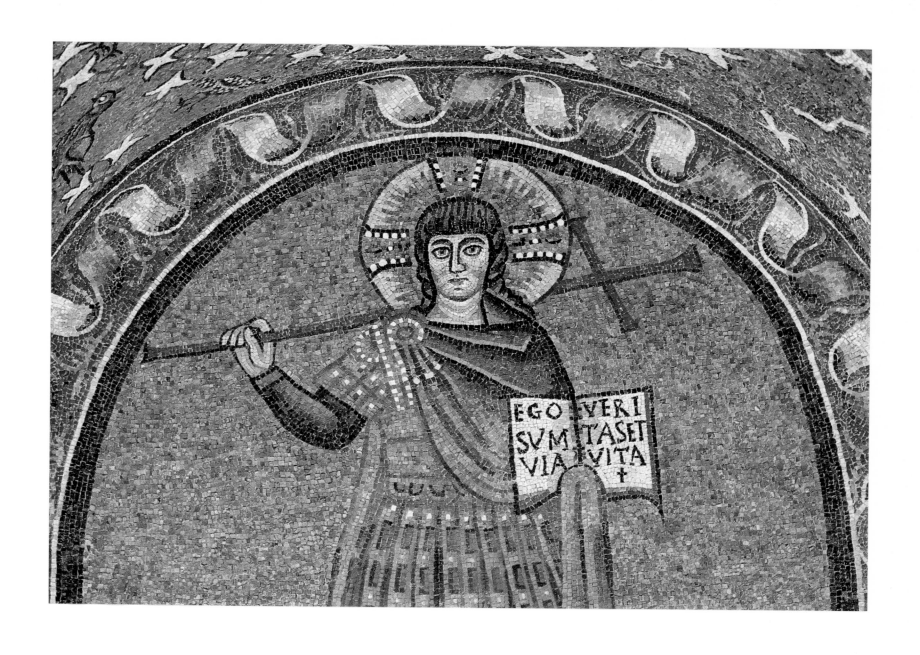

The inscription in the mosaic reads:

EGO | VERI
SVM | TAS ET
VIA | VITA †

◁ 23  *Archiepiscopal Chapel. Vestibule with mosaic inscriptions and*
*Christ Triumphant*

24  *Archiepiscopal Chapel. Christ Triumphant (detail)*

*25 Archiepiscopal Chapel. Flowers and birds in the vault of the vestibule*

A great variety of animals, birds in particular, enliven the many Early Christian and Byzantine floor and wall mosaics, sarcophagi, and ambos that have survived in those lands first touched by Christianity. If certain animals—lambs and sheep (plates 9–11, 103–105, 115), deer (plates 13, 123, 124), peacocks (plates 114, 127)—unquestionably have symbolic significance, a good many of the birds are present only as decoration, a pretext for ornamental variations introduced with skill and imagination into more solemn compositions to which they bring a measure of grace and lightness. In either case, all these animals reveal that even the artists of earliest times had a keen interest in nature.

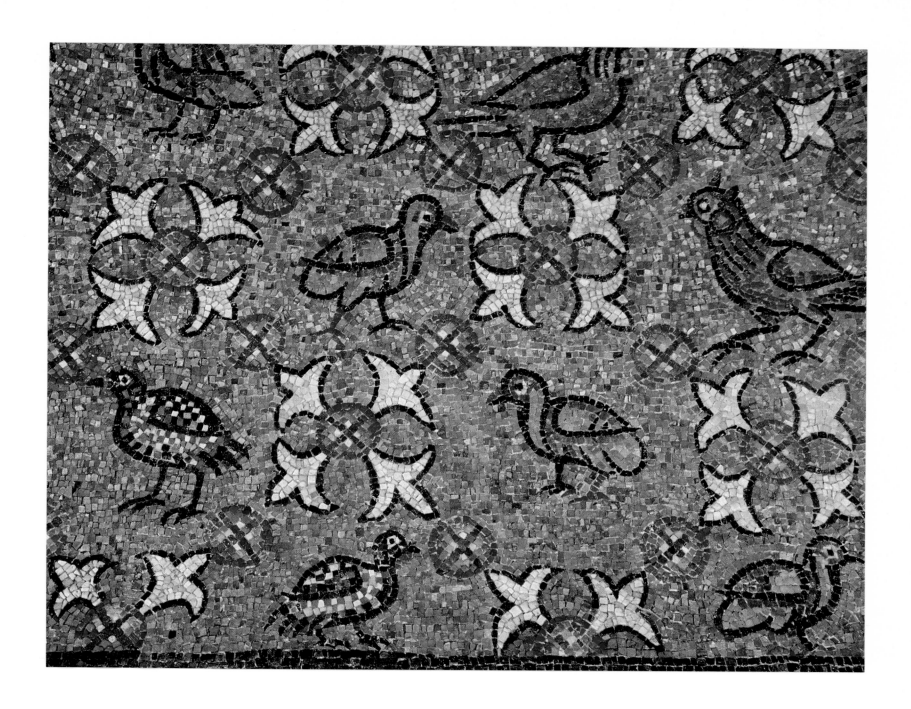

*26 Archiepiscopal Chapel. Saint Cecilia*

All except one of the female saints in medallions on one of the arches of the chapel are portrayed with quite extraordinary richness of attire and headdress. Rows of pearls and gems glisten on their robes and especially on their collars. Each has her hair gathered under a bejeweled hairnet (perhaps the so-called *mitella*) from the crown of which a diaphanous luminous white veil *(maphorium)* falls behind the shoulders.

In these female saints we have a direct reflection of the sumptuous apparel worn by women of rank at the time the mosaics were created, as we shall see again when we come to look at the long procession of female saints in Sant'Apollinare Nuovo (plates 33, 63).

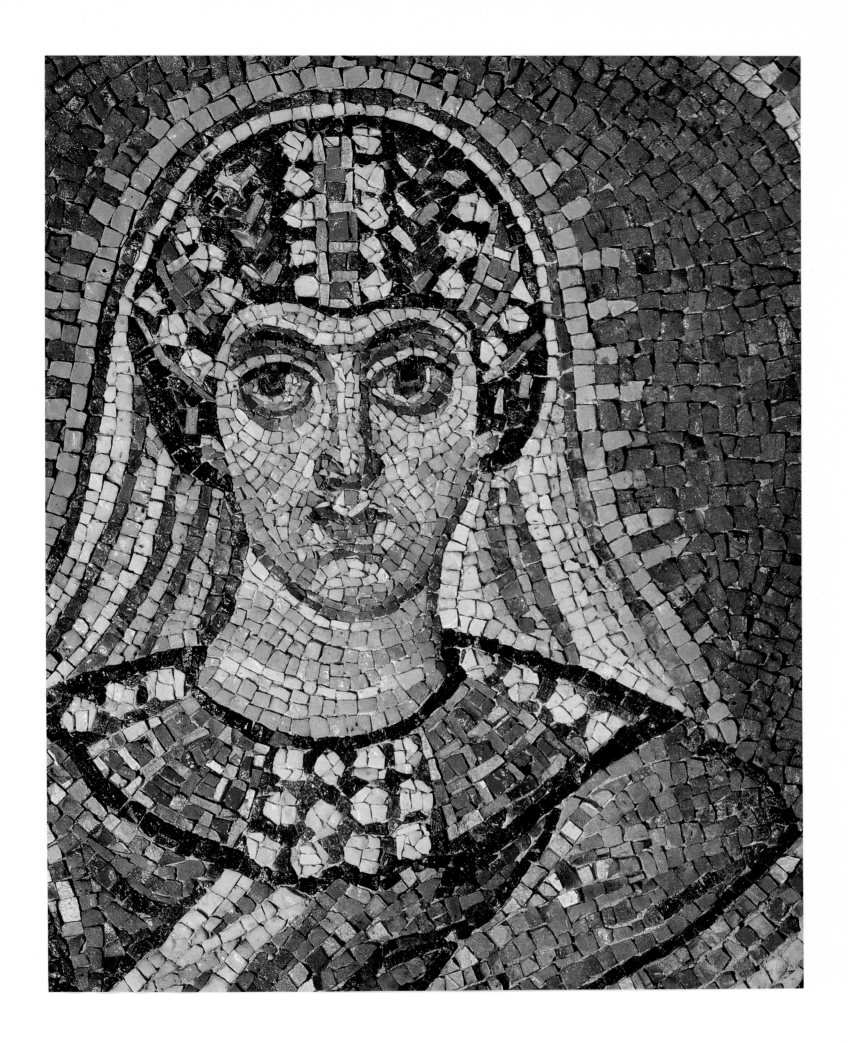

27 *Archiepiscopal Chapel. Saint Felicity*

Felicity alone is dressed differently and less richly. Neither on her head nor around her neck does she display the precious stones and gems her sister-saints almost seem to glory in. Instead she is shrouded completely in a plain brownish violet veil which covers all of her white headkerchief except for an edge around the forehead and temples. If this exceptional attire was intended to indicate that this saint was of lowly birth and even a slave, then she would be the Felicity martyred in Carthage with her mistress, Saint Perpetua. However, it may mean only that she was a widow, in which case she would be the Felicity who was a Roman matron put to death in Rome together with her seven sons.

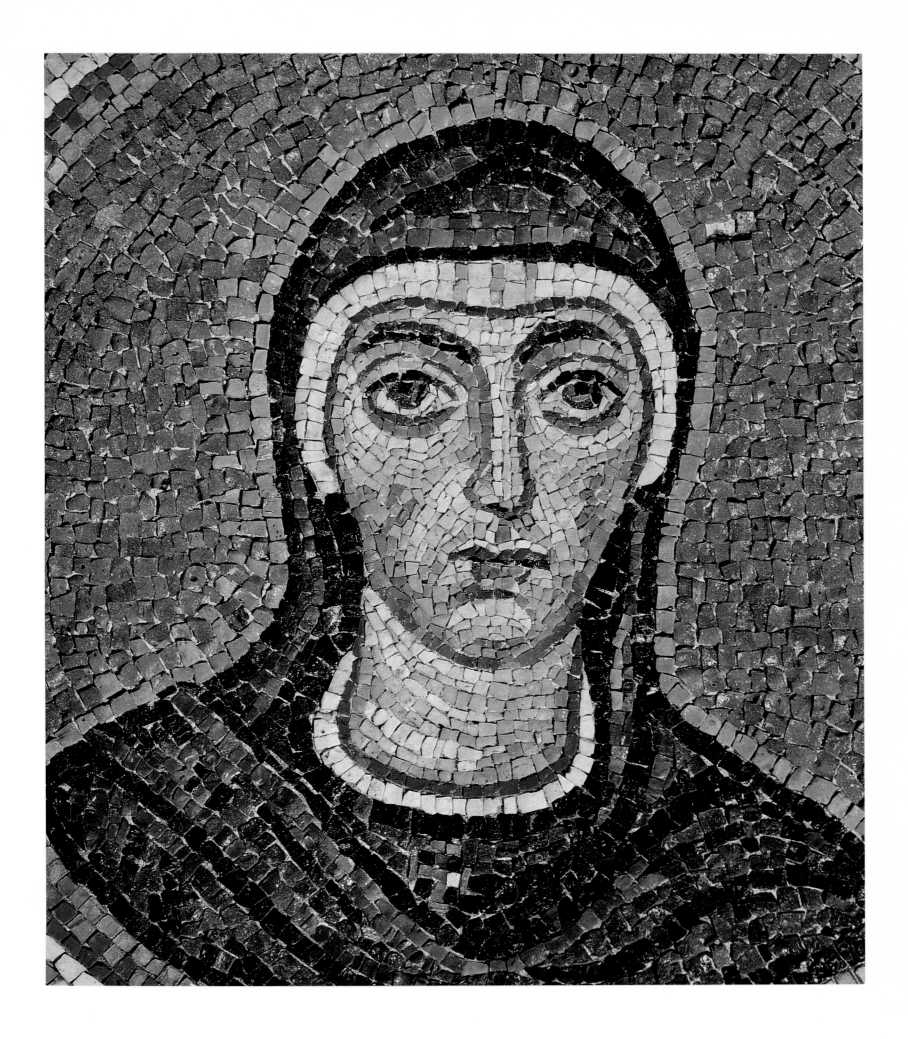

*28 Archiepiscopal Chapel. Christ*

A warm, rosy, youthful light plays on this face, however serious
and impassible it may seem. Here, in this bust within a medallion
at the summit of the northeast arch of the chapel, we have the
*Christus puer*, the young Christ so dear to Early Christian art.
In Ravenna we meet Christ in this guise again in all the scenes of
His miracles and parables on the north wall of the nave of Sant'
Apollinare Nuovo (plates 34–40, 42–46) as well as in the youthful
prince enthroned on the globe in the vault of the apse of San
Vitale (plates 73, 80).

Here a note of majesty is lent to the young face by the great
cross outlined in opalescent pearls that spans the entire large
nimbus behind His head.

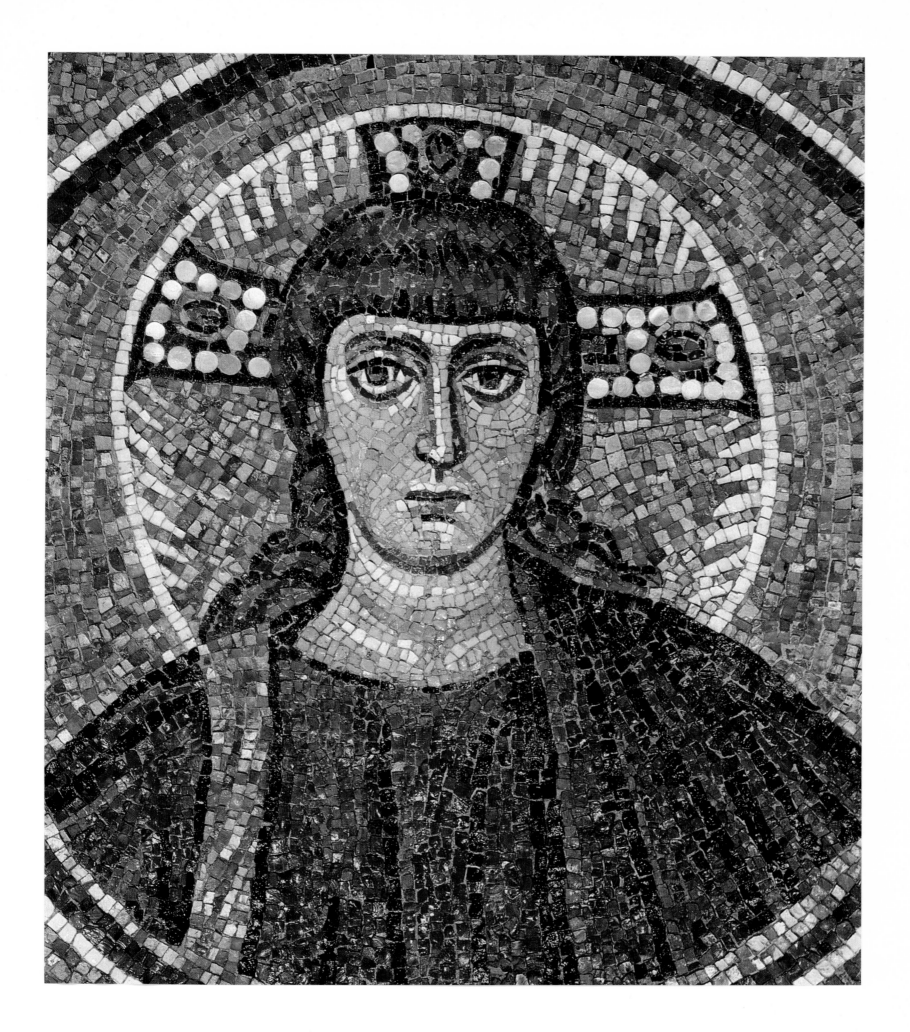

*29  Archiepiscopal Chapel. The Apostle Paul*

The head of the Apostle to the Gentiles is incontestably one of the most beautiful in this small oratory and must certainly be due to a master of high artistic gifts. Its distinction is so much the greater in that no attempt was made to depart from the by then long-established physiognomy of Saint Paul, notably the broad high brow and pointed dark beard.

This bust is exceptional in that it is presented slightly at an angle and not in frontal position or set dead-center within the framing medallion as are all the other busts.

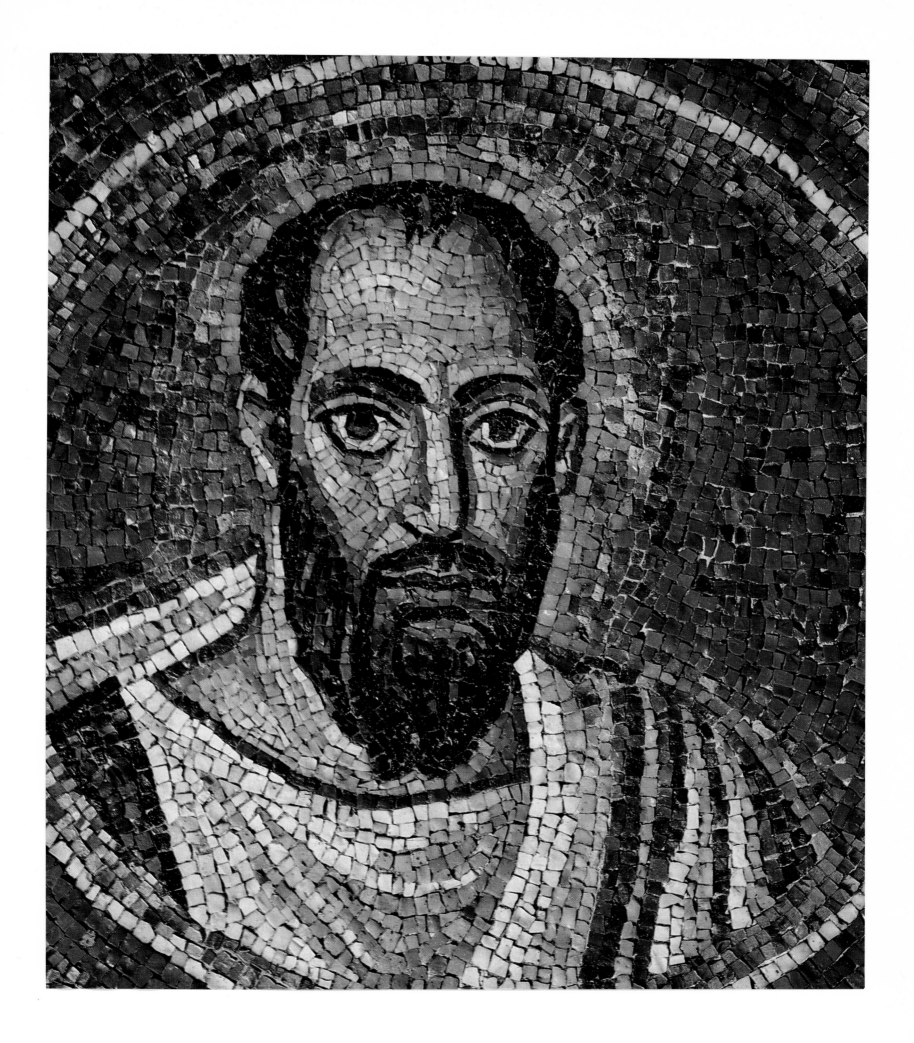

*30 Archiepiscopal Chapel. The Apostle Philip (detail)*

There is a great earnestness or perhaps even sorrow in the face of this apostle with his large dark pupils filling almost the entire eyeballs. With his particularly intense expression and the unflinching concentration of his gaze, his great eyes look far beyond us as if wholly given over to a sense of high spirituality. It was surely not the eyes of such a man as could be met with on earth that the artist strove to portray here but, instead, the inward gaze —the "eyes of the soul"—of a saint. This is something we observe over and over again in these Byzantine countenances wholly absorbed by the spirit and having their true existence beyond place and time.

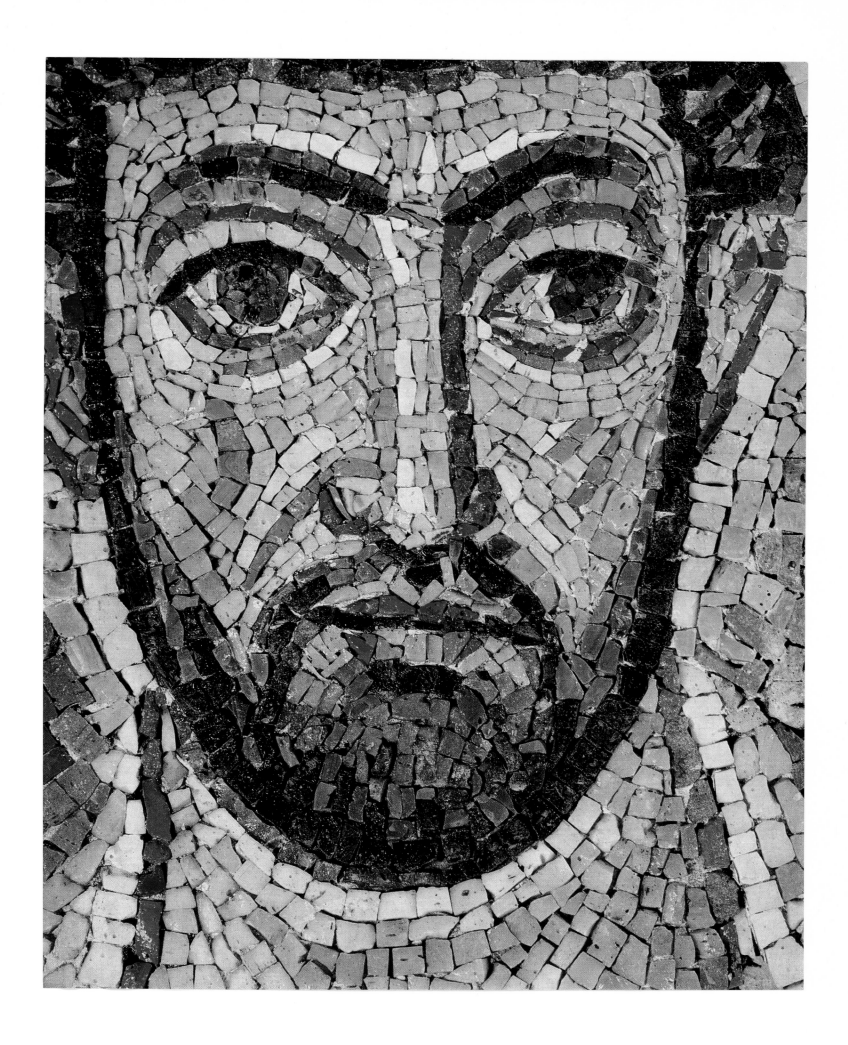

*31  Archiepiscopal Chapel. The Apostle Andrew (detail)*

In the face of Andrew too there is the mark of stern austerity. His features are firmly and markedly delineated, and we recognize in them the signs of a strong man of unshakable determination.

The special characteristic of Andrew is his hirsute mane standing out stiff and shaggy, much as we see it again in Sant'Apollinare Nuovo in the scene where Christ summons him and Peter to become "fishers of men" (plate 36).

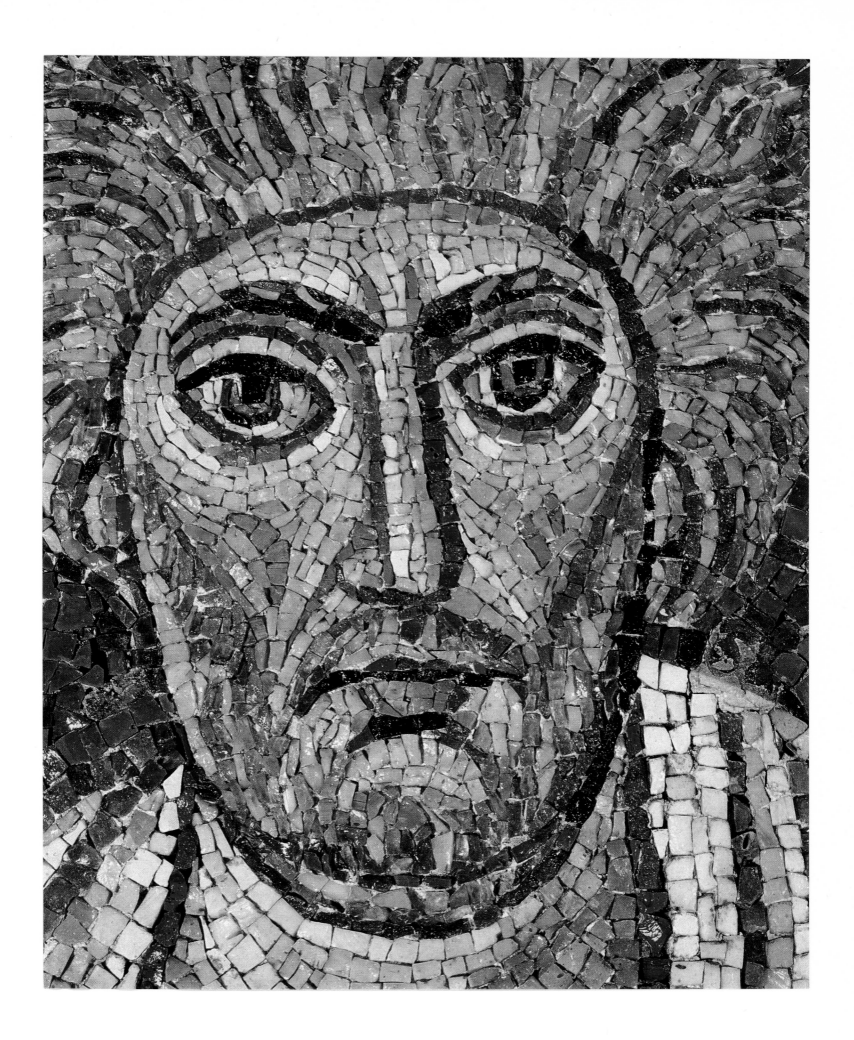

Sant'Apollinare Nuovo. *Drawing of the facade (after De Angelis d'Ossat)*

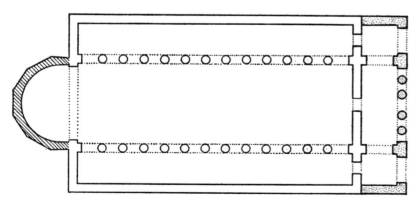

Sant'Apollinare Nuovo. *Ground plan (after Perogalli)*

## 8 Sant'Apollinare Nuovo

*first quarter of the sixth century*

The basilica known today as Sant'Apollinare Nuovo was initially an Arian church dedicated to Christ the Redeemer. That it was founded by King Theodoric himself is clear from the dedicatory epigraph over the windows in the apse which Andreas Agnellus noted down in the ninth century: THEODORICUS REX HANC ECCLESIAM A FUNDAMENTIS IN NOMINE DOMINI NOSTRI JESU CHRISTI FECIT (King Theodoric erected this church from its foundations in the name of Our Lord Jesus Christ). We can take it from this that the church was fully finished before the death of its founder in 526 or the epigraph would have included the name of his successor in this task.

Since the church was situated in the immediate proximity of the *Palatium*, the official royal residence, it is likely that it was utilized for court ceremonies. This would explain the very extensive, rather ostentatious, and obviously very costly mosaic decoration which today entirely covers the long walls of the spacious nave but once also extended to the entrance wall and the apse.

The early history of this church is intimately linked to political events. Some forty years after its foundation it was deconsecrated as an Arian church and turned over to the Catholics when, under the urging of the Catholic Archbishop Agnellus (557–70), Justinian issued an edict about 561—all of twenty-one years or more after the city had been taken by the Byzantines—which automatically transferred all property and possessions of the Arians to the *sancta mater ecclesia Ravennae, vera mater, vera orthodoxa* (the holy mother church of Ravenna, only true mother and truly orthodox). To celebrate the *reconciliatio* he had managed to win, the archbishop promptly changed the name of the church to honor Saint Martin of Tours. The rededication of this former Arian church to a fourth-century bishop famous for his campaigns against pagans and heretics was obviously done with polemical intent.

Not long after the middle of the ninth century the church once again changed its name. In those years the nearby shores of Classis were frequently raided by pirates identified in contemporary sources as *Agareni* but most likely to have been Saracens. In one of their incursions they sacked the great basilica dedicated to Saint Apollinaris and made off with the great silver ciborium from over his tomb. Lest another expedition might go so far as to profane or remove the relics themselves, they were transferred to a safer home within the walls of Ravenna, to the church of Saint Martin, which was thereupon renamed New Saint Apollinaris, the appellation "new" *(nuovo)* being added to distinguish it from a smaller church of the same name in the city. To house the sacred relics, a crypt was hollowed out under the presbytery, using the characteristic design of the period, a central corridor and a circular ambulatory following the lines of the apse above it.

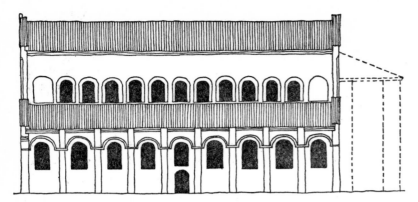

*Sant'Apollinare Nuovo. Drawing of the south side (after De Angelis d'Ossat)*

Today, unfortunately, the crypt can no longer be visited since it is almost always under water.

Around the year 1000 a handsome cylindrical campanile was erected along the right side of the church. Throughout its entire height of 123 feet it is perforated by an ascending series of slots and one-light, two-light, and three-light openings which give the tall tower its light, airy, and picturesque appearance.

In the sixteenth century an elegant marble portico was added to the sober brick front, presumably to replace the original narthex. The major change of that time, however, was made in the interior. Because of the constantly rising ground-water level, the floor had to be raised about four feet, and along with it all the columns and arches. Then, in 1611, Cardinal Caetani had the original bare wooden trussed beams of the ceiling covered over by a flat wooden ceiling with rich gilded coffers. As recently as 1950 a further extensive modification was made when a new apse was built in what was claimed to be the original style and dimensions.

Despite these changes the basilica remains remarkably impressive because the weightiness of its architectonic structures becomes transfigured by the light that pours in through the many wide windows and by the polychrome effulgence of the mosaics, which, with their shimmering gold backgrounds, become almost incorporeal.

The interior is spacious—roughly 104 feet by 71 feet—and is divided into a nave and two aisles by two rows of columns of marble brought from Constantinople. The columns, twenty-four in all, are capped with both capitals and pulvins, or impost blocks. But the main impression created by the interior is one of extensive mosaic decoration whose magical and vibrantly alive presence intensifies the luminosity characteristic of this medium.

The uppermost zone of the side walls of the nave is given over to a series of twenty-six mosaic scenes from the life of Christ, thirteen per side, which alternate with similar rectangles containing a purely ornamental motif (plates 32, 33). Illustrating the miracles, parables, and Passion of Christ plus certain events posterior to the Crucifixion (plates 34–59), this is the most important New Testament iconographic cycle in mosaic to have survived from the earlier centuries. Other cycles existed, we know, but like that which once adorned the church of the Holy Apostles in Constantinople, they have all been destroyed.

Comparison of the scenes of miracles and parables with those of the Passion and subsequent events strongly suggests that such a different approach to composition could only have come from two different mosaicists. The first of them, and presumably the earlier, consistently depicted Christ as young and beardless and reduced the action to only those personages essential to the incident, portraying them in calm and restrained poses and gestures. The second master, however, presented a Christ of mature years and wearing a beard, introduced numerous figures whom he tended to unite in compact groups, and infused his scenes with a greater feeling of dynamism and drama without hesitating to emphasize their pathos.

32   *Sant'Apollinare Nuovo. Interior*   ▷

33   *Sant'Apollinare Nuovo. The sixth-century mosaics on the north wall of the nave*   ▷ ▷

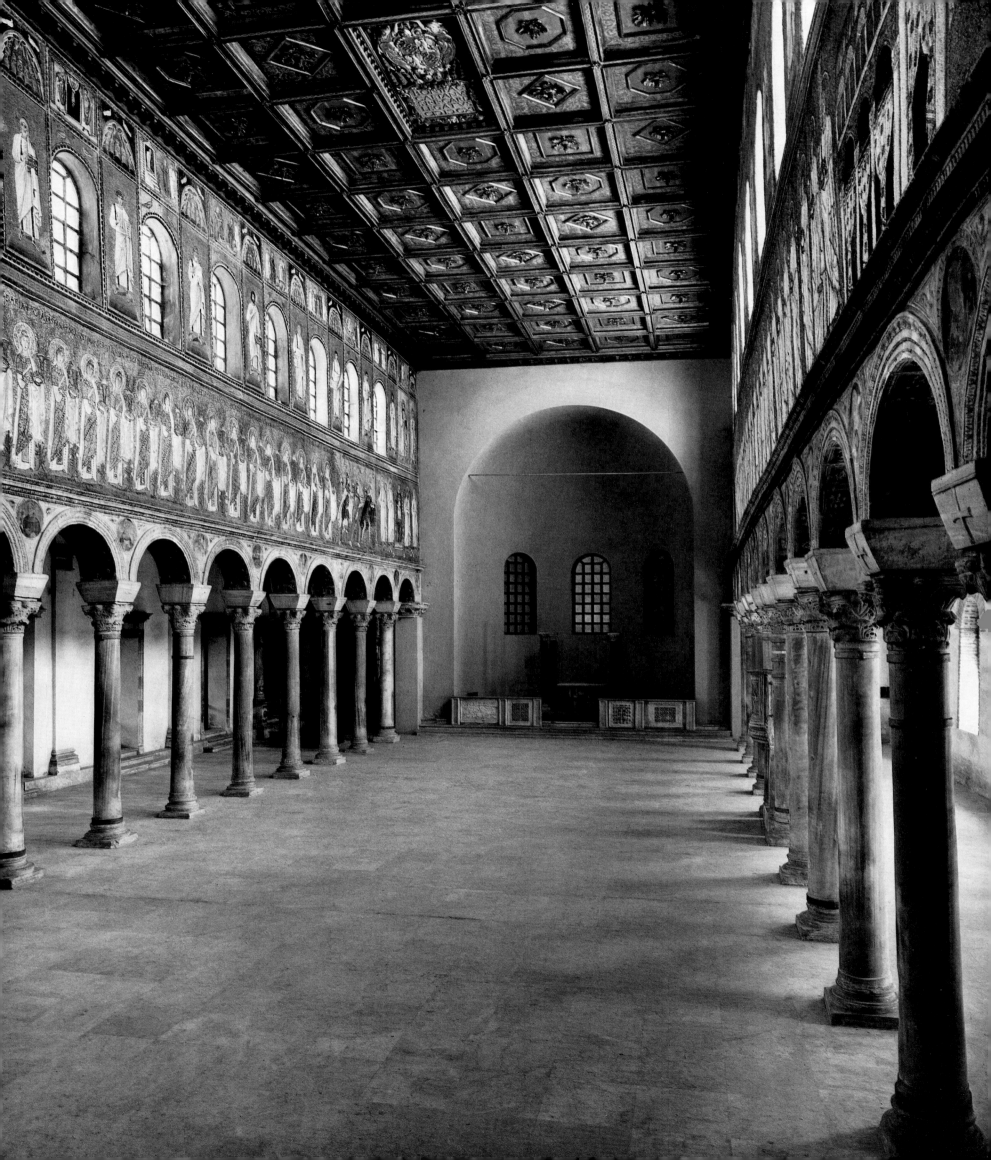

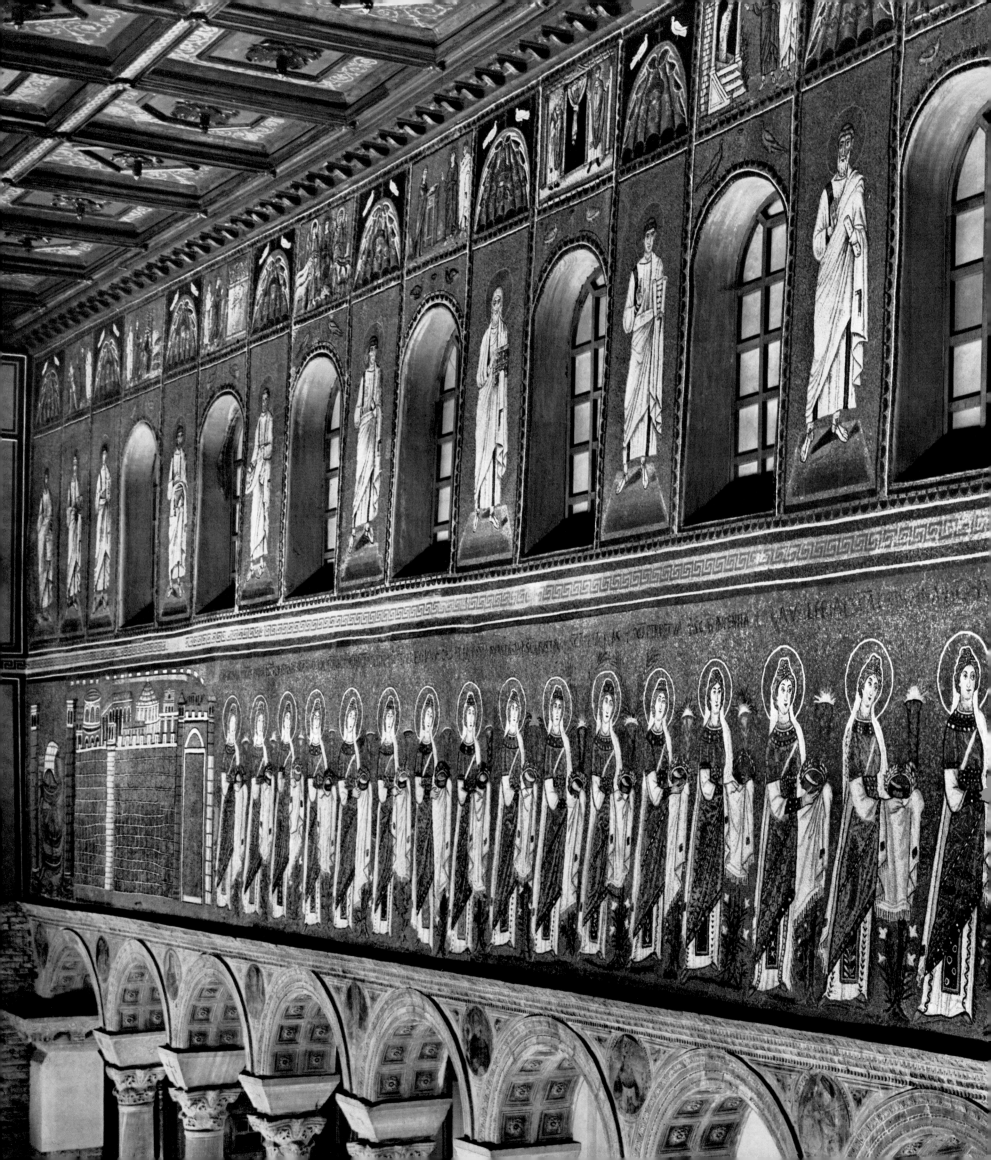

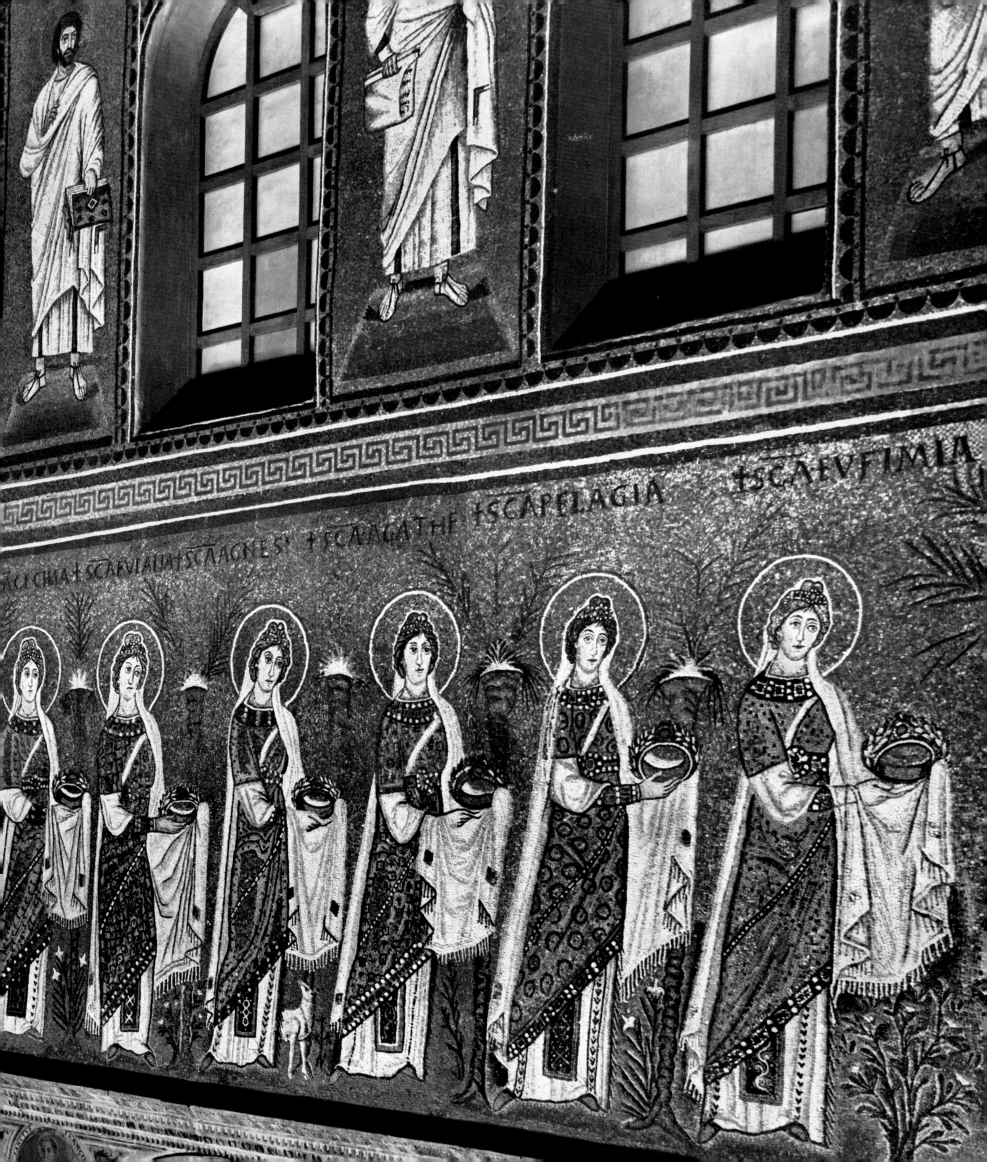

34

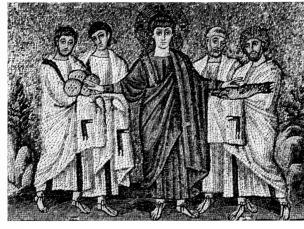

35

36

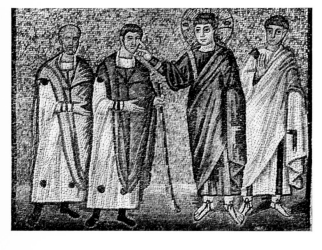

37

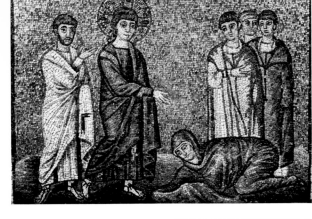

38

39

40

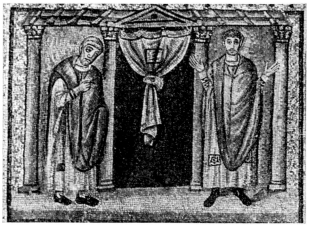

41

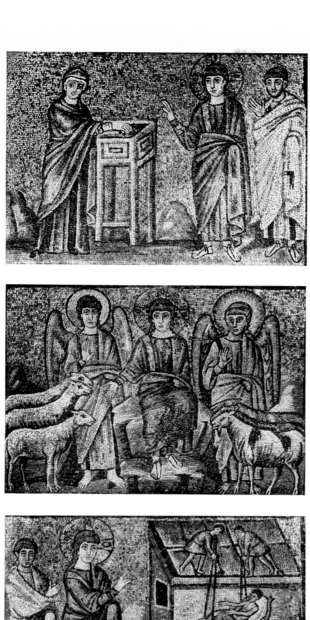

42

43

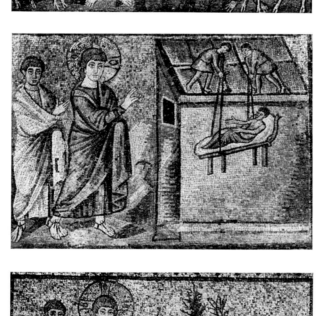

44

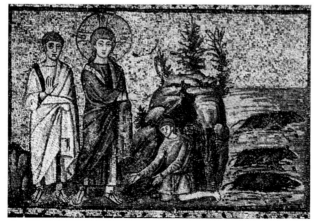

45

46

47

48

49

50

54

51

55

52

56

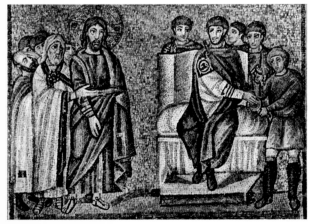

53

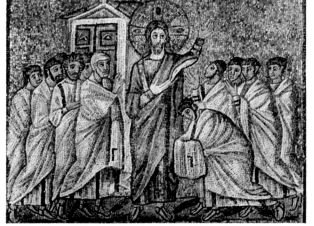

57

*34 The Multiplication of the Loaves (originally the Marriage Feast at Cana)*

The serving man and all the baskets of bread are the products of an erroneous restoration done about the middle of the last century in which the original subject—the first miracle of Christ, namely the transformation of water into wine at the Marriage Feast at Cana—was completely misunderstood, as we know from a seventeenth-century drawing which shows the servant filling six tall jars with water.

*35 The Multiplication of the Loaves and Fishes*

Christ stands in the midst of four apostles and accomplishes the miracle of the Multiplication of Loaves and Fishes by imposing His hands on them. The composition is absolutely symmetrical and scrupulously balanced.

*36 The Calling of Peter and Andrew*

More than the miraculous draught of fishes, the real subject here is the summoning of Peter and Andrew to join the disciples. The two fishermen are irresistibly drawn to Christ, who calls on them from the riverbank to leave their nets and become fishers of men's souls.

*37 The Healing of the Blind at Jericho*

By laying on of hands Christ brings about the miraculous cure of the two blind men of Jericho, who, secure in their great faith, cried out to Him, "Thou son of David, have mercy on us" (Matt. 9:27).

*38 The Healing of the Woman with the Issue of Blood*

The woman here is not, as some have thought, the adulteress whose defense Christ took or the Canaanite who beseeched Him to expel the devil from her daughter but, instead, the woman with the issue of blood who, healed now, casts herself before the feet of the Savior.

*39 The Woman of Samaria at the Well*

In showing Christ with the Samaritan woman drawing water from the well of Sychar, the artist undoubtedly wished to refer to His comforting words: "Whosoever drinketh of this water shall thirst again: but whosoever drinketh of the water that I shall give him shall never thirst; but the water that I shall give him shall be in him a well of water springing up into everlasting life" (John 4:13–14).

*40 The Raising of Lazarus*

Unlike almost all other early representations of this miracle, Christ does not bring back Lazarus by means of the wonder-working rod but only through the words, "Lazarus, come forth!"

(John 11:43), which we can assume are expressed here by His gesture.

*41 The Pharisee and the Publican Before the Temple*

Before a temple stand a publican on the left and a Pharisee on the right. The publican freely admits his shortcomings, the Pharisee exalts his own merits. Here the artist has caught their psychological characteristics with admirable insight: the humility of the one, the ostentatious pride of the other.

*42 The Widow's Mite*

The humble gift of "two mites which make a farthing" that the poor widow drops into the poor box of the temple is judged by Christ as more meritorious than the rich contributions of those that "did cast in of their abundance," because "she of her want did cast in all that she had, even all her living" (Mark 12:44).

*43 The Separation of the Sheep from the Goats*

This is a clear allusion to the separation of the good from the evil on the Day of Judgment. The angel in red, the color of light, symbolizes the Good; the angel in blue, color of night and darkness, is the symbol of Evil.

*44 The Healing of the Paralytic of Capernaum*

As told in the Gospel, the paralytic of Capernaum was healed inside a house into which he had been lowered after the roof was removed, there being so many people gathered around Christ that it was impossible to bring the man on his sickbed through the door. Here, however, to simplify the composition the mosaicist set the action outside the house.

*45 The Liberation of the Man Possessed by Devils*

It is rare for artists to depict this miracle in which Christ drove the unclean spirits out of a man and into a herd of swine who then rushed into the sea and were drowned. Here, exceptionally also, much has been made of the naturalistic setting of the grotto in which the possessed man had his dwelling.

*46 The Healing of the Paralytic of Bethesda*

During World War I an Austrian bomb struck the basilica and destroyed part of this mosaic, which was subsequently reconstructed on the basis of existing photographs. The paralyzed man is shown here at the moment when he takes up his bed and walks.

*47 The Agony in the Garden*

While Jesus prays fervently alone in the garden of Gethsemane, the disciples huddle together in two groups on the lower slope of the hill, weary and disconsolate. A strong note of pathos is conveyed by the various inclinations of their heads.

### 48 The Betrayal by Judas

Here one is struck by the calculated effort to characterize psychologically the moment in which Judas betrays Jesus by a kiss. The traitor's sullen and evil expression contrasts with the sorrow to be read in the faces of the apostles, whose white garments are counterposed to the vividly colored tunics of the soldiers.

### 49 Jesus Brought to Judgment

With slow but firm step Jesus proceeds to the seat of the Sanhedrin, who are to be His judges. He is surrounded by a group which, in accord with the Gospels, includes on the left the elders of the people and on the right the scribes.

### 50 Jesus Before Caiaphas

Here Jesus stands before the supreme council. Caiaphas, the high priest, is seated between two pontiffs and, like them, is dressed in a tunic over which is worn the Roman *lacerna*, a full mantle clasped over the chest by a brooch. The composition is stamped with a feeling of dignified solemnity.

### 51 Peter Denies Jesus

The serving maid who guards the door asks Peter if he is not among the disciples of Jesus. He draws back in confusion and, in a very spontaneous gesture, throws up his hands, palms outward, in eloquent denial.

### 52 The Repentance of Judas

Overcome by remorse for his treasonable deed, Judas has put into a small sack the thirty pieces of silver received as blood money and attempts to be rid of them. But Caiaphas, standing in front of the temple with the elders behind him, shows by his absolute immobility that he will neither accept back the money nor have anything to do with the betrayer.

### 53 Pilate Washes His Hands

Brought before Pilate, Jesus towers over the accusers pushing Him forward. As representative of the imperial authority, Pilate—like Christ—wears a purple mantle. Enthroned on the judgment seat, Pilate washes his hands and proclaims himself innocent of the blood of the guiltless prisoner.

### 54 The Ascent to Calvary

Abandoned by Pilate to the will of the priests and elders, Christ is led up to Calvary, which is perhaps symbolized here in the small mound at the right margin of the picture. The cross is borne for Him by Simon of Cyrene.

### 55 The Two Marys at the Tomb

When the two women come to the tomb, represented by a round aedicule, and find it empty, they both express their astonishment in the same spontaneous gesture while the Angel of the Lord, in "raiment white as snow," tells them of the Resurrection.

### 56 The Road to Emmaus

Two apostles, wearing over their tunics the kind of Roman mantle called a *paenula*, journey from Jerusalem to Emmaus conversing with the risen Christ, whom they have failed to recognize. The castle in the upper left corner probably signifies Emmaus and is among the few attempts at definition of landscape in these mosaics.

### 57 The Risen Christ Appears to the Apostles

Christ appears to the gathering of the apostles and displays His wounded hands and side. They all crowd around with a certain animation except for Thomas, who, having doubted, now beholds the truth and so inclines in the gesture of submission and adoration known in the Eastern Church as the *proskynesis*. He speaks the words, "My Lord and my God" (John 20:28).

### 58 Sant'Apollinare Nuovo. The Last Supper ▷

Jesus and the Twelve Apostles recline in Roman fashion around a semicircular table. He and Judas are at opposite ends of the table, and the dramatic force of the composition is entrusted above all to the expression of the eyes: sad in the apostles who gaze upon the Master, filled with contempt in those who turn toward His betrayer.

*59   Sant' Apollinare Nuovo. Christ Foretells the Denial of Peter*

With right hand raised in the manner of one who makes a pronouncement, Christ assures Peter that he will deny Him three times before the cock crows. And there, in fact, on the tall pillar stands the cock itself.

*60   Sant'Apollinare Nuovo. Above: panels with decorative motifs and the Risen Christ Appearing to the Apostles. Below: three prophets*

While the upper band of mosaics just below the ceiling alternates scenes from the life of Christ with a decorative motif involving a shell-shaped niche, a cross, doves, and a jeweled crown, in the middle tier there are vertical oblong panels, each with a solemn figure of a prophet, which alternate regularly with the windows except at the ends of the walls, as here, where three figures are immediately juxtaposed (see plates 32, 33). The figures are all fully frontal in pose and are set against a gold ground; at the bottom of each panel there is a patch of grassy green as if of a meadow, thereby achieving some hint of spatial depth. As heralds of the coming of the Messiah, all the prophets, whether young or old, hold in their hands sacred books in the form of either bound volumes or scrolls.

*61   Sant' Apollinare Nuovo. Above: prophets. Below: the port and
city of Classis*

The treatment of the drapery in the statuesque figures of prophets
reveals clearly that the artist took evident pleasure in problems
of form and plastic volume. Beneath their tier and at the
beginning of the north wall (see plate 33) is a nonperspective view
of the port which Augustus created and alongside it the city of
Classis, whose tall towers behind stout walls make it appear
truly impregnable.

   It is only fair to point out that most of the upper part of the wall
and almost all of the edifices seen above the city wall between the
white tower and the gate were redone in the latter half of the
nineteenth century.

*62   Sant' Apollinare Nuovo. The palace of King Theodoric*

The inscription PALATIVM on the pediment of this edifice tells
us that it is an official residence, in fact the famed palace of the
Ostrogoth King Theodoric. From the description by the
contemporary Cassiodorus we know that it was surrounded by
porticoes and decorated with mosaics depicting "those roseate
winged virgins, the Victories," and, in fact, on looking closely one
can just make them out here in the spandrels of the arches.
The buildings rising beyond and above the roof of the palace are
probably intended as the churches Theodoric founded in Ravenna.
It is likely that, originally, dignitaries of the court of Theodoric
were portrayed between the columns and that around 561,
when the Arian church was "reconciled" to the Catholic rite,
they were replaced by these simple knotted hangings. The evidence
for this is the fact that, halfway up certain columns, there remain
bits of hands and forearms of the figures that must once have
been there.

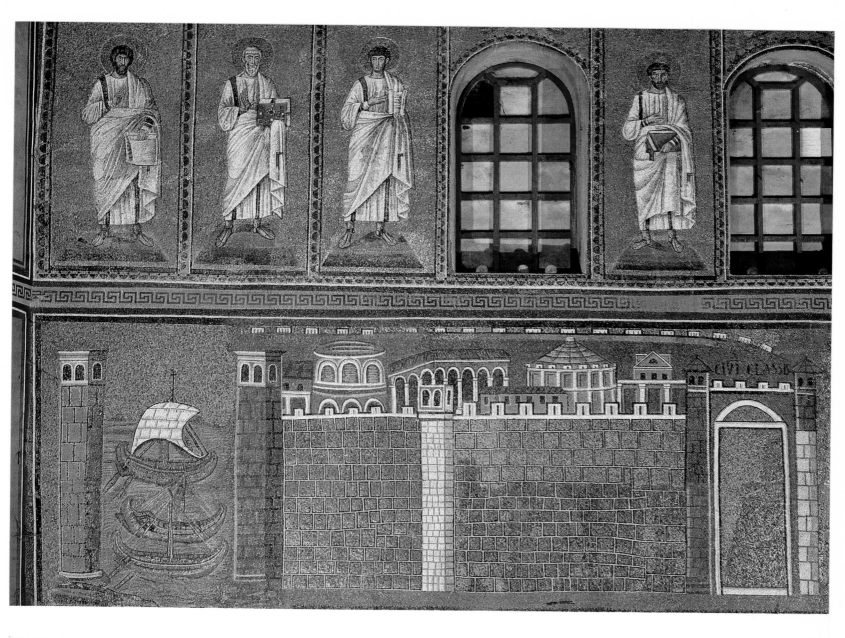

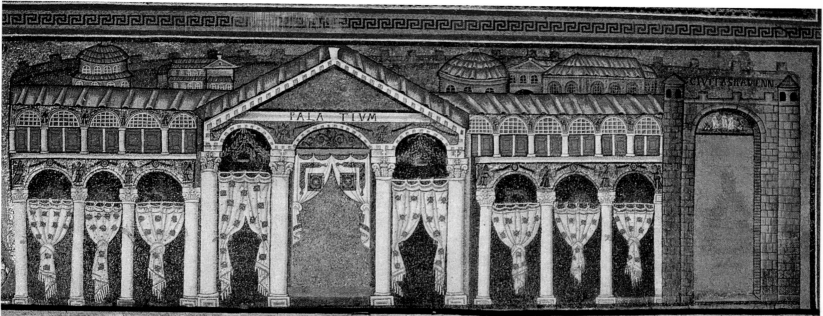

*63 Sant'Apollinare Nuovo. The procession of female saints (detail).*
*Third quarter of the sixth century*

Along the lower band of mosaic on the north wall of the nave a
splendid procession of female saints winds in hieratic solemnity
(see plates 32, 33). With slow and noble tread they traverse a grassy
meadow dotted with the white and red flowers of slender young
plants. Their continuous movement is not even interrupted by
the palms of martyrdom which are the only separation between
one figure and the next. Each saint is identified by her name written
above her halo. They are all dressed in sumptuous gold garments
adorned with embroidery, and each carries a symbolic gemmed
crown. The cortège is made up of no less than twenty-two
figures and is too long to be viewed in its entirety from any single
point in the church. Each saint has the same movement, the same
gesture, so that a single rhythm is renewed over and over again,
and it is this which constitutes the spirit governing all of this
splendid composition, certainly one of the most significant in all
Byzantine art.

*64 Sant'Apollinare Nuovo. The procession of male saints (detail).*
*Third quarter of the sixth century*

Like a visual echo counterposed to the cortège of holy women,
a procession of male saints stretches across the opposite wall of the
nave. They too march slowly on, carrying in their hands, most
often veiled by the pallium, the crowns of glory they bring in
homage to Christ. As with the women, their names too are written
above their halos, and their heads likewise are framed by the
green fronds of palms which separate them and join above each
head almost like a Gothic pointed arch. There is some diversity
in their faces, the positions of their feet, and the way they hold
their crowns, but the overall intonation of all twenty-six figures
is the same and puts one in mind of Vergil's phrase, "*Vox omnibus
una*" (all as if from a single voice).

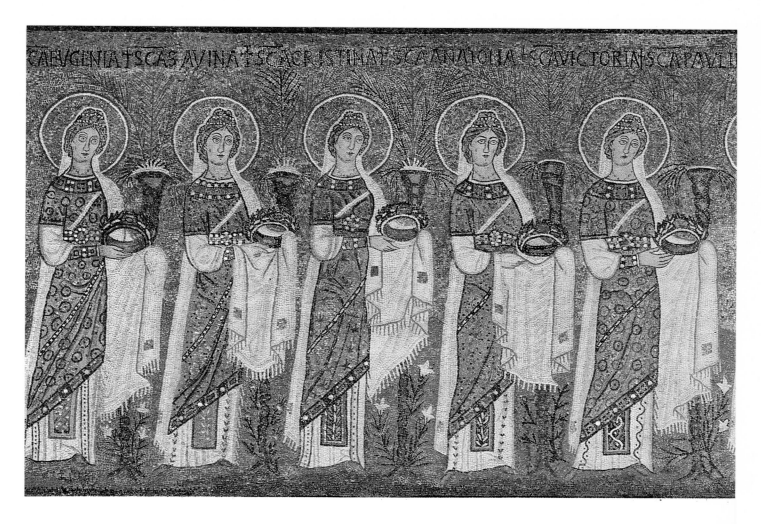

CEABVGENIA ↑SCAS AVINA ↑SCACRISTINA↑SC̄A ANATOIIA ↑SC̄AVICTORIN SC̄A PAVLI

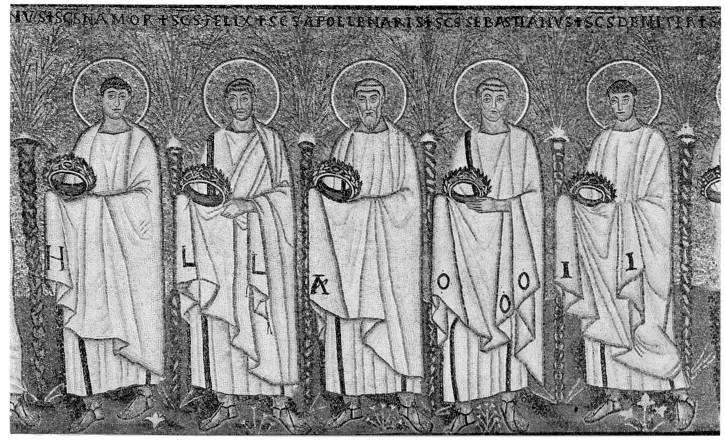

NVS↑SGS NAMOR ↑SGS FELIX ↑SC̄S APOLLENARIS↑SC̄S SEBASTIANVS↑SC̄S DEMITERES

*65   Sant'Apollinare Nuovo. The Virgin and Child Enthroned*

At the end of the north wall, in the lowest band of mosaics, the Virgin with the Christ Child in her lap is depicted according to the Greek type of *Theotokos*. The Child has a gold halo with superimposed cross and is dressed all in white, making a striking color contrast with the Madonna's dark amethyst tunic and mantle. The throne is richly set with pearls and gems, as is the podium on which it rests. The artist who conceived this composition manifested a skillful sense of formal values in the way he enhanced the elongated hieratical aspect of the figure of the Virgin by stressing the emphatic verticals of the uprights of her throne.

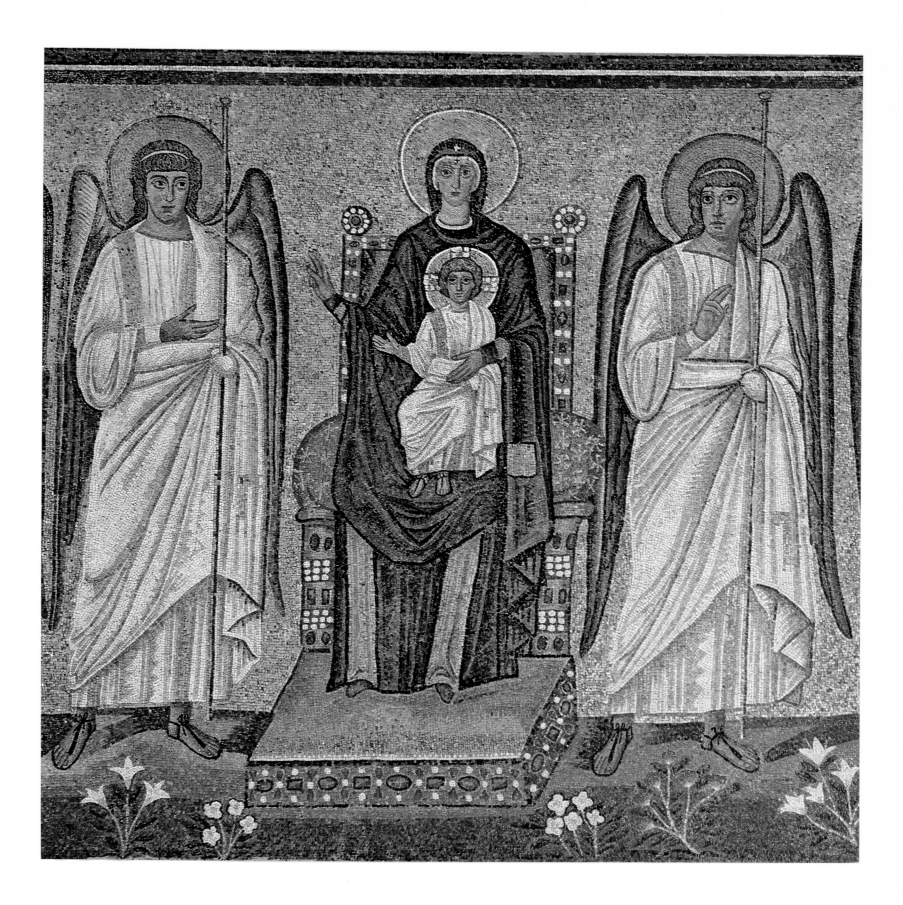

66  *Sant' Apollinare Nuovo. Head of an angel attending the Enthroned Christ*

Just as the Virgin on her throne is flanked by two pairs of angels, so too is the Christ enthroned on the facing wall. Garbed in white tunic with gold *clavus* and white pallium, each angel has his great brown wings folded back and holds in his left hand the messenger's staff that belongs to his function. Posed fully frontally, their abundant locks are bound by a thin white band and fall in waves behind their shoulders. Their faces are decidedly oval, their noses are long and straight, their large eyes stare out fixedly.

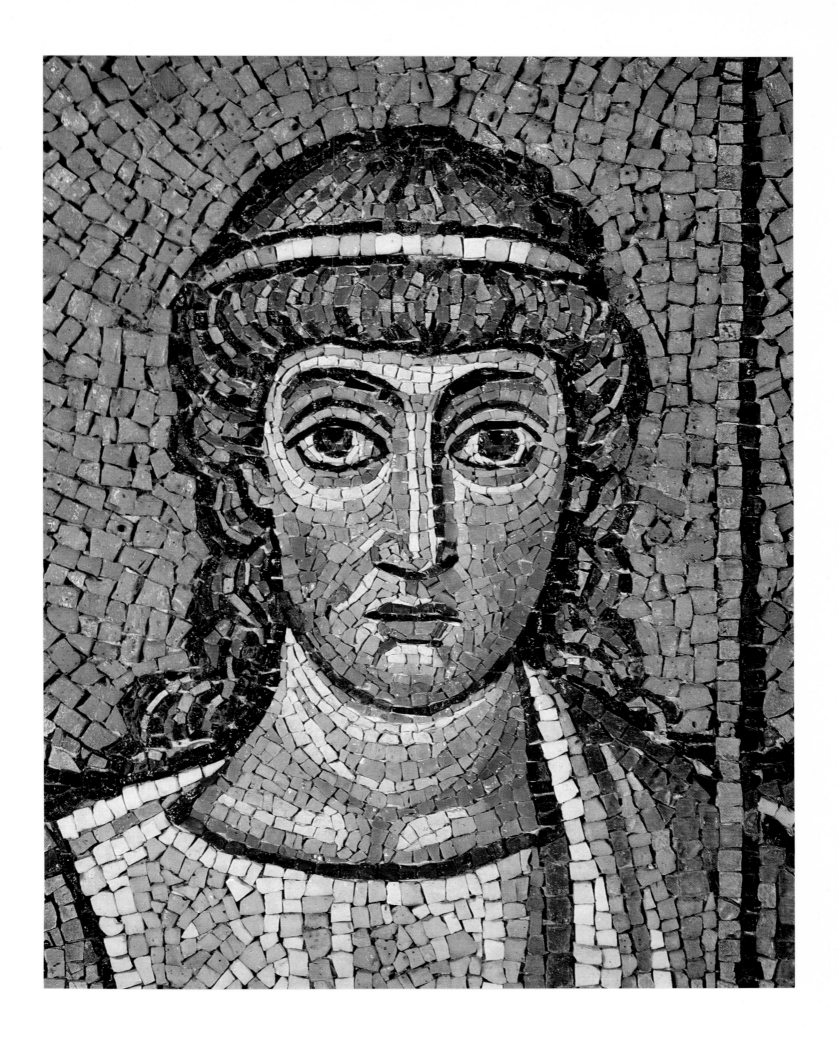

*67   Sant'Apollinare Nuovo. The Enthroned Christ (detail)*

As in the Passion cycle along the top of the south wall, here too Christ is bearded and of a mature age, although it was more or less the rule in Ravenna to depict Him as young and beardless. Certain scholars incline to ascribe the bearded Christ to Syrian prototypes.

The ill-defined scepter in Christ's left hand is another of the errors of the mid-nineteenth-century restorers. It is known that originally the figure held a book open to the words: EGO SVM REX GLORIAE (I am the King of Glory).

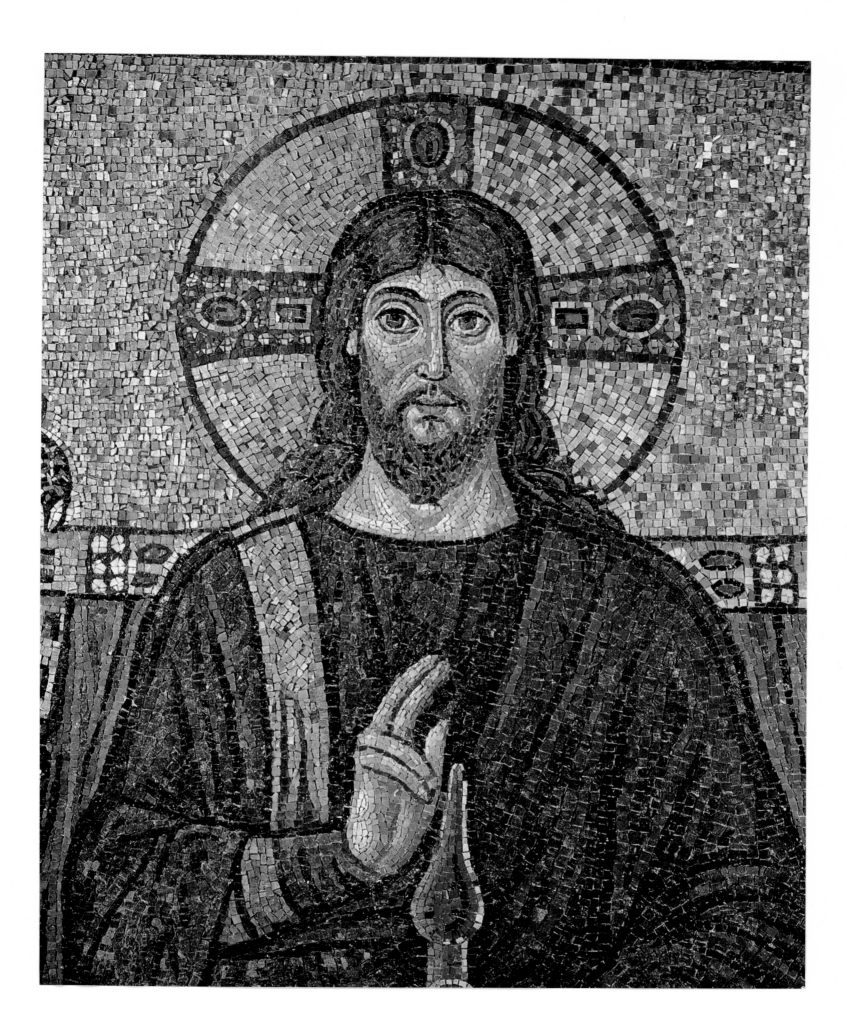

68  *Sant'Apollinare Nuovo. The Enthroned Christ (detail of the head)*

This enlargement of the head seen in the preceding plate is a dramatic illustration of the mosaic worker's art. The mosaic image is composed of a great number of small units known now as tesserae but called *abaculi* by the Romans. Here they are enamels, squares of a vitreous paste whose various colors are obtained by fusing the pigments. The squares were laid into a layer of plaster which, upon hardening, anchored them permanently one next to the other exactly according to the lines and colors called for in the composition. Not all the tesserae were cubes. Where it was not a matter of a regular area of relatively unified color, for example in rendering facial features and expressions, the artist could have recourse to a variety of small *abaculi* which might be oblong, square, triangular, round, or even reduced to very tiny irregular chips.

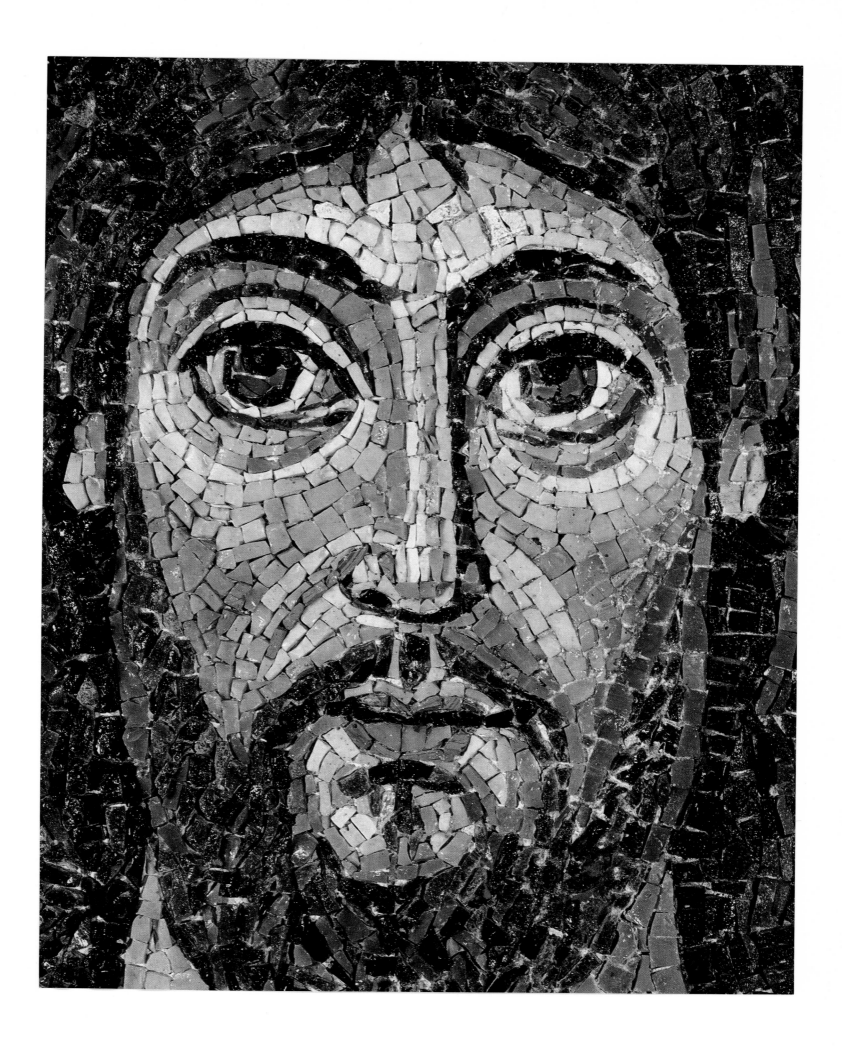

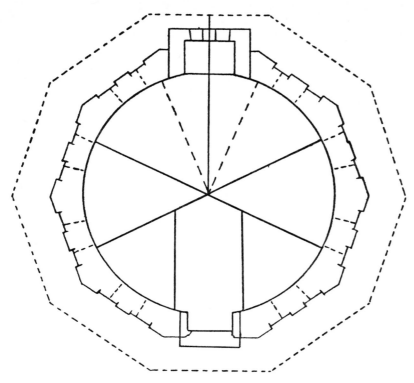

*Mausoleum of Theodoric. Ground plan of the upper story (after De Angelis d'Ossat)*

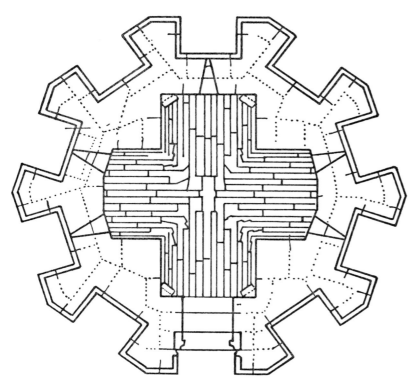

*Mausoleum of Theodoric. Ground plan of the lower story (after De Angelis d'Ossat)*

## 9 Mausoleum of Theodoric

*first quarter of the sixth century*

Austere, massive, imposing, the Mausoleum of Theodoric looms up in a solitary locality a half-mile or so from Ravenna, tall dark cypresses circling its bulk like a solemn crown.

An anonymous sixth-century text, known to scholars as the Anonymus Valesianus because the Latin fragment was published for the first time in the seventeenth century by a Frenchman Henri Valois, tells us that the King "erected during his lifetime his own funeral monument in square-hewn stone blocks, a work of marvelous grandeur, and for it he sought out one enormous block to be used to roof it over."

Indeed, what strikes one most is precisely the fact that, unlike the other ancient monuments of Ravenna which are all built from brick, this one owes its massive appearance to its solidly joined blocks of stone and to its roof, which is a single *ingens saxum*, a huge monolith calculated to weigh something like three hundred tons.

All this material is a finely porous limestone brought from the opposite shore of the Adriatic, from Istria in present-day Yugoslavia, which means that to transport something like the immensely heavy monolith it was necessary to build a special ship which could land in the immediate vicinity of the mausoleum site.

The building consists of two stories. The ground floor is ten-sided and on each of the sides there is a broad and deep niche crowned by a semicircular arch composed of interlocking toothed stones. The upper story, of lesser diameter, is likewise ten-sided below, although circular at the top. On each side, except for that in which a door is opened, there are two ornamental blind embrasures, each topped by its own small lintel and lunette. Immediately above these the wall becomes circular and ends in a frieze formed by the repetition of an element resembling pincers or tongs, one end of which each time terminates in a small curl or twist.

The colossal monolith crowning the edifice is hewn out roughly into the shape of a cupola. Along its rim all around the building at regular intervals there are twelve handle-like projections, each with a large perforation and each shaped at the top like a gable roof (plate 70). It is generally thought that the ropes used in the difficult procedure of hoisting the monolith into position were fastened to the openings in the twelve handles.

Each story consists of a single room, the lower one cruciform, the upper one round. Presumably there was an altar in the ground-floor room which would have been used for the funeral rites, while the upper floor housed the tomb of the sovereign, a porphyry tub *(labrum)* still to be seen there (plate 71).

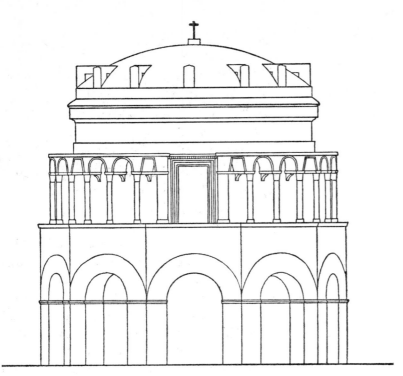

*Mausoleum of Theodoric. Drawing of the exterior (after De Angelis d'Ossat)*

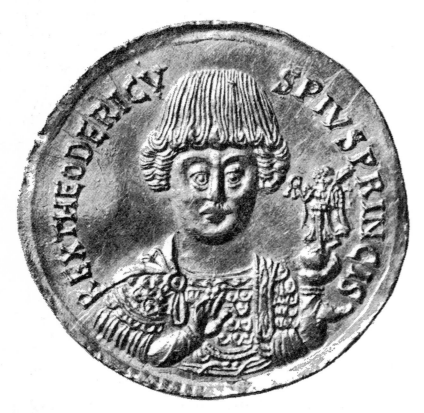

*Gold coin (aureus) with bust of Theodoric. Museo Nazionale Romano, Rome*

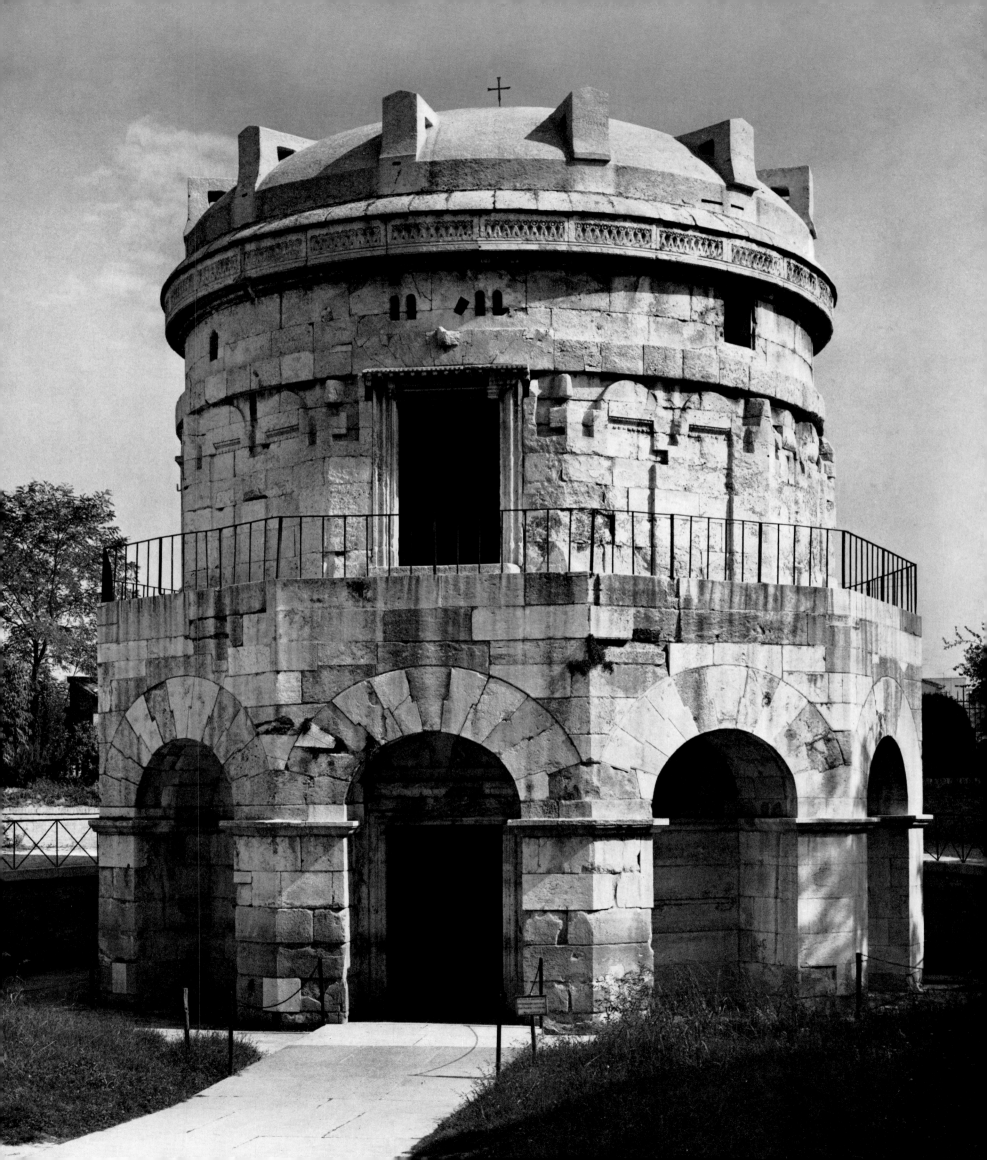

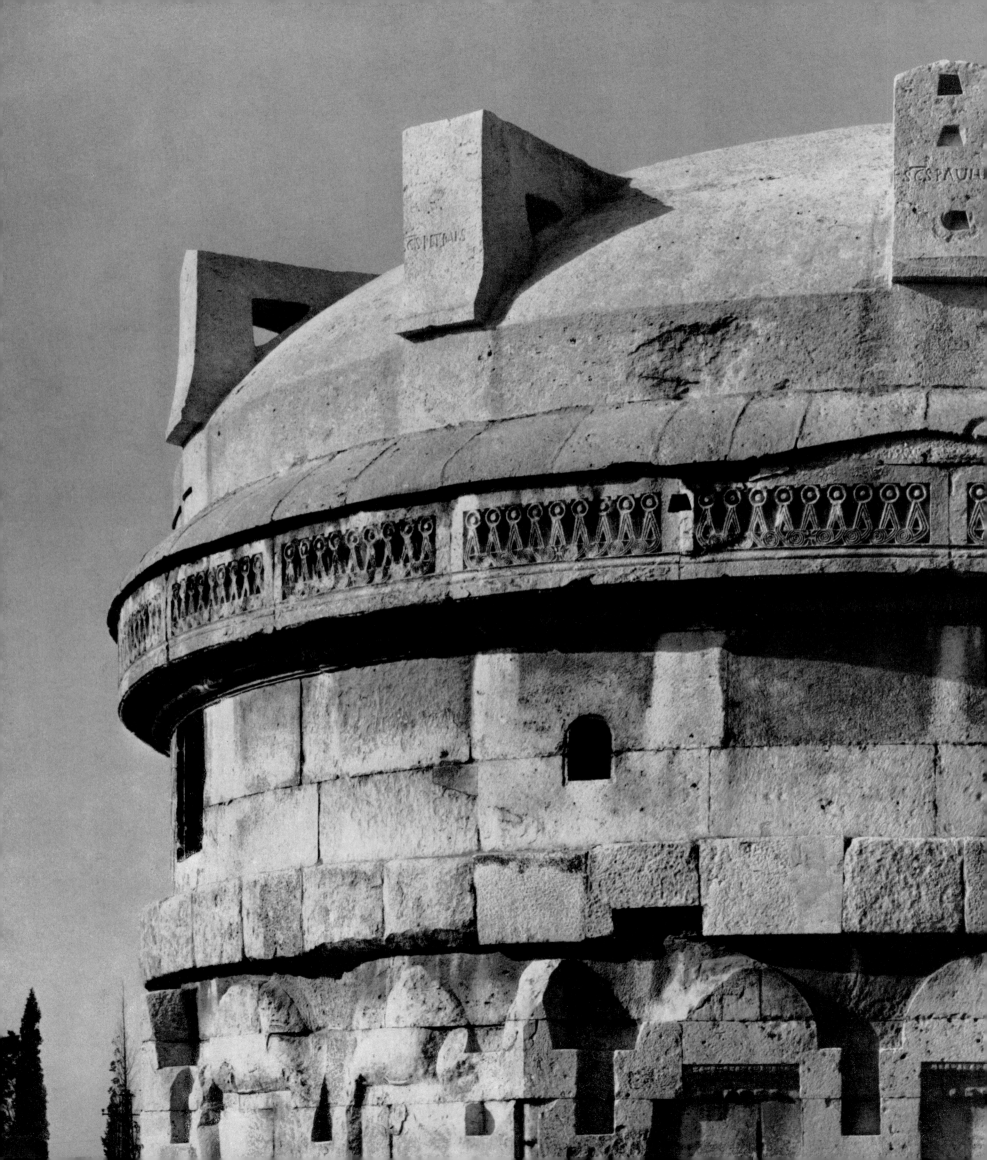

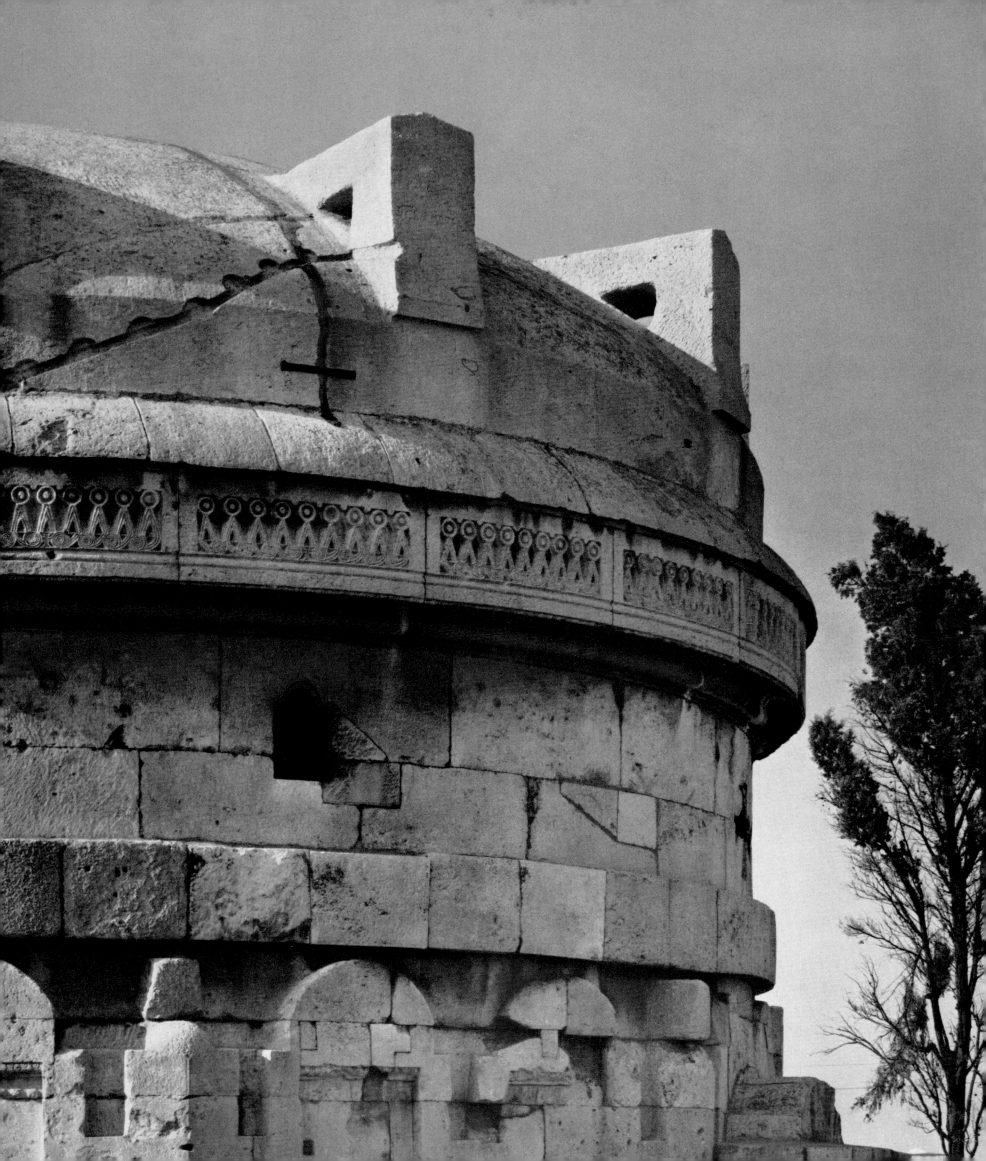

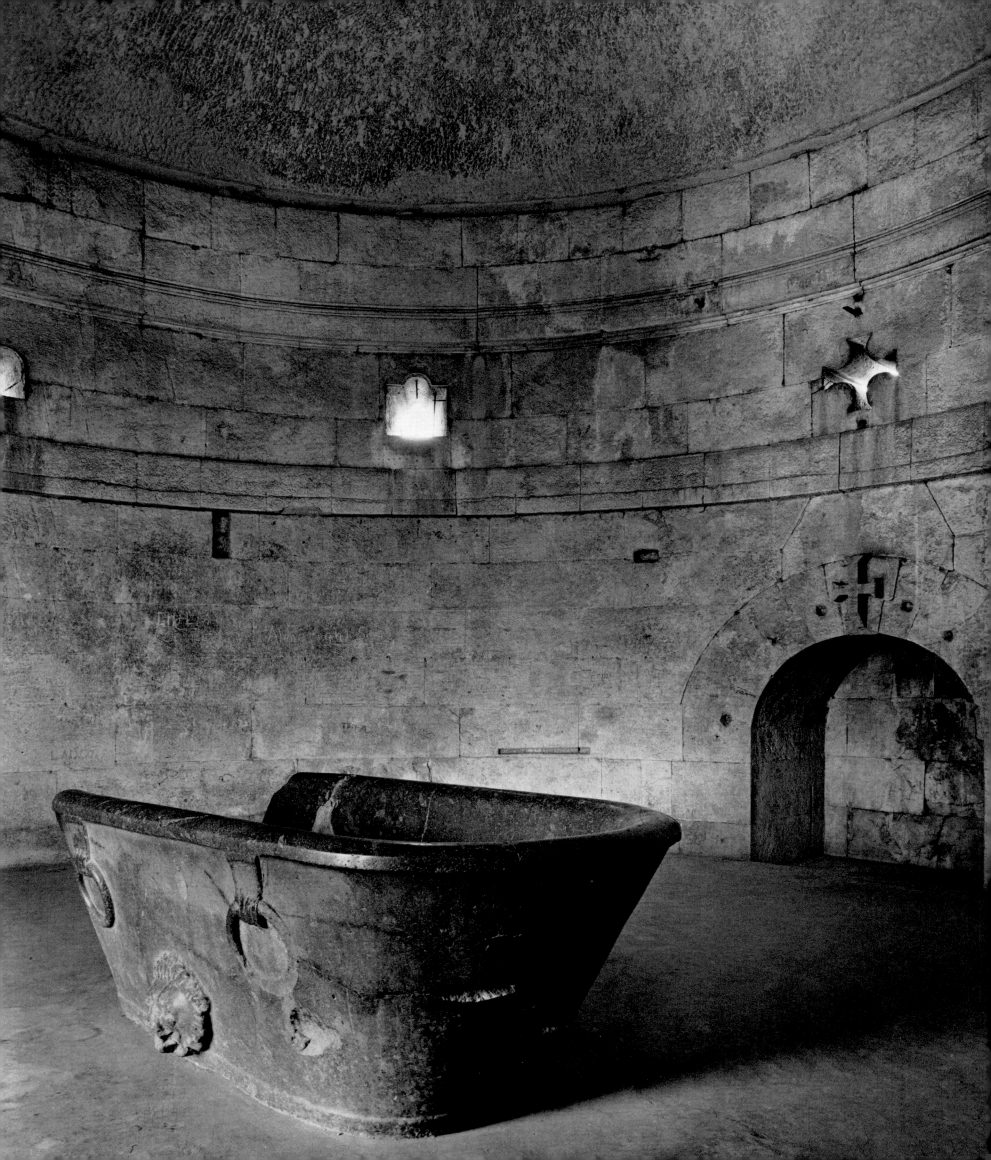

*San Vitale. Exterior*

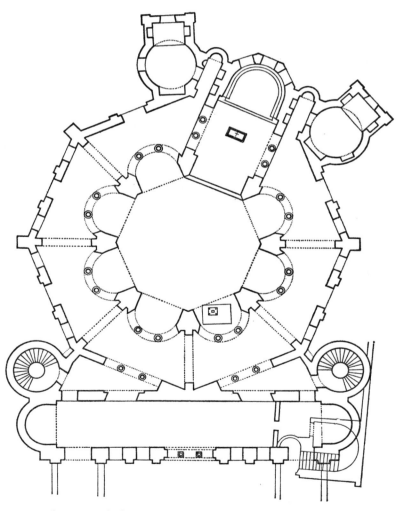

*San Vitale. Ground plan*

## 10  San Vitale

*second quarter of the sixth century*

This is one of the most sumptuous early churches in Ravenna, and its unique architecture is of perennial fascination to historians and critics of art alike. In the ninth century Andreas Agnellus affirmed outright that no church in Italy could bear comparison with it *(nulla in Italia ecclesia similis est)*. Ten centuries later Choisy could still write that nowhere else in a single building could one find associated in a more harmonious and fascinating ensemble such structural stability coupled with such architectural daring, such purity of line along with such splendid color.

Diggings undertaken in 1911 showed that the basilica was built in an area utilized a century earlier for a modest shrine whose mosaic pavement was found to be only two and one-quarter feet below the floor of the present church.

When San Vitale was begun, Ravenna was still under the rule of the Goths. The approximate date is known because Agnellus reported that it was built at the behest of Bishop Ecclesius (see plate 83) after he had returned from the East, where he had accompanied Pope John I on a diplomatic mission in 525 at the orders of Theodoric. This makes it likely that building began after 526, Theodoric having died in that year and the reins of government having been taken over by his daughter Amalasuntha in the name of her young son Athalaric.

To be in charge of the work of construction the bishop chose Julianus Argentarius, an individual about whom much has been written though not always correctly. Rather than the actual architect or the treasurer of the diocese of Ravenna as various scholars have thought, he was a plain though extremely wealthy private banker. It is known, for example, that for this undertaking he supplied no less than 26,000 gold coins, each of which weighed 4.45 grams. But the bishop who launched this church, Ecclesius (521–32), did not live to complete it, nor did his immediate successors Ursicinus (d. 536) and Victor (d. 545). The dedicatory epigraph recorded by Agnellus gives the date of consecration as May 17, 547, or, more likely, 548.

The edifice is octagonal and therefore based on a central-plan system with all components coordinated in a logical relationship to the center, a type of building with many prototypes in both Rome and the East. The walls were built of rather long and thin red bricks commonly called "julians" because they were used almost exclusively in those buildings in Ravenna for which Julianus Argentarius was responsible, notably San Michele in Affricisco and Sant'Apollinare in Classe. The warm-colored bricks absorb and hold sunlight and thus give rise to a sober play of color unique to this material and unobtainable by any other means.

From the outside, San Vitale appears to be composed of two distinct major octagonal structures: one, lower and wider,

corresponds to the perimeter of the two superimposed ambulatories of the interior; the other, taller and narrower, conceals the cupola under a pyramidal roof.

The simple geometrical articulation of the taller structure is characterized by a crystalline clarity of lines. The smooth walls of its eight sides are clearly defined, each with a broad decorative arch around a large and airy window in its center.

The two-storied lower structure around this taller core conveys much more feeling of dynamism. There are two levels of windows separated by a small overhanging dentiled cornice which not only contributes a note of sober picturesqueness but also marks the level of the second story of the gallery running around the interior. The windows alternate with engaged pilasters which serve as support for the two-storied gallery but also as decoration, as do likewise the sturdier buttresses at the corners of each face of the octagon. The result is a sober and regular exterior which, however, becomes somewhat more animated and varied on the side with the old entrance—made up of a narthex in so-called forceps design, that is, terminating in Roman fashion in two semicircular apsidioles or exedras facing each other—and on the side of the apse. The apse consists of half of a hexagon surmounted by a somewhat recessed tympanum and is flanked by the *pastophoria*, the subsidiary sacristies we have seen elsewhere. These various components combine to make a more active and dynamic play of volumes rendered even more light and agile by the ascending rhythm of the various sloping roofs.

The ample and airy interior is highly impressive. Its architecture creates a space which is mobile, restless, and, in consequence, full of life, spreading inward from the crown of semicircular apses curving between the eight slender pillars in the center and rising past the resilient high arcades toward the cupola, which symbolizes the "heaven of heavens," to borrow the words of a Syriac hymn referring to the vault of the cathedral at Edessa. This upward-soaring dynamism is something unique and not found in any Byzantine church of the time, and its antecedents are quite certainly Roman.

Drenched in light as is the central area, the ambulatory around it is almost swallowed up by shadow. This skillful contrasting of closed and open areas, of lights and shadows, creates an eminently chromatic effect whose climax comes in the dazzling mosaics of the presbytery and the apse, the only parts of the church to be decorated in that manner. The mosaics in this church clearly come from two different schools. One had its roots in Hellenistic-Roman art, and its settings are by preference in some way intimately linked to nature, whereas the other school installed its solemn and hieratical images against a deliberately abstract background. In my opinion the first style is to be found in the presbytery mosaics, the second in those of the apse.

The mosaics on the presbytery walls probably antedate by a few years those in the apse proper. There is no doubt that they should be attributed to *pictores imaginarii* trained in the Hellenistic-Roman tradition. To be convinced of this it is sufficient to look at their landscapes, vibrant with atmosphere, and at their figures, which assume a wide variety of poses and whose anatomical structure is always recognizable beneath their costumes.

On the other hand, the decoration of the apse must have been confided to artists of typically Byzantine tradition. A flat continuous gold ground replaces any suggestion of landscape, so that the settings are unnaturalistic, abstract, and transcendental. Further, the figures are all posed frontally, rigid and static, and with all hint of living flesh concealed beneath their heavy garments.

As for the wisps of white and red or white and blue clouds that drift across the summit of the apse and serve to mitigate somewhat the rigor of the gold background, it is not impossible that they were suggested by a Western mosaicist to the Byzantine artist responsible for this area, since this touch of naturalism is certainly not borne out by anything else in this otherwise fully abstract backdrop.

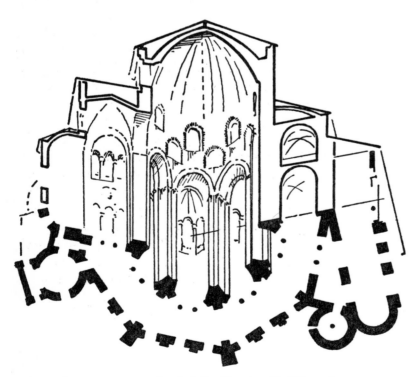

*San Vitale. Axonometric sketch (after De Angelis d'Ossat)*

72   *San Vitale. View of the north inner ambulatory looking through to a part of the apse and presbytery*   ▷

73   *San Vitale. The mosaic in the vault of the apse*   ▷ ▷

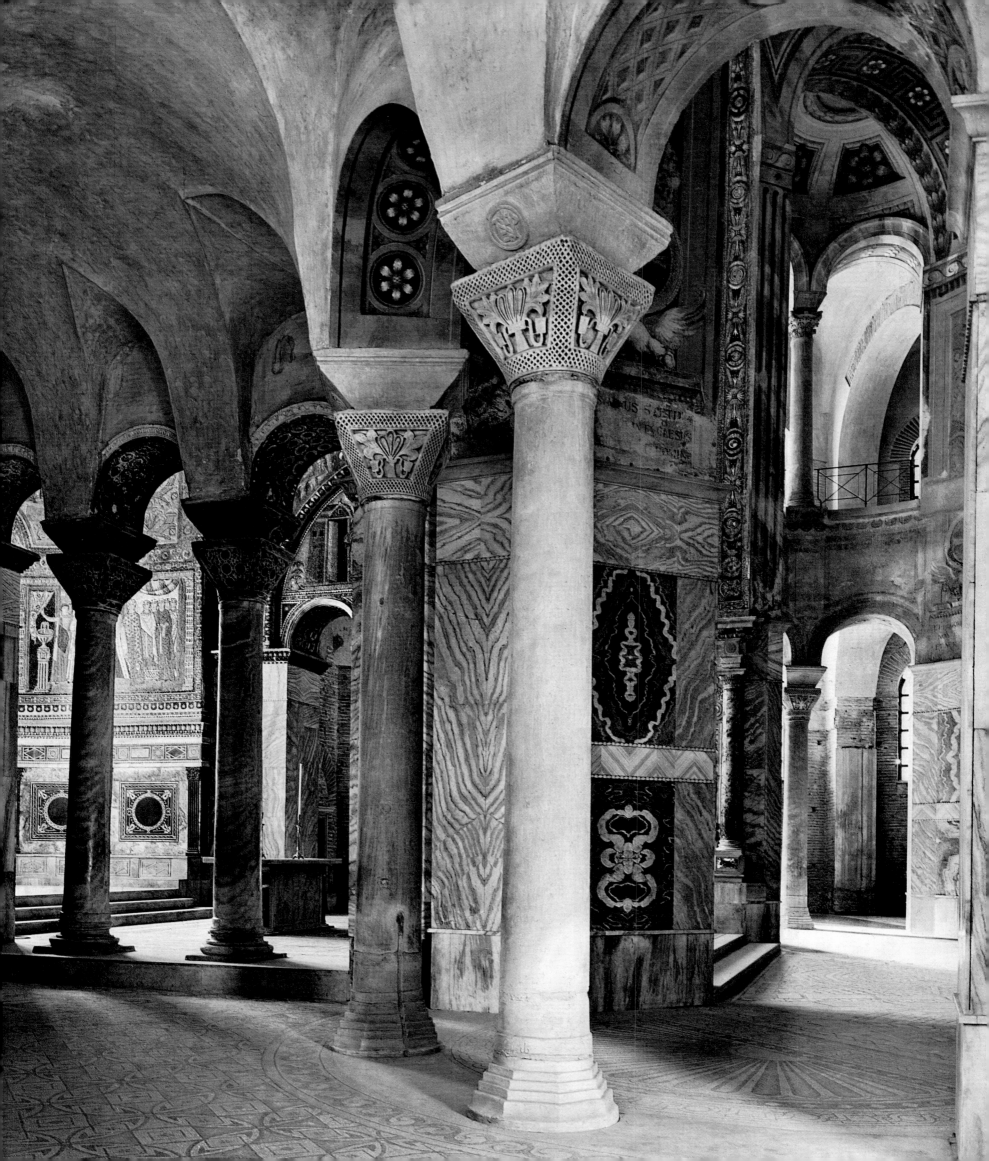

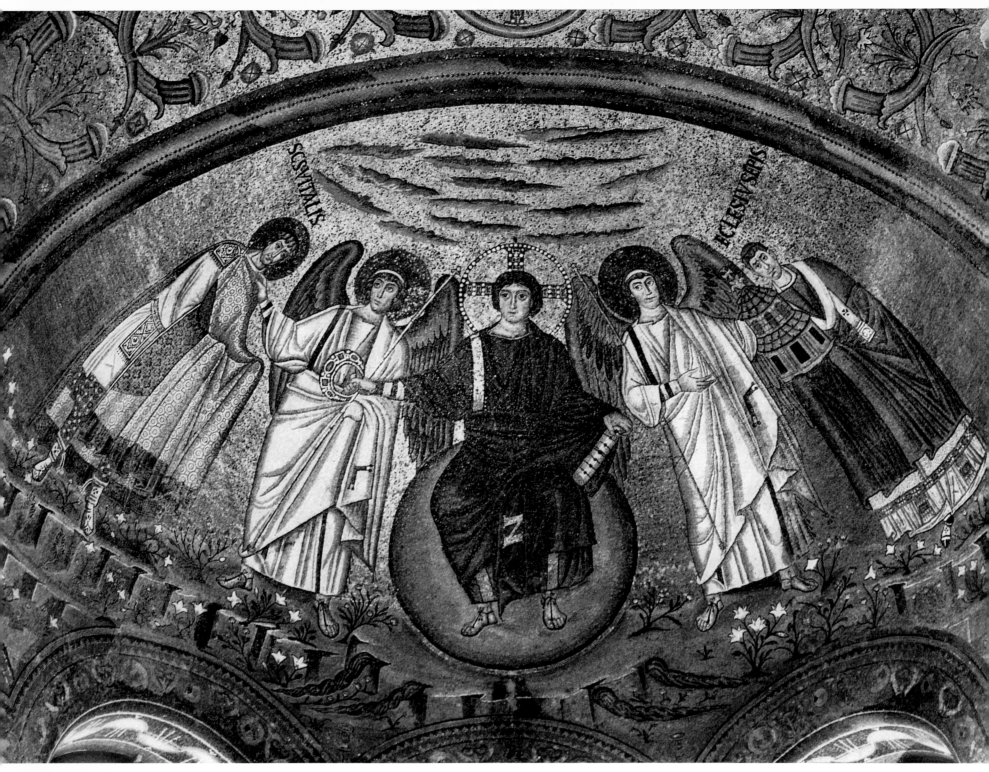

73

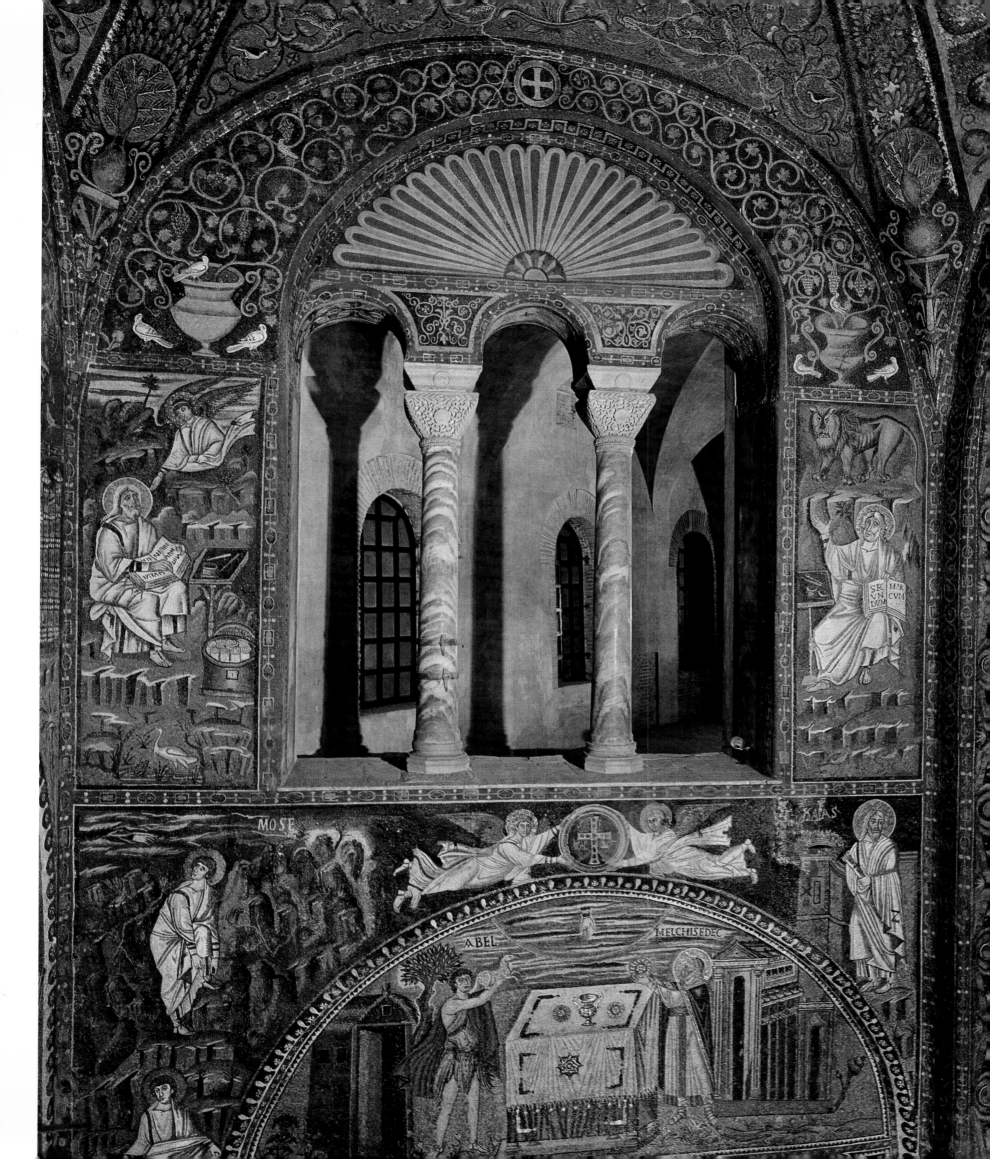

MOSE

ABEL    MELCHISEDEC

SEC·VN·DVM    MAR·CVM

◁ *74 San Vitale. Mosaics on the south wall of the presbytery*

*75 San Vitale. Mosaics on the arch of the presbytery*

The somewhat unusual decoration on the soffit of the great arch preceding the chancel is made up of a continuous series of round medallions, each of them supported by a small shell and two dolphins with tails intertwined. The medallions contain the busts of Christ (completely redone), the Twelve Apostles, and Saints Gervase and Protase, who were thought to be sons of Saint Vitalis. This type of *imagines clipeatae* in which portraits are set within a shield that serves as frame comes chiefly from Hellenistic art, where it was used to give prominence to heads and busts of gods and of persons decreed worthy of special honors, though in Roman times in particular its use extended to likenesses of ordinary citizens. Among the busts of particular artistic merit here are those of Saints Peter and Andrew, both of which strike one as remarkably plastic in modeling and with physical traits rendered with marked vitality and psychological insight.

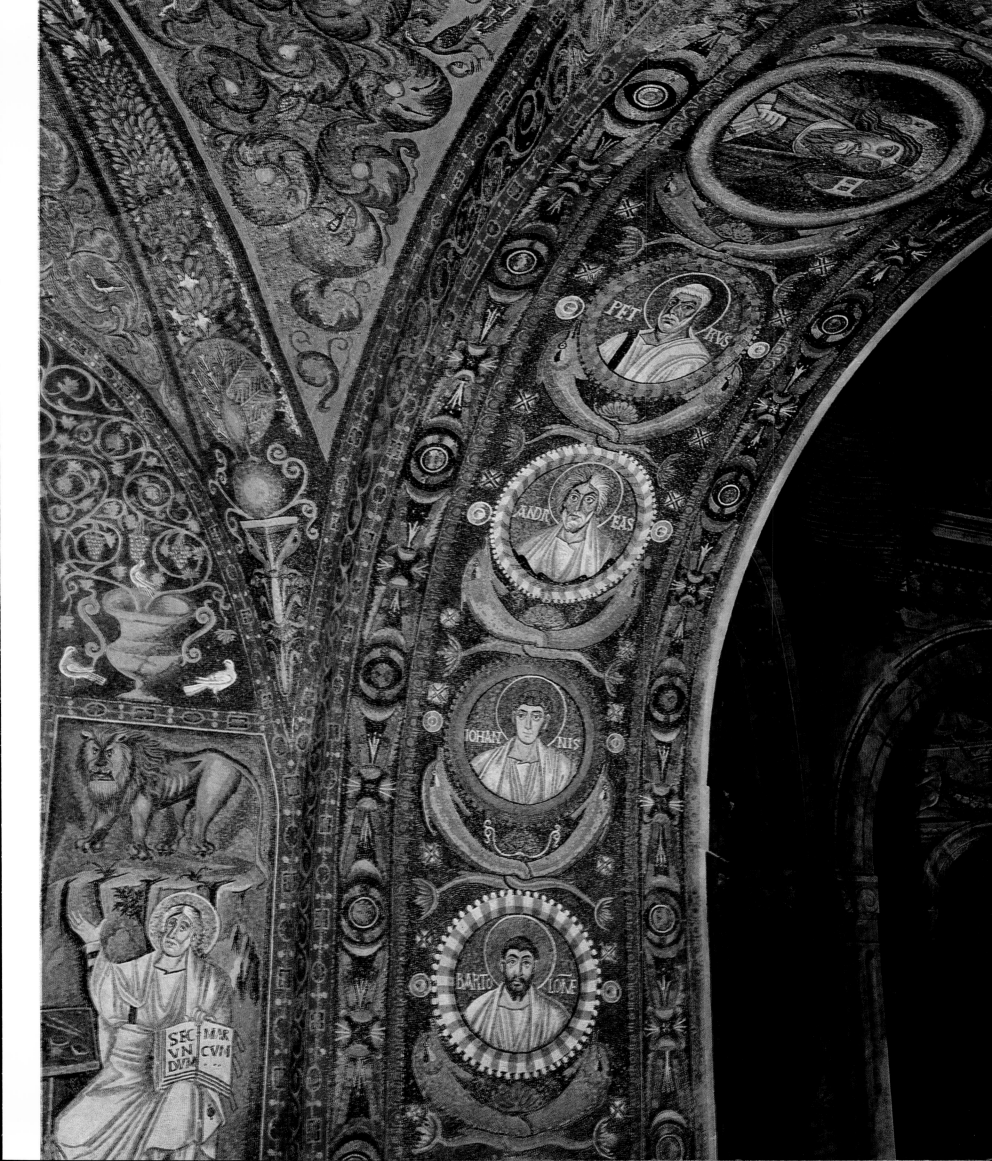

76 *San Vitale. Abel Sacrificing a Lamb (detail)*

As we know, the frescoes and mosaics in earlier churches were often there not so much as embellishments but rather as the means of familiarizing those unable to read with the chief Biblical events. This was a principle explicitly enunciated around the end of the fourth century when Saint Nilus wrote that church decorations were meant not only to be a pleasure to the eyes but must draw inspiration from both the Old and the New Testaments so that the faithful would be incited to imitate what they see in them.

The offering of a lamb on the part of Abel serves here to illustrate the idea that the offerings of the just meet favor in the eyes of the Lord whereas those of the unjust—Cain—are rejected.

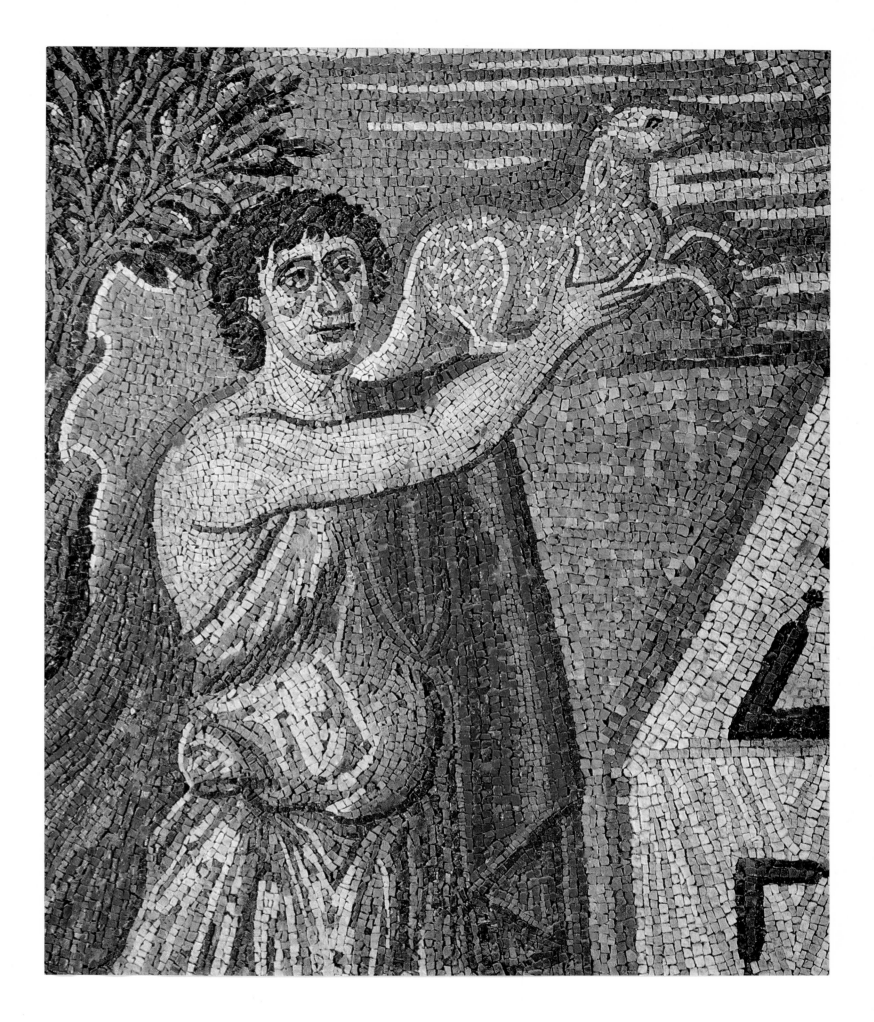

*77 San Vitale. Detail of the lunette showing the sacrifices of Abel and of Melchizedek*

The two scenes in which Abel and Melchizedek bring their respective offerings to God are linked together into a single pictorial composition by what we see here. Above, emerging from long slender strands of pinkish and red clouds is a hand, to be understood as a symbol of God the Father. Below, there is an altar with a chalice and two loaves of bread, and this would be a prefiguration of the Eucharist. Note how the altar cloth is decorated with a dark-colored motif whose simple geometrical form serves to frame and emphasize the altar itself and the objects on it.

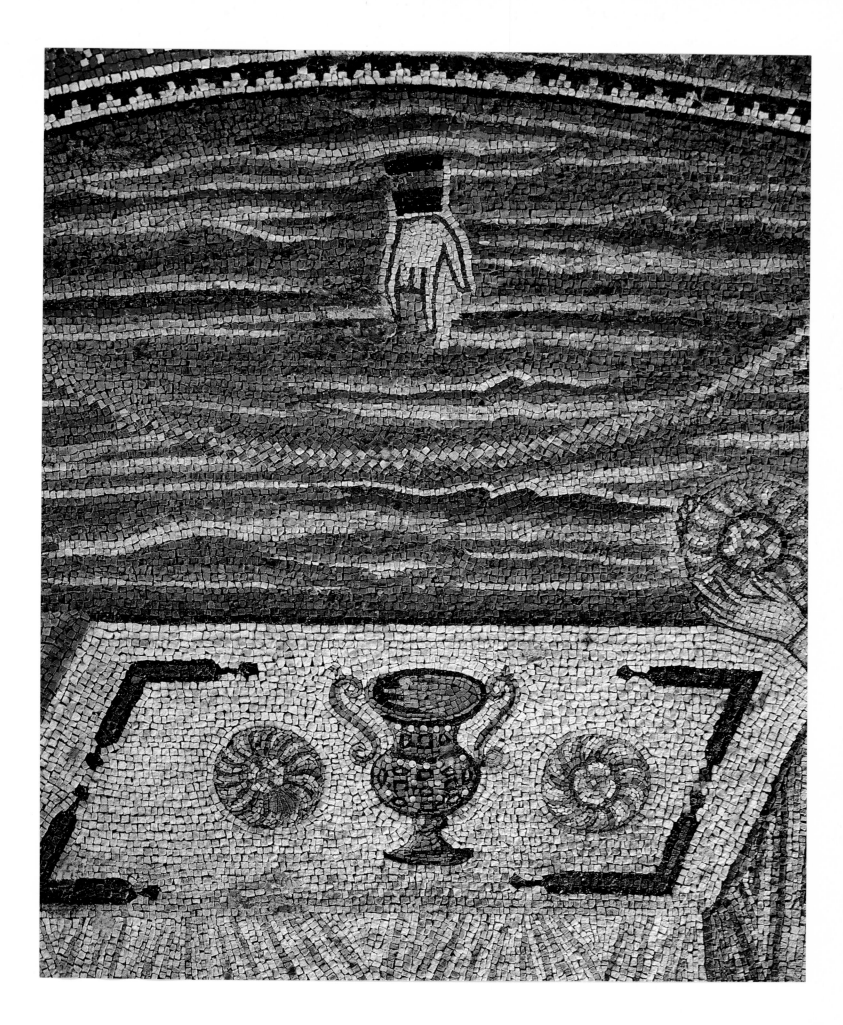

Counterposed to the lunette with the sacrifices of Abel and Melchizedek, on the north wall of the chancel another lunette depicts two episodes from the life of Abraham. In Genesis we read how the patriarch, at the age of ninety-nine and for decades married to Sarah, who was by then eighty-nine, complained bitterly about their childlessness: "Behold, to me thou hast given no seed: and lo, one born in my house is mine heir. And, behold, the word of the Lord came unto him, saying, This shall not be thine heir; but he that shall come forth out of thine own bowels shall be thine heir. And he brought him forth abroad, and said, Look now toward heaven, and tell the stars, if thou be able to number them: and he said unto him, So shall thy seed be" (Gen. 15:3–5). And, as the Lord foretold, Abraham did indeed have a son, Isaac, who assured him a numerous posterity. In this connection it is worth remembering that in Hebrew the name *Ab-ram* resembles by assonance *Ab-hamon*, which means "father of peoples."

79　*San Vitale. The Prediction of the Birth of Isaac*

The Lord appeared to Abraham in the plains of Mamre, some twenty-five miles from Jerusalem, in the guise of three men. The patriarch thereupon hastened to set a meal before his guests, and Sarah made ready three cakes and a calf that was "tender and good." The repast concluded, the Lord predicted that in the coming year Sarah would give birth to a child. Considering her advanced age, the incredulous Sarah could only laugh, to which the Lord answered: "Is any thing too hard for the Lord?"

The Biblical passage (Gen. 18:1–16) speaks of Abraham's guests sometimes as "the Lord," sometimes as "three men," because, as we are given to understand, one was the Lord Himself and the other two His angels.

The artist showed much skill in depicting the three personages seated at the table. The composition might all too easily tend to monotony or at least uniformity, but instead it is infused with a relaxed movement through the diversified gestures of hands and feet. Note that what we see here is a direct continuation of the scene in plate 78, where Abraham is bringing to the table his "tender and good" calf.

*80   San Vitale. Christ (detail of the mosaic in the apse)*

Garbed in dark purple, the youthful beardless Christ sits enthroned
on the orb of the world, behind His head a large halo outlined by a
continuous circle of disks of mother-of-pearl and enclosing a
cross likewise studded with pearls and gems.

The Early Christian artists borrowed from pagan art the halo
(or aureole, glory, or nimbus, however it be called) as symbol of
divine light, witness the mosaic of the god Silvanus found in Ostia
and now in the Lateran Museum in Rome. At the outset the
Christians used the nimbus for certain symbolic figurations such
as the allegorical figure of Summer on a fresco in the so-called
Greek Chapel of the Catacomb of Priscilla in Rome. By the fourth
century the halo had become the attribute not only of Christ
but often also of the Virgin, angels, apostles, saints, prophets, and
even sometimes of the emperor and empress, as the reader will
remark throughout these pages.

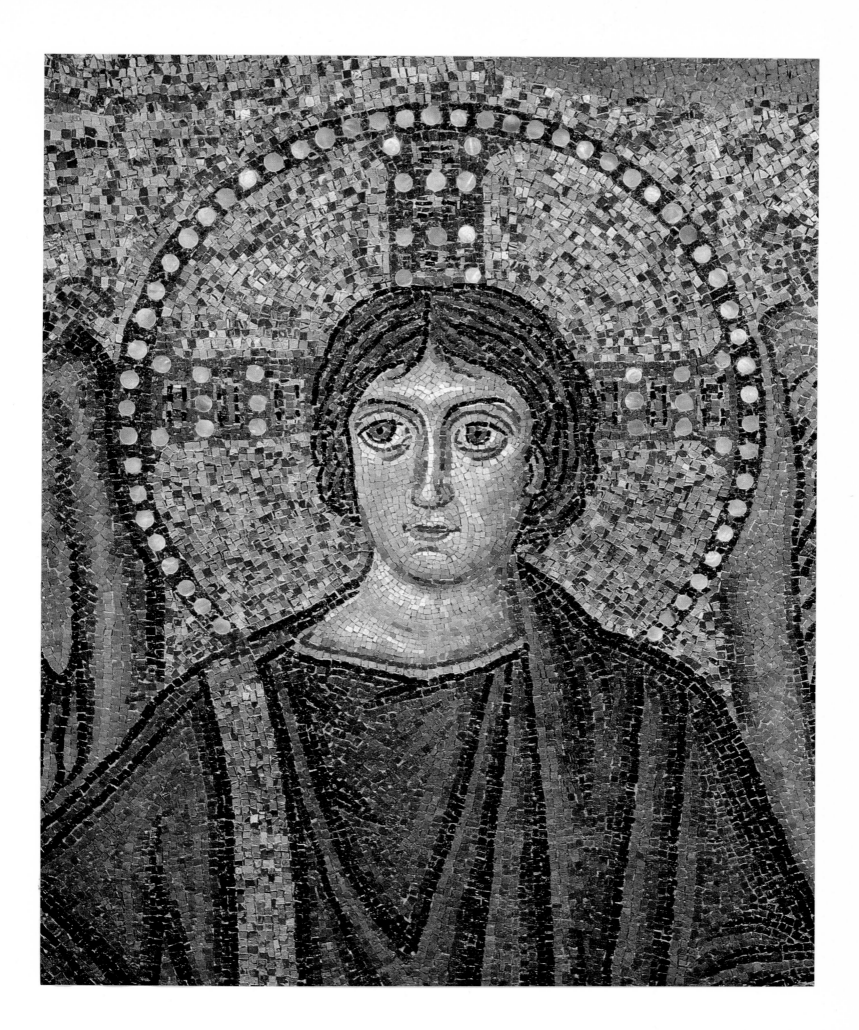

*81 San Vitale. Saint Vitalis (detail of the mosaic in the apse)*

Tradition has it that Vitalis was a Roman official, which is why he is shown here in the garments appropriate to his office: a rather short tunic girdled around the waist by a jeweled *cingulum* and over it the chlamys, a mantle which here is patterned with a geometrical motif of interconnected squares, circles, and octagons. The same pattern is found on the mantle of the court lady immediately alongside Theodora in the mosaic on the right wall of this same apse (see plates 86, 96). That this was no mere invention of the artist but was used on the textiles of an early time is proved by a scrap of cloth with very similar design which was found in the Tomb of Saint Julian in Rimini (now in the Museo Nazionale, Ravenna).

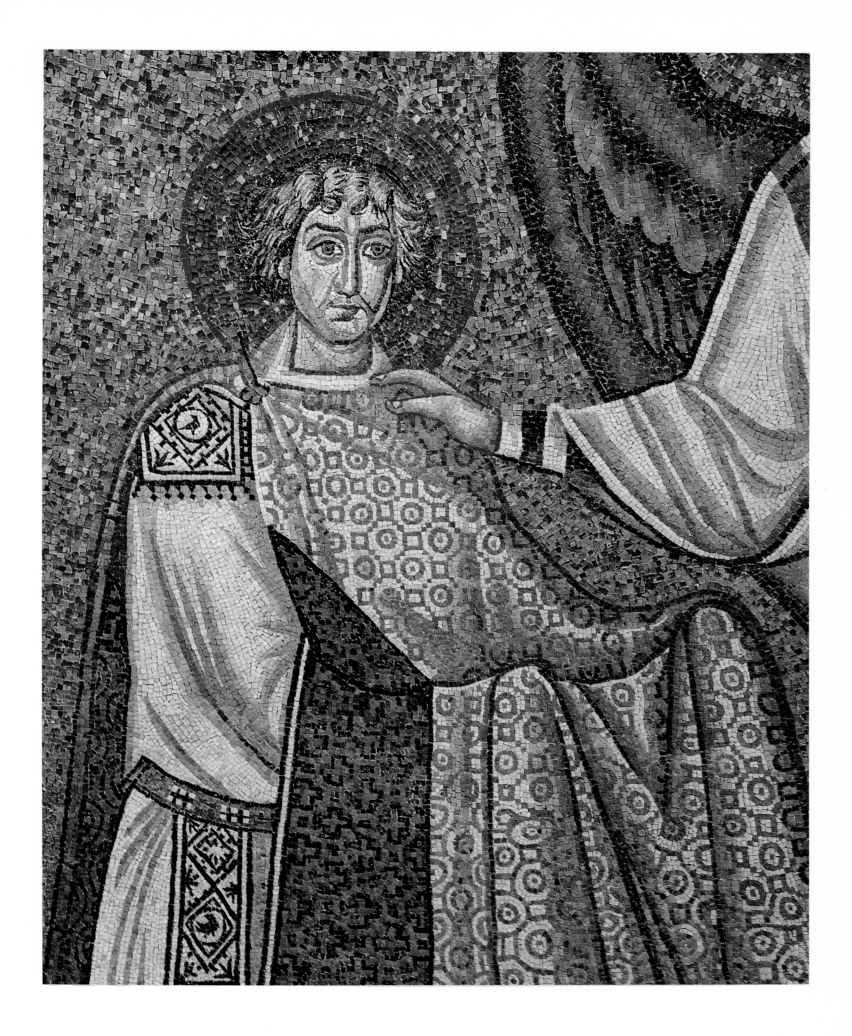

82 *San Vitale. Christ bestowing the crown of martyrdom on Saint Vitalis (detail of the mosaic in the apse)*

The golden crown studded with pearls and gems that Christ consigns to Saint Vitalis is the recompense for martyrdom, for having won out in the arena of life in the service of the faith. It would seem evident that the Early Christians took over the symbol of the crown from the simple laurel wreath with which victors in games and contests were crowned in ancient Greece. In time the crown became the distinguishing mark of victorious military leaders and even of outstanding citizens who, as we know, were awarded *coronae triumphales* in the East as well as in Greece. Only later did crowns begin to be made of gold.

References to crowns are numerous in Christian writings. Among countless examples one can adduce these: "Be thou faithful unto death, and I will give thee a crown of life" (Rev. 2:10); "Henceforth there is laid up for me a crown of righteousness" (2 Tim. 4:8); "Blessed is the man that endureth temptation: for when he is tried, he shall receive the crown of life, which the Lord hath promised to them that love him" (James 1:12); and, in the early-third-century *Ad Martyres* of Tertullian, the "*corona aeternitatis*"—the crown of eternity.

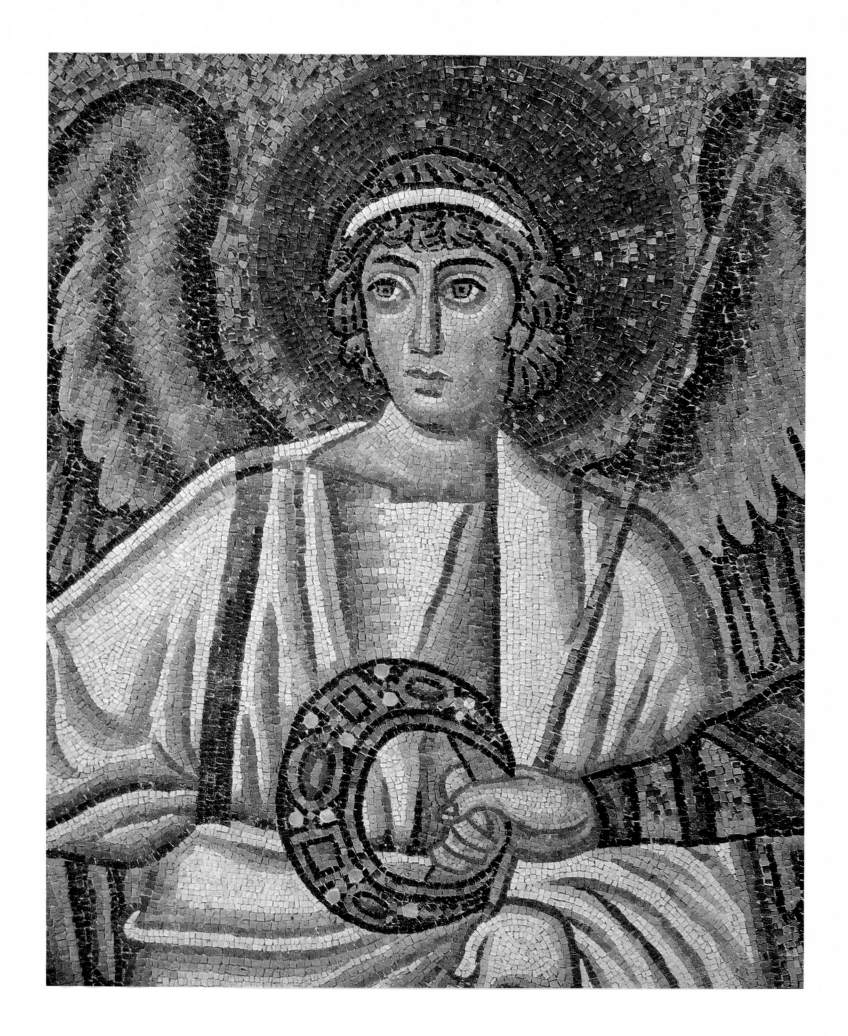

*83   San Vitale. Bishop Ecclesius, founder of the church (detail of the mosaic in the apse)*

In Early Christian art and especially from the sixth century on, the founders of churches, whether popes or bishops, were often depicted in the act of presenting to Christ a small model of the edifice. There are a number of early examples of this in mosaics in Rome—notably in the churches of Santi Cosma e Damiano, San Lorenzo fuori le Mura, and Sant'Agnese fuori le Mura—as well as in the sixth-century Basilica Euphrasiana in the old Roman and Byzantine city of Poreč in Yugoslavia.

At San Vitale likewise, in the mosaic in the vault of the apse, we find the *episcopus mandans*, the bishop who initiated the work, though as it happened Ecclesius did not himself live to complete it and it had to be continued under his successors Ursicinus and Victor and finally completed by Maximian. The model that Ecclesius offers to Christ is of a central-plan edifice not too dissimilar to San Vitale in general structure.

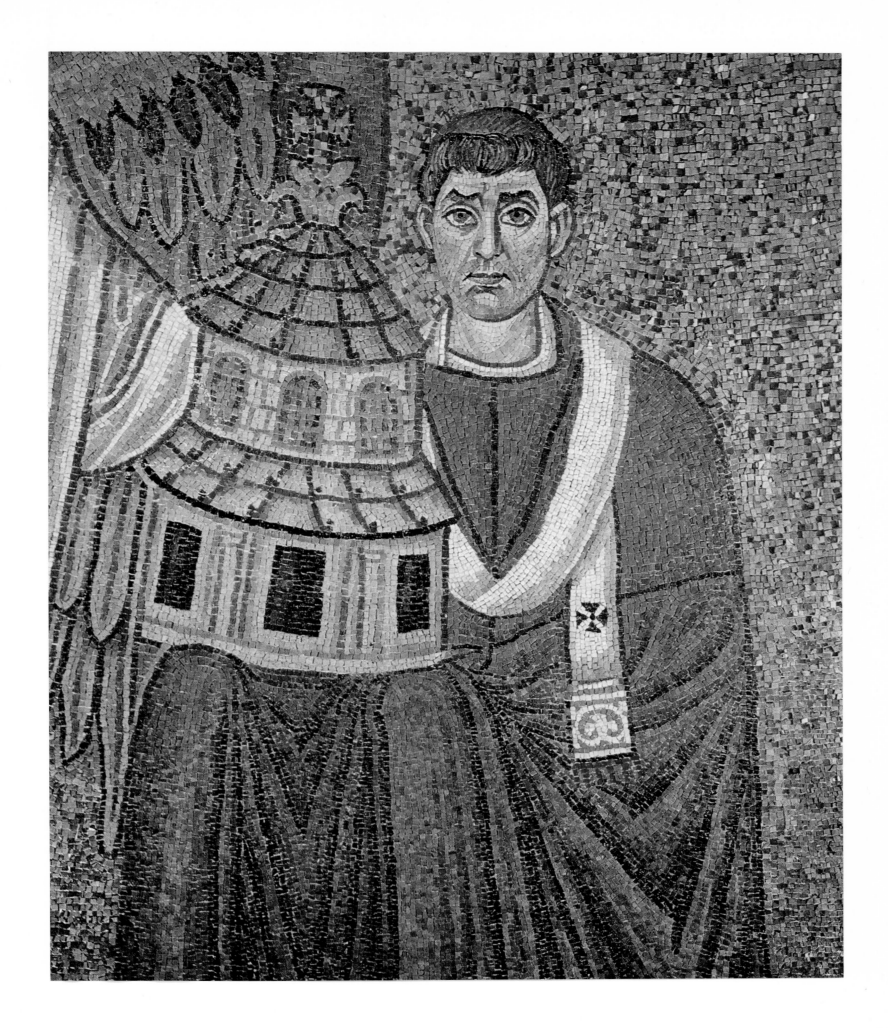

*84   San Vitale. The rivers of Paradise (detail of the mosaic in the apse)*

The four symbolic rivers of Paradise were often depicted in Early Christian art as gushing from clefts in a mountain at the top of which stood either Christ or the Mystic Lamb. Galla Placidia had them represented in mosaic on the front of her church of Santa Croce according to Agnellus, who recorded the metric inscription on the mosaic: TIGRIS ET EUFRATES, TISON ET IPSE GEON.

Here we see two of the rivers (for the others, see plates 73 and 85). Their waters—resembling nothing so much as skeins of wool—flow from shelves of rock supporting the cerulean globe, symbol of Creation, on which the Redeemer sits.

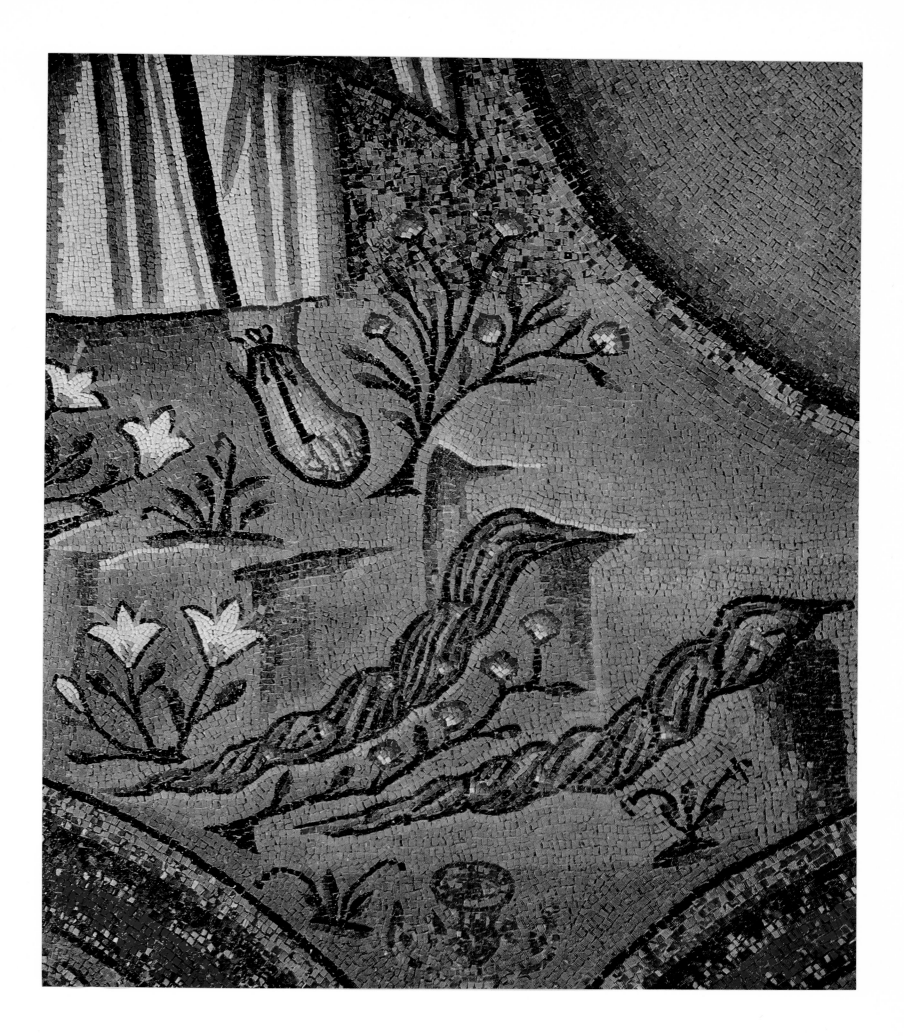

*85  San Vitale. The flowers of Paradise (detail of the mosaic in the apse)*

To judge by the liturgy they brought into being, the first Christians conceived of Paradise as a *locus aeternae beatitudinis*, a *habitaculum lucis et laetitiae*, a *locus pacis*, a *locus viridis* (a place of everlasting happiness, a dwelling of light and joy, a place of peace, a green and verdant place). Thus, in an early fresco in the Catacomb of Callixtus in Rome the so-called Five Saints are shown in attitudes of prayer in the midst of flowers and green fronds or, to borrow the words of the late-fifth-century poet Dracontius (*De Laudibus Dei*, III, 689), "*inter odoratos flores et amoena vireta*" (amid fragrant blossoms and lovely greenery). No wonder then that the meadow of Paradise, the *caeleste paradisi nemus*, is shown strewn and enlivened with white and red blossoms as here in San Vitale (see also plate 84) as well as in Sant'Apollinare Nuovo (plates 63–65), Sant'Apollinare in Classe (plates 101, 103–105), and elsewhere.

The two mosaics along the walls of the apse (see plate 72) portray Justinian and Theodora with their respective courts and constitute one of the highest manifestations not only of the mosaic art of Ravenna but also of Byzantine art as a whole. They are unequivocal evidence that by the sixth century the churches were no longer averse to celebrating the imperial secular power, a theme previously restricted to civil edifices.

Viewed from the nave, on the left we have the Emperor Justinian, on the right his consort, Theodora, both of them bearing gifts. This is the earliest scene of *oblatio Augusti et Augustae* known to us, the imperial couple being shown in the act of bringing gifts to the church of San Vitale on the occasion of its consecration. Their offerings are, respectively, a gold paten and a gold chalice, both studded with gems, and we know from the writings of Constantine Porphyrogenitus that it was the custom at the Byzantine court to give such liturgical vessels to the churches of Constantinople, especially at Easter. Nevertheless it should be kept in mind that these two mosaics are by no means realistic but, instead, are much more in the nature of emblems or ideal images. The fact is, Justinian and Theodora never themselves set foot in Ravenna and did not personally present their gifts to this church, built after the Byzantine conquest of the city. This does not, of course, rule out the likelihood that such offerings were actually made, but it was probably through the intermediary of the *praefectus praetorii* for all of Italy, their representative, whose seat was in Ravenna itself.

In the mosaic depicting Justinian, the emperor occupies the center as befits his rank, and with the nimbus behind his head—which is there to emphasize that he rules by divine right—he towers over the members of his retinue. They are lined up frontally and, as if in obedience to some predetermined rigid ritual, stand virtually immobile. Not only do they not step out by a hair's breadth from the post and position to which they have been assigned, but they seem not even to let their eyes stray to either side. Yet one has the impression that the slowly moving imperial cortège has just now come to rest and turned to face us, though only for the briefest instant since the horizontal disposition of their forearms suggests that from one moment to the next they

will resume their solemn march. The procession is led by the ecclesiastical dignitaries, at their head Archbishop Maximian, who is the only figure identified by an inscription, and he is followed by the emperor and the civil authorities and, to bring up the rear, the men-at-arms.

The broad areas of color used to render the sumptuous garments—which reveal nothing of living bodies beneath their heavy drapery—plus the abstract golden glow of the uniform background both contribute to transposing the procession into some intangible and spiritualized sphere almost wholly divorced from the vicissitudes of time and space, of the here and now, and this despite the fact that the face of the consecrating bishop is rendered with such marked realistic characterization as to achieve a high degree of expressive power.

On the opposite wall the ceremonial progress of Theodora is preceded, as protocol would have it, by two high functionaries, and she is followed by two court ladies and a bevy of maidens, some to the fore, some to the rear. Here the background is by no means as abstract as in the companion mosaic. To some extent at least there are distinct and well-defined spatial areas. At the left a tall door opens wide into the interior of the church to which the cortège is proceeding, and before the door stands a small fountain whose detailed ornamentation and spouting waters are clearly delineated. The empress herself stands well within an apse or niche under a half-shell vault.

Here again the individual figures, especially that of the empress towering above her ladies and maidens, are so tall, slender, and full of grace, and so aristocratic in bearing, that they almost give the impression of having transcended mere flesh and blood. Indeed, all told they are no more than rhythms of lines, a succession of cadences as in a musical score, and the sumptuous and iridescent color, for all that it is restricted to strident juxtapositions like gems of different kinds placed directly next to each other, succeeds nevertheless within its own chromatic range in transfiguring everything and in blending all of this quite elaborate image into a single magical harmony.

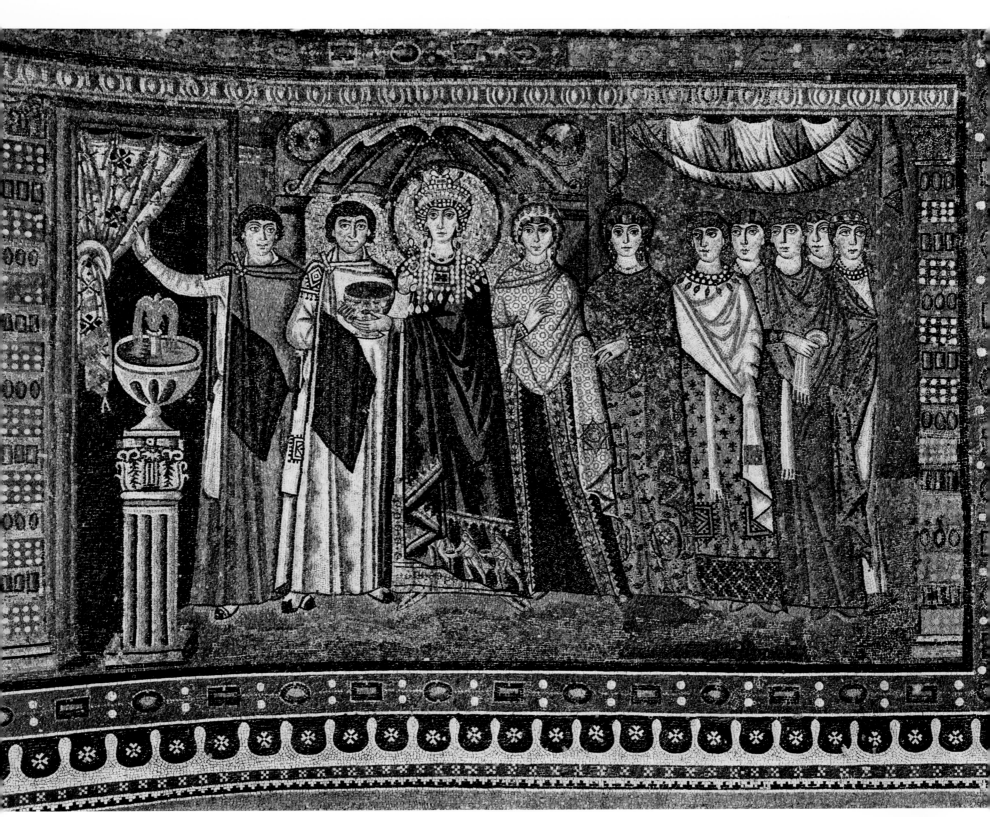

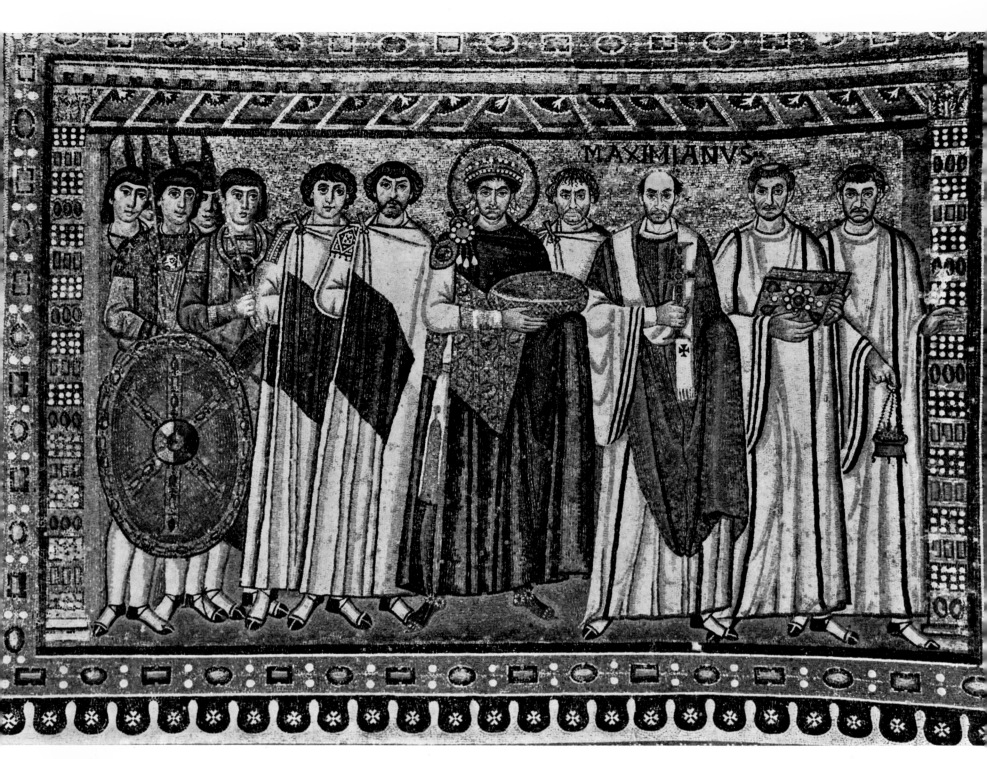

87

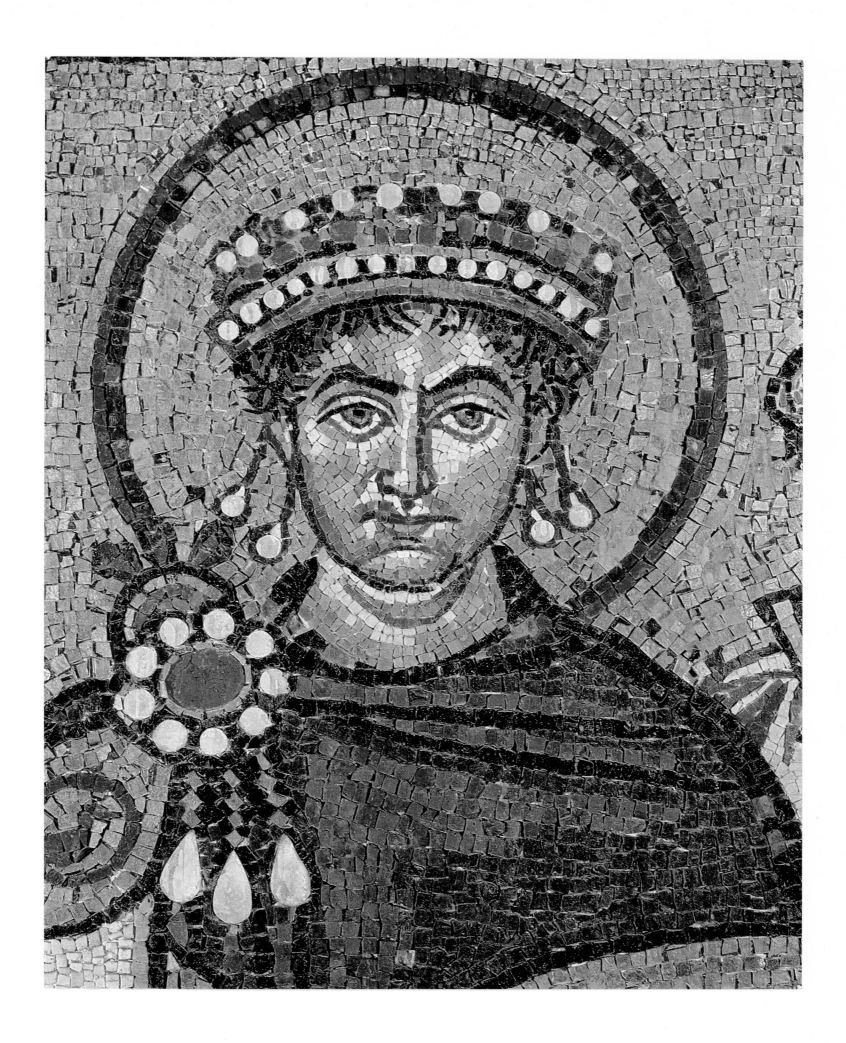

The attribute most commonly identifying an ecclesiastic as bishop was the pallium. Here, however, the pallium is not the usual long rectangular mantle worn by men and thrown loosely over the shoulders so that it falls freely in front. Instead it is a rather narrow band decorated with crosses worn around the neck and falling over the chest, an item of liturgical vestment derived from the *omophorion* of the Eastern Church. Writing in the first half of the fifth century, Saint Isidore of Pelusium interpreted the pallium as the symbol of the heavy burden that the bishop, as shepherd of a human flock (compare plate 103), must bear around his neck in imitation of the Good Shepherd, who carries on His shoulders the weak and infirm among His sheep.

Archbishop Maximian (the first among the bishops of Ravenna to use the title of archbishop) is further identified here by the bejeweled gold Latin cross in his right hand, the processional cross with which bishops bless their congregations.

90   *San Vitale. The imperial guard (detail)*

No official ceremony attended by the emperor could be complete
without his personal bodyguards, and so we find them bringing
up the rear of the procession of the emperor with his ecclesiastical
and civil dignitaries. They wear bright-colored parade uniforms,
have their hair long (in what we would call a page-boy bob),
and grasp long lances in their right hands; some also have a
neckband or ring, the *torques*, from which hangs a *bulla* (an oval
medallion). To give the impression that they are numerous, the
*pictor imaginarius* packed the figures closely together and lined
some up behind the others, even if nothing can be seen of those in
the rear ranks other than the crowns of their heads.

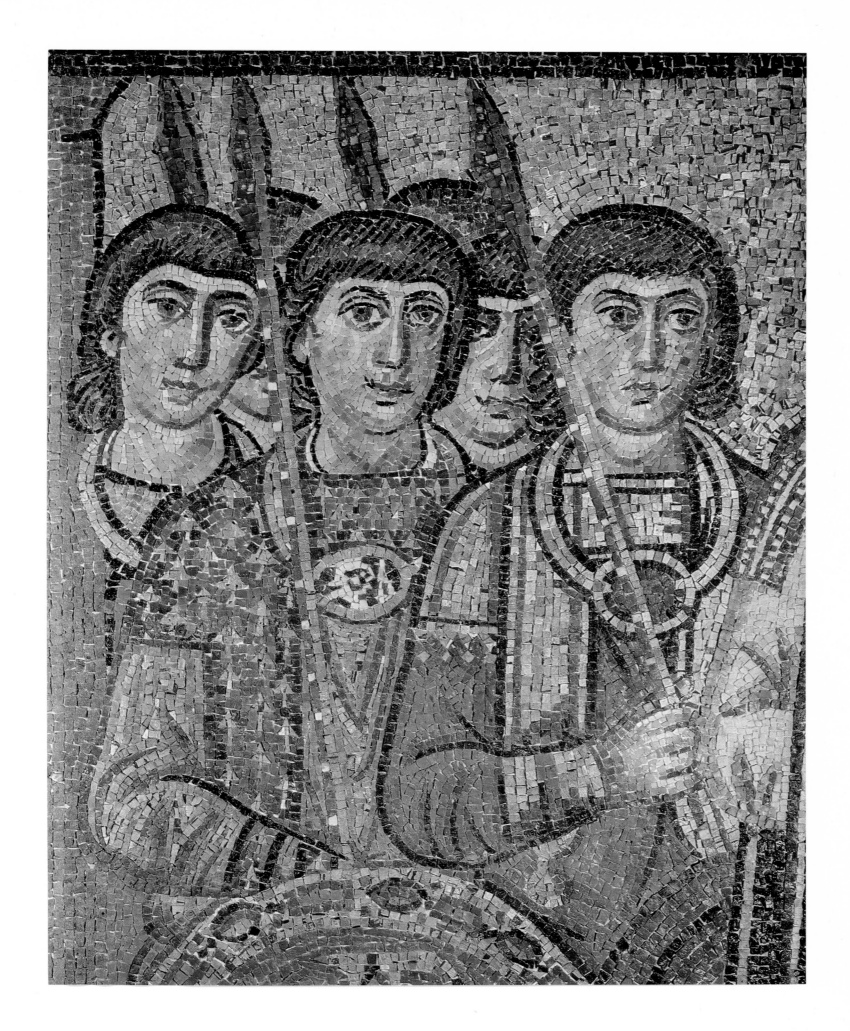

91 *San Vitale. The Empress Theodora (detail)*

The empress is dressed in the costume prescribed by court ceremonial for official events: a dark purple royal mantle (the chlamys) and crown. The crown is made up of a diadem formed by three strips of cloth studded with gems and precious stones and topped by a *lophos* (an aigrette likewise of precious stones), the whole resting on a kind of skullcap *(propóloma)* from which fall long strands of pearls *(praependúlia)*. Besides these the empress also wears pendant earrings and a flexible necklace of elliptical emeralds alternating with gold laminae. Around the shoulders and over the chest she has a broad band of cloth *(maniákion)*, a sign of dignity and authority which seems to derive from something worn in ancient Egypt or at Palmyra.

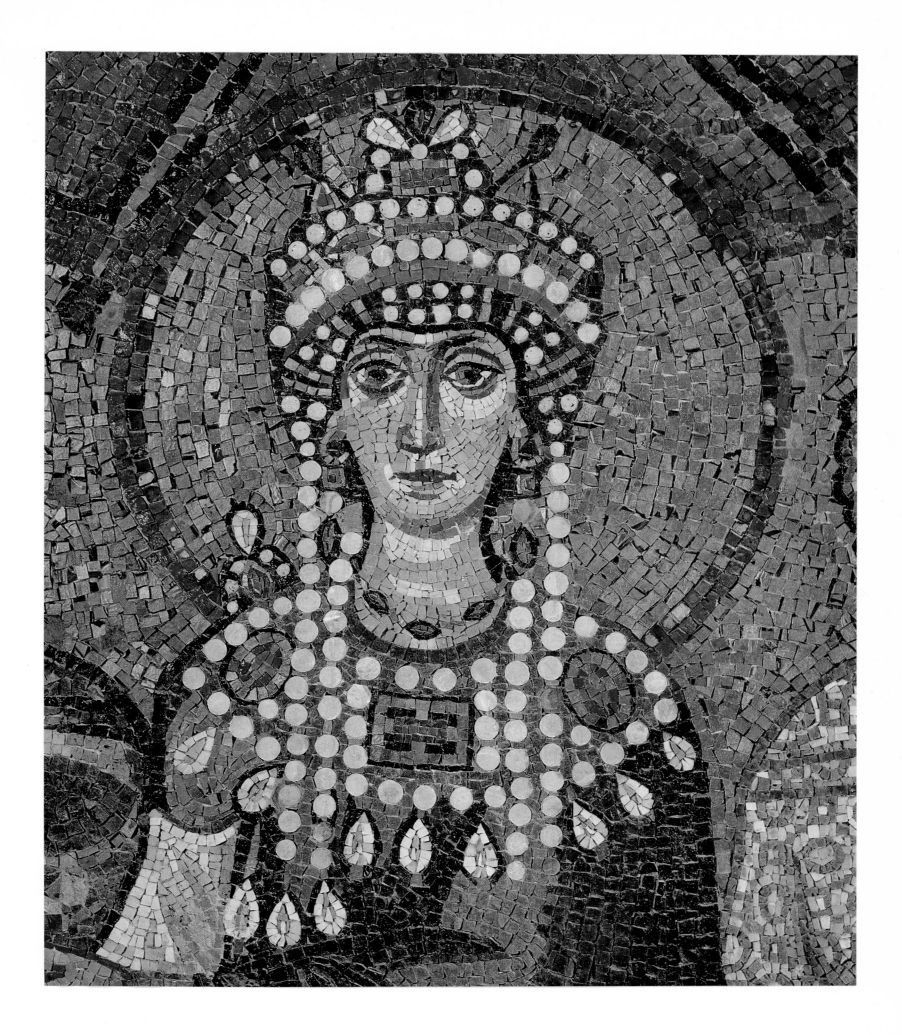

*92   San Vitale. Empress Theodora with the gold chalice (detail)*

Arms outstretched in an emphatic gesture, Theodora offers to the church a priceless gold chalice inlaid with gems. Like the paten held by Justinian (see plate 87) the chalice was one of the gifts of liturgical vessels that the sovereigns of Byzantium must have sent to the new church in Ravenna on the occasion of its consecration.

The custom of donating gold *calices* or *sciphi* to churches was already well established in Rome, and there are numerous references to gifts from Constantine the Great and from various popes in the *Liber pontificalis ecclesiae Romanae*, and in Ravenna there had been the example of Galla Placidia reported by Agnellus.

Almost always in Early Christian art the chalice is shown with two handles (as in plate 77). The one held by Theodora, however, is handleless, shaped like a plain large cup, and provided with a slightly conical foot.

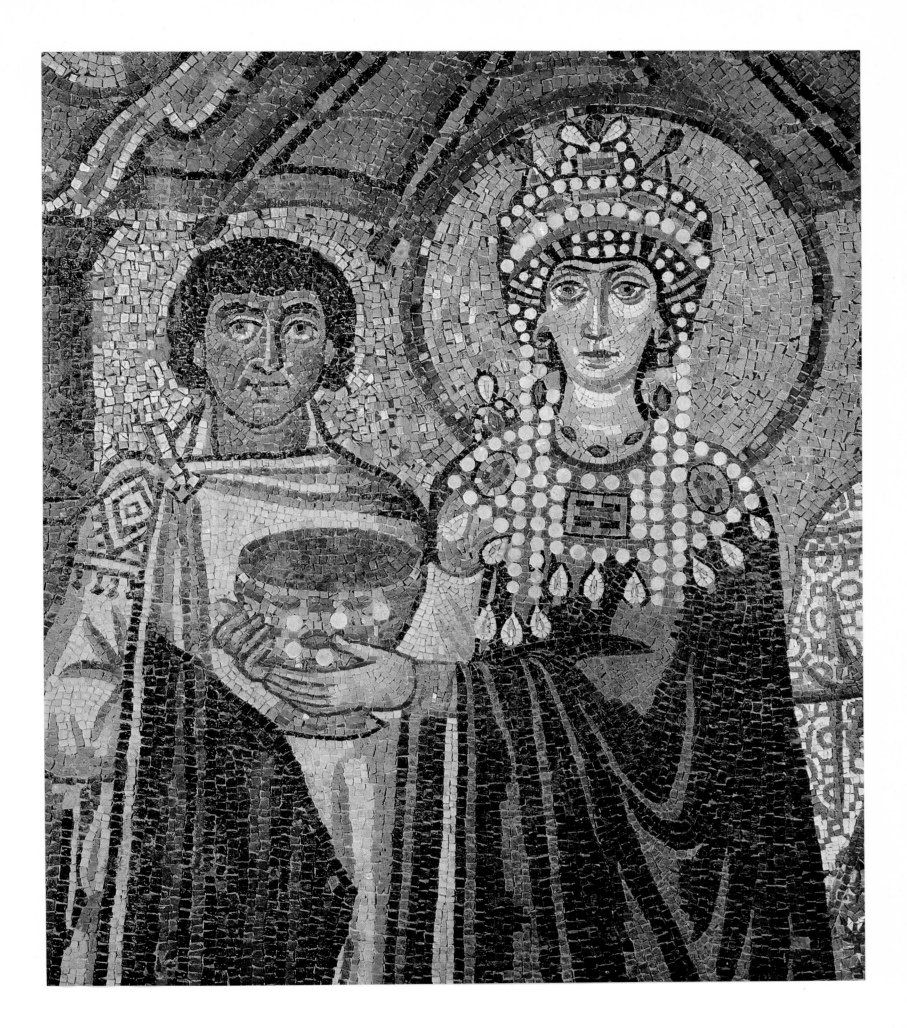

*93   San Vitale. The ladies of the court in the retinue of Theodora*

The slender and elegant women in attendance on the empress
wear splendid gowns which would seem to be of silk. There are
two groups of them. The first is composed of the two mature
women closest to the empress, and it is notable that their faces are
somewhat individualized and that, although they stand together,
some space is left between them. The second group includes the
five remaining women, all with uniform facial features and
lacking in any personal expression. They crowd together in a
compact group which, significantly, stands slightly apart from
that of the two chief ladies. All of them wear full-length cassock-
like tunics in differently patterned material over which are
draped ample shawls whose gorgeous richness and vivid coloring
nevertheless do not detract from the sumptuousness of the tunics
they cover.

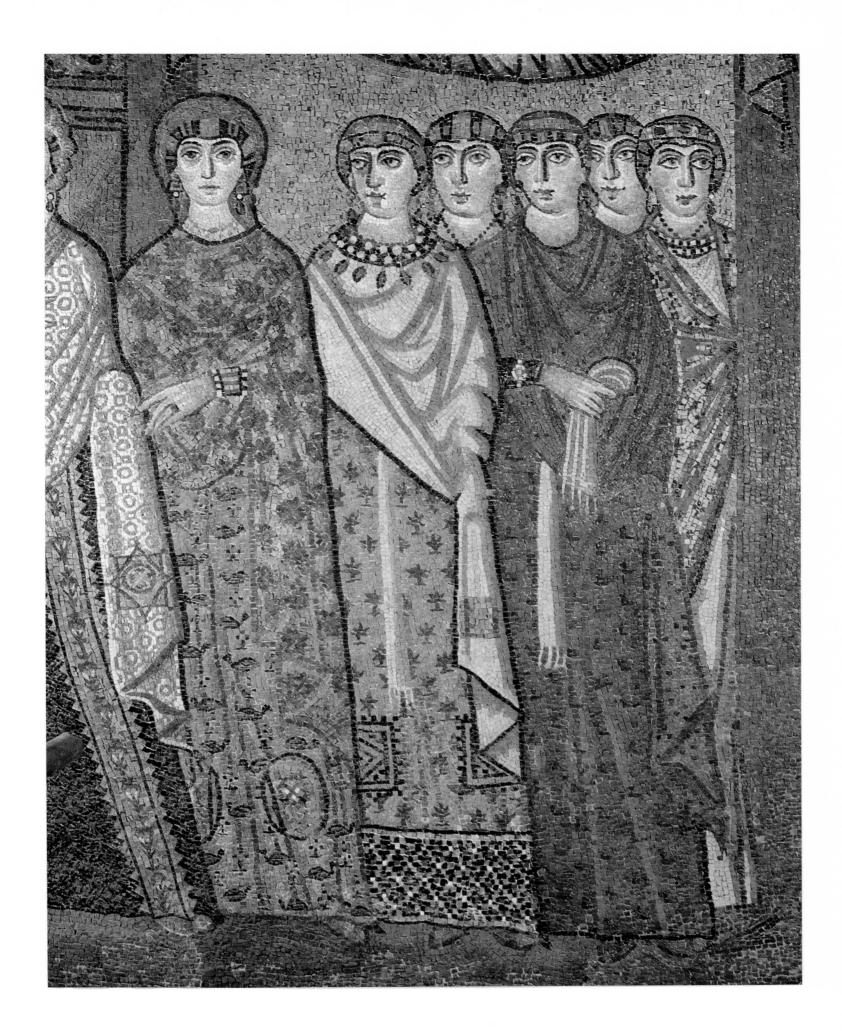

*94 San Vitale. Head of a court lady, the so-called Joannina, daughter of Belisarius*

The head of this young woman, the second to the right of Theodora (see plate 86) and thought to be the daughter of the Byzantine general Belisarius, stands out against a partly green and partly gold background.

Gold and silver tesserae were not produced in the same manner as the enamels (see page 102). The gold or silver was not amalgamated with the vitreous paste but instead applied directly to sheets of the paste (called "pizzas" by Italian mosaic workmen today!) in extremely thin leaves which in turn were protected by a fine film of glass, usually colorless. Then the vitreous paste was fused by heat to the other components and flattened down, then returned to the oven and finally removed and allowed to cool, after which it could be cut into tesserae.

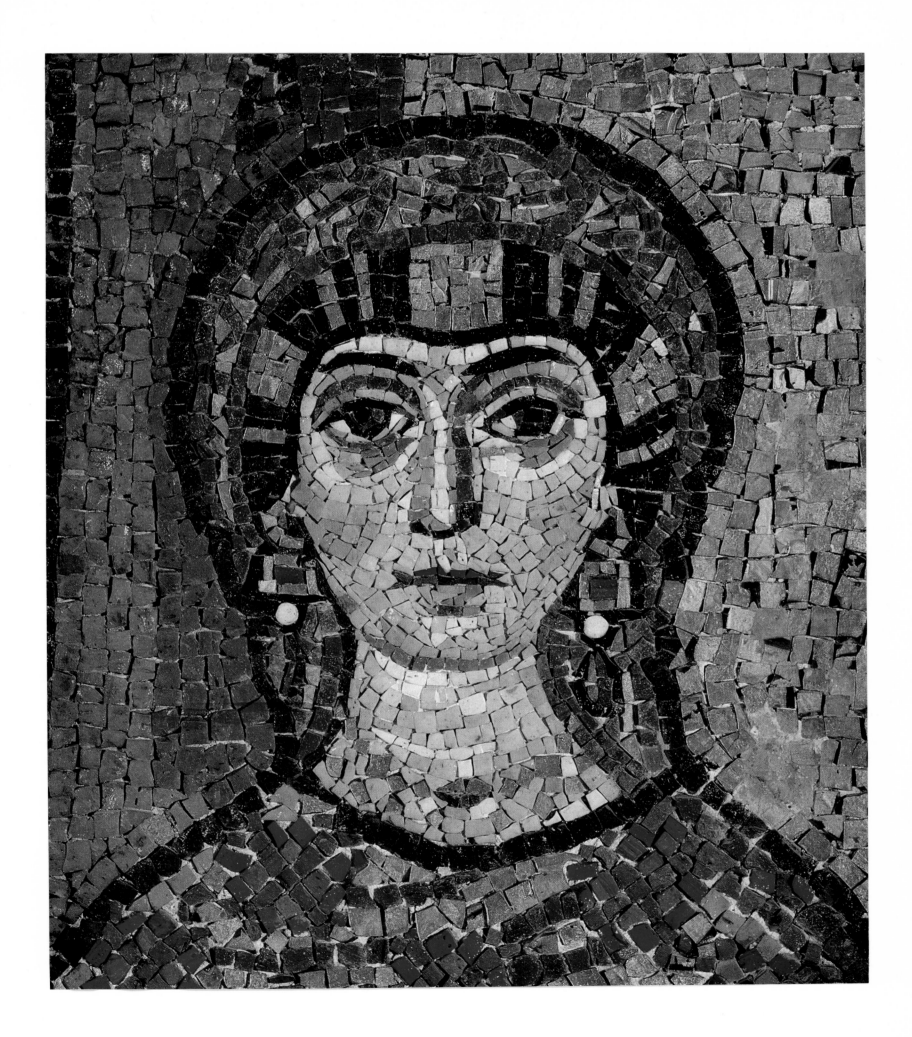

*95  San Vitale. Hand of the so-called Joannina*

The young woman presumed to be Joannina wears a luxurious shawl of gold cloth embroidered with stylized flowers in red and green. It completely swathes the upper part of her body, so that all one sees of her tunic there is the high cuff adorned with gems from which emerges her long, slender, aristocratic hand displaying a single plain ring set with a rectangular emerald.

The aristocratic woman immediately alongside the empress
likewise wears a splendid shawl, and its decorative pattern
resembles that which we saw on the chlamys of Saint Vitalis
(plate 81). She too seems to have her own individuality, and
although her features are finer they are much like those of the
considerably younger woman at her left. Their resemblance and
the difference in their ages have led some writers to think that
they might be mother and daughter, possibly Antonina and
Joannina, the wife and the daughter of Belisarius, the general who
conquered Ravenna in 540 in the name of Justinian. While this is at
best a hypothesis, it cannot be ruled out, the more so since
Procopius of Caesarea described the two women as intimates of
Theodora.

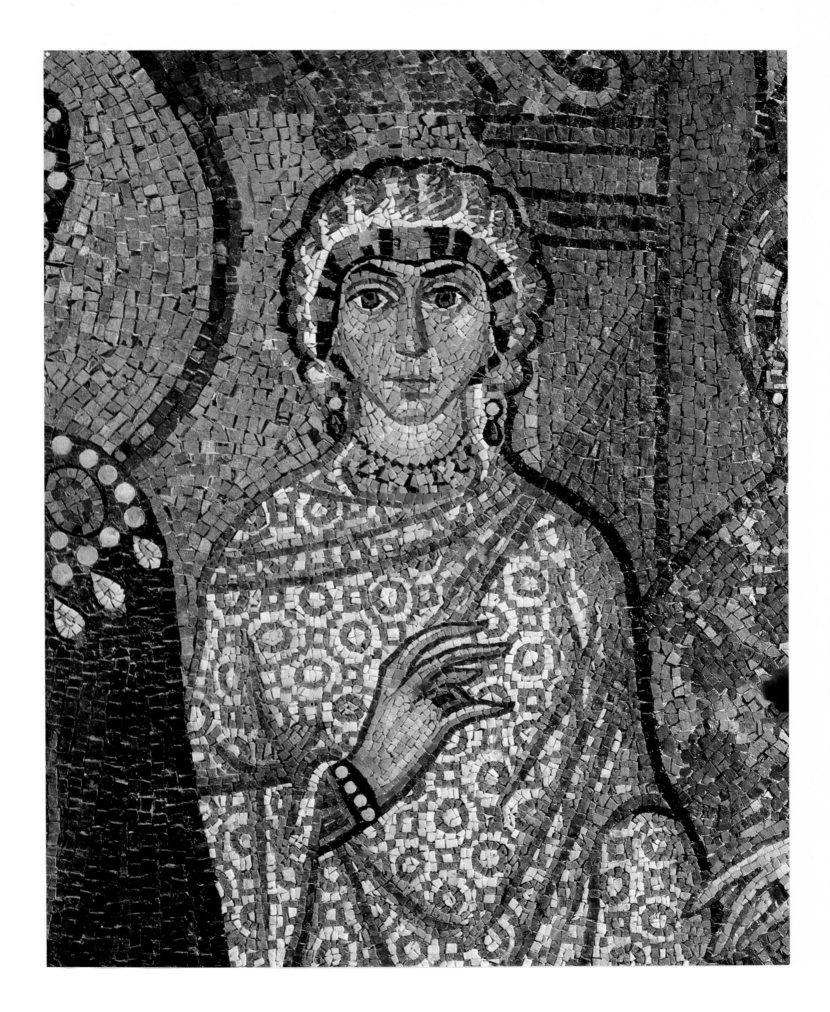

97 *San Vitale. Two women in the retinue of Theodora (detail)*

Wearing garments of much the same type—shawl and tunic—but of different colors, the other women escorting the empress form a dense group which makes the stereotyped lack of individuality in their faces so much the more noticeable. What distinguishes them one from the other is chiefly their ornaments, in particular their necklaces. The foremost of these two women wears quite an elaborate one made up of a band with two rows of pearls of different sizes and, pendant from it, drops of precious stones of remarkable colors tending to periwinkle and turquoise. Much simpler but no less elegant, the necklace of her neighbor is a simple chain of small dark rhomboids.

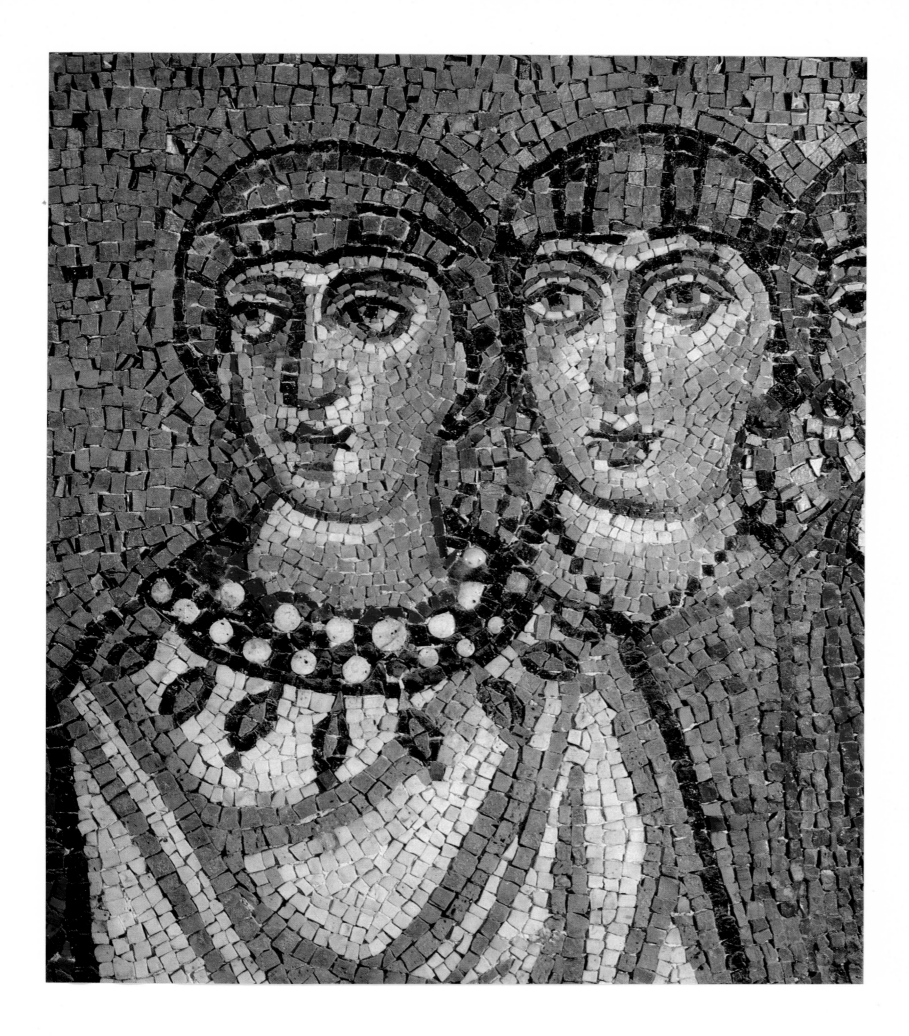

*98   San Vitale. Hand of a woman in the retinue of Theodora*

The court lady wearing a bright orange-red shawl embroidered with small green squares is the only one to hold something in her hand, a kind of fringed white handkerchief known as a *mappula*. From under her shawl falls a white scarf or band, also with fringed ends, something worn also by the woman to her right (see plate 93). She is, furthermore, the only woman to wear anything on her wrist, a gold bracelet slipped on over the cuff of her tunic.

*Sant'Apollinare in Classe. View from the front*

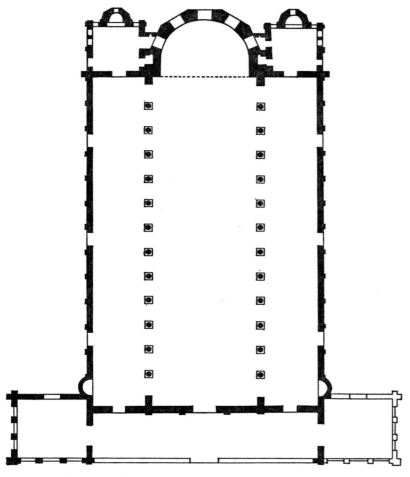

*Sant'Apollinare in Classe. Ground plan (after De Angelis d'Ossat)*

## 11   Sant'Apollinare in Classe

*second quarter of the sixth century*

In Classe, the ancient Classis, the only one of all the many buildings of the fifth and sixth centuries to survive is the imposing, solemn basilica of Sant'Apollinare known as "in Classe" to distinguish it from the like-named church in Ravenna proper. From earliest imperial times on, Classe was a suburb of Ravenna and its chief outlet to the sea, the port being capable of receiving no fewer than 250 ships at one time according to Dion Cassius. Together with a fleet based at Misenum on the Tyrrhenian Sea, the formidable fleet *(classis)* at Classe was charged with the surveillance and defense of the sea lanes of the Empire both near to home and far abroad.

There was a time when the sea came close to the basilica, but with the centuries the port silted up and the shoreline retreated so that now the church rises, a solitary monument, in the countryside some three miles southeast of Ravenna. Behind it stretch the vast dark green pine woods whose praises were sung by Dante and Byron.

It was precisely in the *oppidum Classis*, among the heterogeneous population of soldiers, workers, shipwrights, merchants, and all the hangers-on of a great port, that Saint Apollinaris, a native of distant Antioch, first preached the word of Christ and soon also won over the nearby Ravenna and the cities of the Roman province of Aemilia. However, despite the legendary *Passio Sancti Apollinaris*, the conversion did not take place in apostolic times, that is, within the first century of our era, but in all likelihood as late as around the close of the third century.

We know that Apollinaris was the first bishop of the city and was interred in an *arca saxea* (a stone sarcophagus) in one of the local burial grounds. It was alongside that tomb that a grandiose basilica was erected in his honor during the second quarter of the sixth century. The work was initiated by Bishop Ursicinus, but neither in his brief episcopate, the four years between 532 and 536, nor in that of his successor, Victor, was it brought to completion. It fell to the same Archbishop Maximian who had consecrated San Vitale about a year earlier to dedicate the new basilica on the ninth of May, 549. The dedicatory epigraph, lost but recorded by Agnellus, is our source for this information. Not only did it name as the founder of the church Bishop Ursicinus (who is portrayed in a mosaic between the windows in the apse) and as *episcopus consecrator* Archbishop Maximian, but it also identified Julianus Argentarius as the *aedificator* and *ornator*. The latter fact explains why here again we have bricks of a particular format and color which are the hallmark of all of his constructions.

It is not only its imposing dimensions that distinguish this grandiose temple but also the harmoniousness of its classical basilica design. Originally it was preceded by a *quadriporticus*,

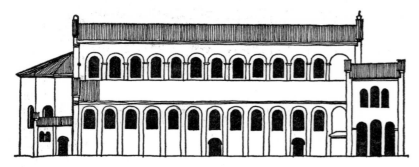

*Sant'Apollinare in Classe. Drawing of the north side (after De Angelis d'Ossat)*

vestiges of which were unearthed in the nineteenth century. The east side of that atrium comprised the present portico (now almost entirely a modern reconstruction) set directly against the church front and flanked by two two-storied structures (only the one on the north side survives). We have no idea what the function of those two tower-like structures may have been, but on the basis of their position they would seem to have something in common in their design with certain religious edifices in Syria.

The upper part of the front elevation is flanked by flat pilasters and still has in its center the lovely original triformed window which not only admits light but also serves to make the broad flat expanse of red brick across the front seem less massive. The outer walls—those of the upper part of the nave as well as those of the two side aisles, which are considerably lower—are pierced by a close succession of tall windows each of which is recessed on the exterior in a blind arch of the same shape, each arch set in slightly from the plane of the flat wall. This continuous rhythmic

scansion lends life and movement to the architectonic bulk of the building.

The exterior of the apse has rather more movement and articulation of its volumes. It is a fairly high and clearly defined seven-sided structure flanked by two rectangular service annexes of the type we have seen elsewhere and which in their turn each end in small five-sided minor apses.

Somewhat detached from the north side of the basilica, the sturdy bell tower rises to a height of 123 feet. It has the characteristic cylindrical form, and its tiers of windows are given particular grace and elegance by the small marble colonnettes which mark off the different number of lights in the openings from story to story. Clearly a more recent construction, the campanile would appear to date only from the end of the tenth century.

The broad and solemn interior (182 feet by 99 feet) is impressive above all for the breadth of its nave (it measures exactly twice the width of the two side aisles) and for the abundant light that pours in through the very numerous windows, fifty-six in all, opened not only in the apse and the walls of the high nave but also—and this is far less usual—in the walls of the much lower side aisles. Thus light itself becomes the true protagonist of the interior architecture because, as De Angelis d'Ossat has pointed out, by eliminating or at least attenuating shadows it renders the architectonic elements more limpid and unsubstantial. Today the light is no longer mirrored by the marble which once covered the side walls (long since removed and taken elsewhere), but nonetheless it still accentuates the rhythmic cadence of the columns, plays within the embroidery-like butterfly-winged leaves of the elaborately elegant capitals, and, above all, illuminates the vivid resplendent colors of the mosaics that stretch across the entire chancel arch and the hollow of the apse.

*99   Sant'Apollinare in Classe. Interior. Second quarter of the sixth century*   ▷

*100   Sant'Apollinare in Classe. Interior viewed from the south lateral aisle*   ▷ ▷

*101   Sant'Apollinare in Classe. The mosaics of the chancel arch and apse. Fifth decade of the sixth century*   ▷ ▷ ▷

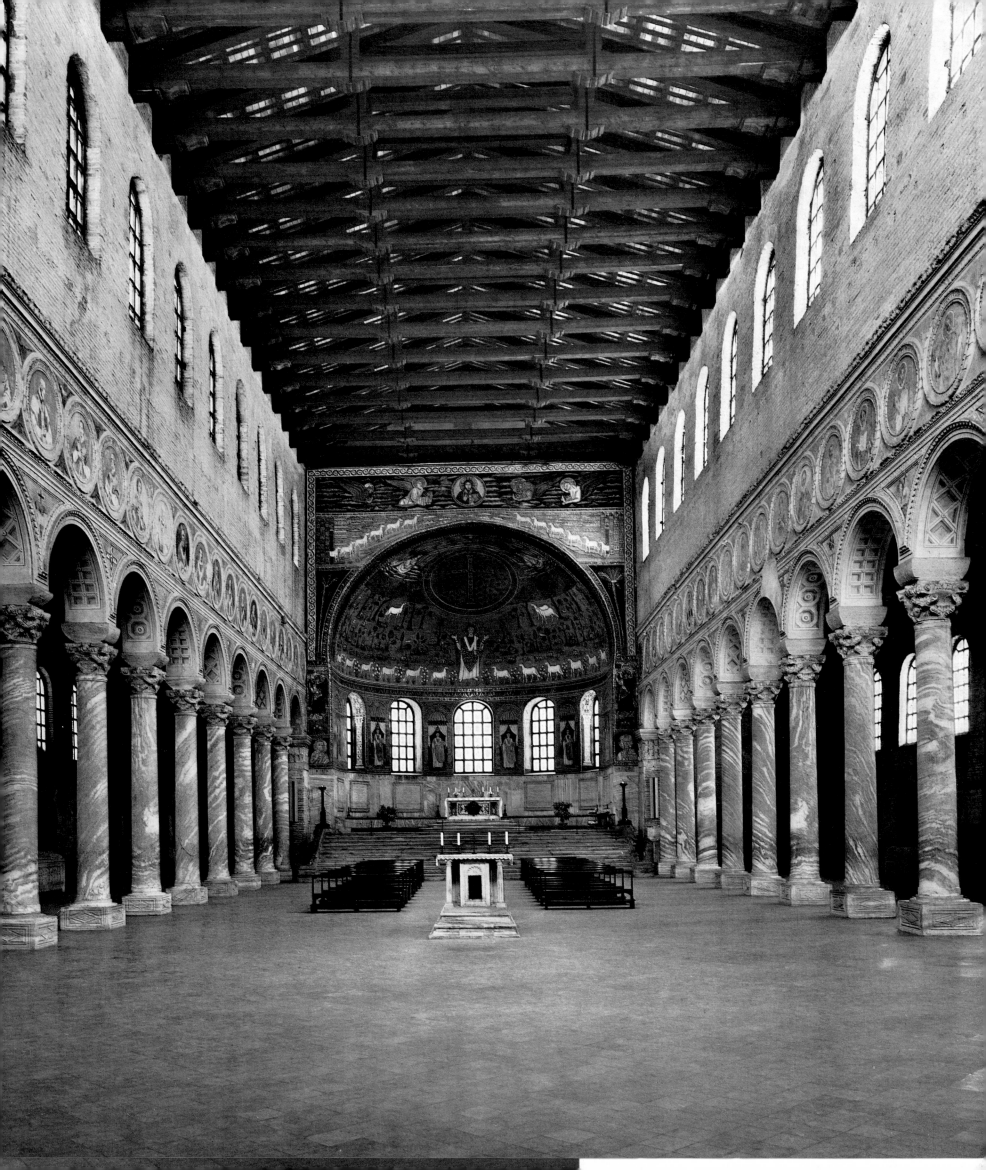

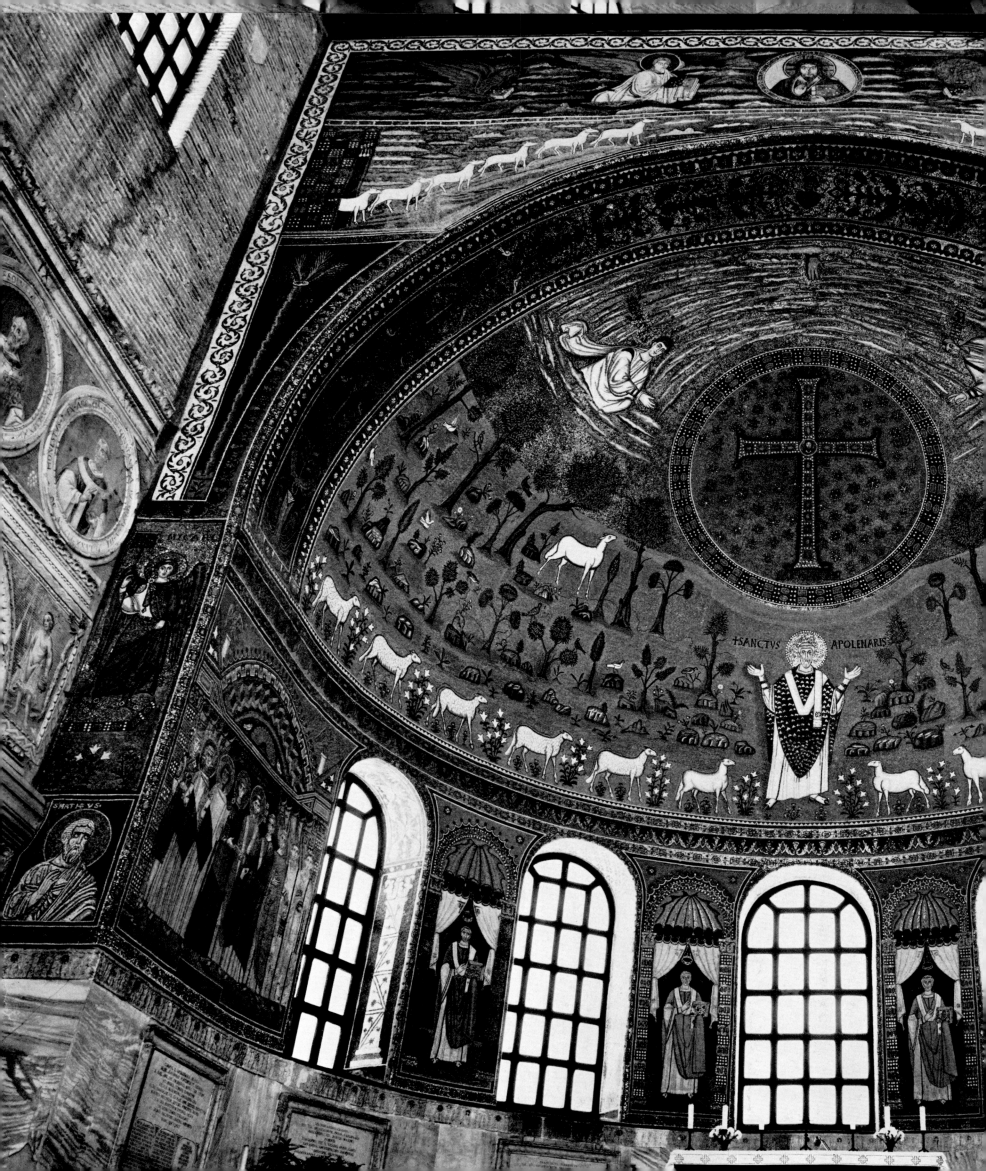

+SANCTVS APOLENARIS

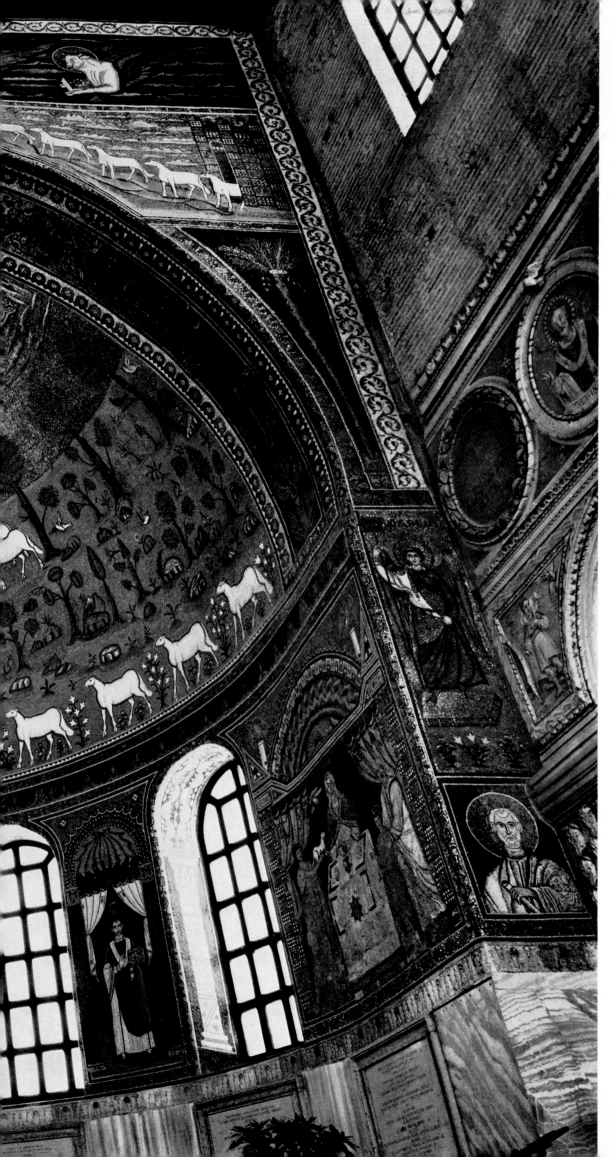

101

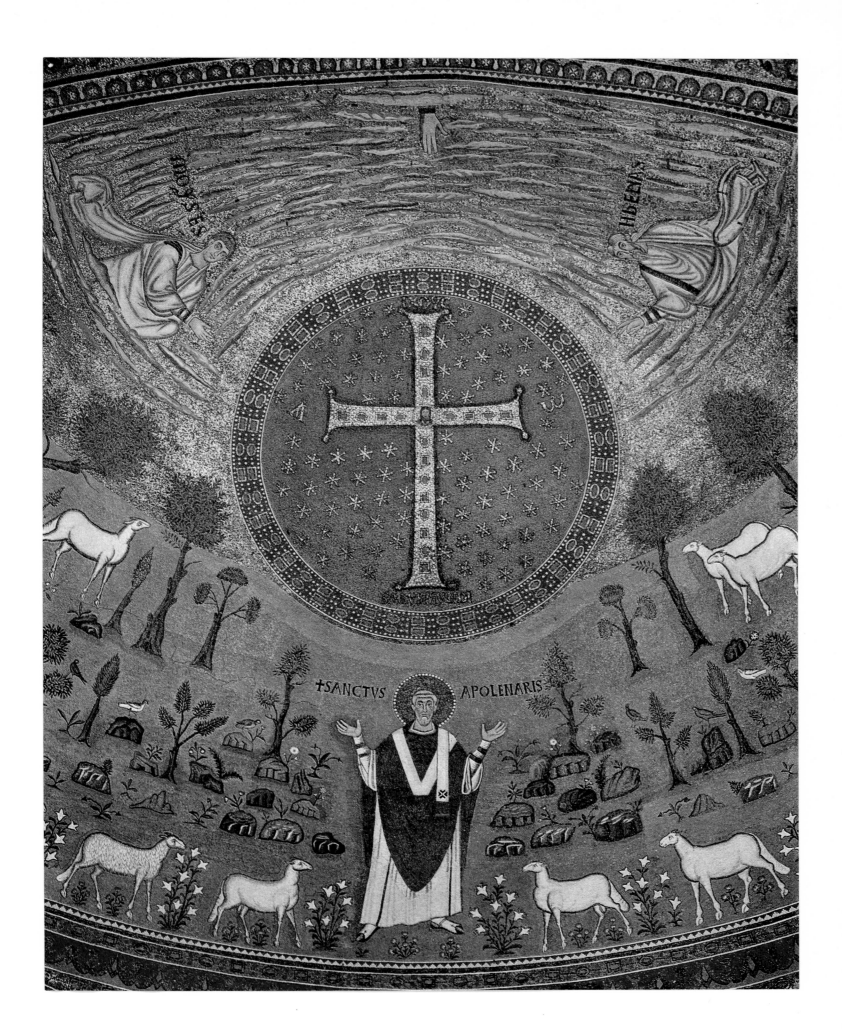

◁◁ *102   Sant' Apollinare in Classe. The colonnade between the
north lateral aisle and the nave. Second quarter of the sixth century*

All of the marble columns in the basilica were brought from the
East. The marble itself is rather unusual, its veining running
horizontally rather than vertically. Even the bases of the columns
are anything but conventional with their excessive height, their
rectangular forms set right on the floor, and the decorations of
lozenges within geometrical framings.

◁   *103   Sant' Apollinare in Classe. The saint and the cross (detail of
the apse mosaic). Fifth decade of the sixth century*

In terms of composition the mosaic in the vault of the apse is
clearly divided into two zones. The upper one is dominated by a
gem-studded gold cross within a great disk likewise gleaming
with gems and stars. Above it the hand of God reaches down;
to either side Moses and Elijah appear in the clouds; on the earth
below there are three sheep. The allusion to the Transfiguration of
Christ in the garden of Gethsemane is evident. The lower zone
centers on a large, solemn, and hieratical figure of Saint Apollinaris
at prayer in a landscape.

*104   Sant' Apollinare in Classe. The garden of Paradise (detail of   ▷
the apse mosaic)*

The vault mosaic represents the Transfiguration of Christ, but
the scene is not rendered realistically as it is, for instance, in the
mosaics of the monastery church of Saint Catherine on Mount
Sinai. Instead, the approach is abstract in part at least, with the
Savior present not in human form but symbolically in the guise of
a great gemmed cross. Although Moses and Elijah appear as real
men emerging from a polychrome sea of clouds in the upper
part of the mosaic, the apostles who were present in the flesh at the
Transfiguration—Peter, James, and John—are likewise shown
in symbolic form, as three lambs gazing up at the all-dominant
cross, one at the left of the great disk, the other two at the right
(see plate 105).

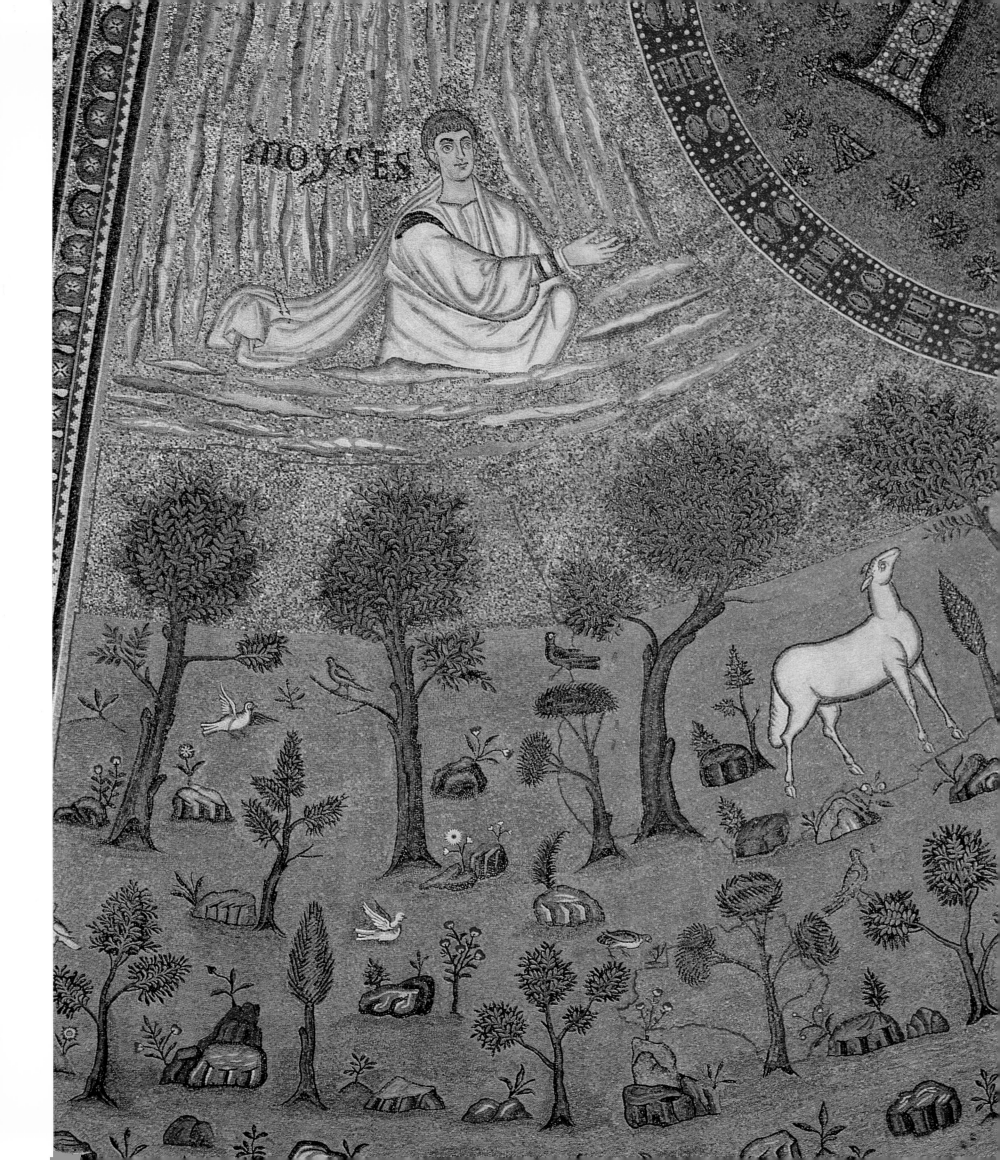

*105 Sant'Apollinare in Classe. The garden of Paradise (detail of the apse mosaic)*

The landscape spreads out open and airy. Its verdant meadow has a lyrical rhythm set by the repetition of stylized rocks, bushes, flowers, birds, plants, and trees, conspicuous among the latter being the pines which are still the characteristic feature of the Ravenna coast. The artist, whoever he may have been, portrayed all this felicitously with a highly refined range of greens and with such naive freshness and natural spontaneity that one feels he has really caught the charm of a quiet morning already touched by the sun. Nature here becomes the very image of felicity, and one senses, almost without thinking, that these must be the gardens of Paradise, the Elysian Fields, where pure white lambs parade in orderly fashion. Rather than alluding to the apostles here, the lambs strike us as representing the faithful as a whole, especially because they gather around their spiritual shepherd, the first bishop of Ravenna, Saint Apollinaris.

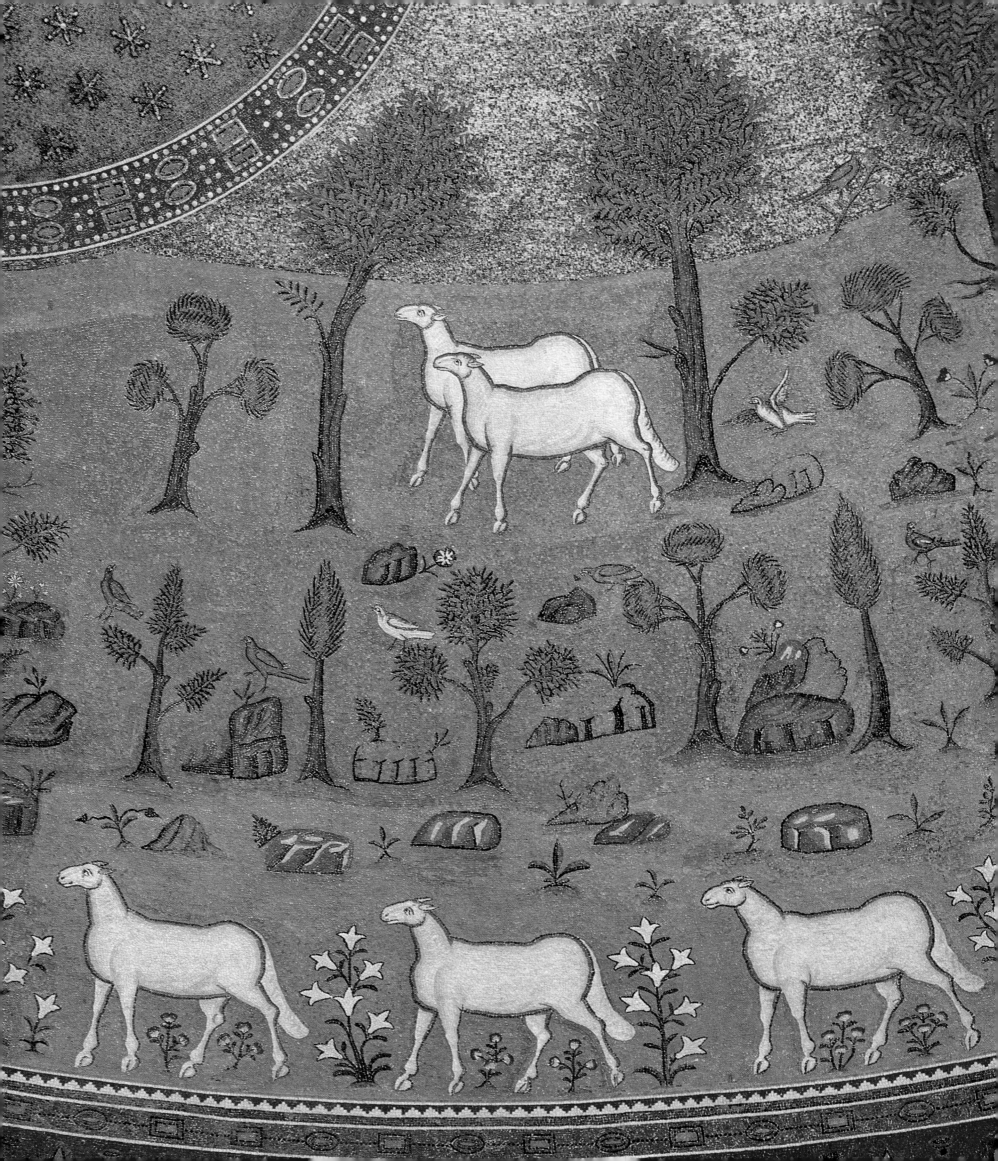

# 12   Sarcophagi

These pages have shown what remarkable contributions Early Christian and Byzantine Ravenna made to architecture in the ingeniously varied forms of its churches, baptisteries, and mausoleums, and the art of its mosaics has been long and justly famed. But there were other arts, most notably sculpture, which may not have reached such heights in this Byzantine capital of the West but nonetheless had their own particular idiom and expression quite independent of anything being produced in Rome at the time. This is especially evident in the sarcophagi, in the forms they assumed, their iconography, and their stylistic and formal characteristics.

As concerns their form, the sarcophagi of Ravenna were most often sculpted on all four sides rather than only on the front and short ends as they were throughout the Roman world up to the end of the fourth or the beginning of the fifth century. This means that normally the burial chest was not inserted into a niche, an *arcosolium*, or placed directly against a wall but, instead, sat isolated in the center of an area either roofed over or open to the elements and, in consequence, was visible on all sides.

Further, compared with those of Rome the sarcophagi of Ravenna tended to be more monumental. This was accentuated even more by the fact that their coffers were not covered by simple lids with more or less elaborately sculptured ridges along their fronts but, instead, were weighed down under heavy covers either sloping to front and rear like peaked roofs and having projecting acroteria at the corners or else shaped like high half-cylinders such as one still finds on old storage trunks (see plates 106–108, 114, 115).

For their iconography Roman sarcophagi depended almost exclusively on the rich diversity of episodes in the Old and New Testaments, often alternating scenes from the two sources. Generally, however, the earlier Ravenna coffers preferred scenes of theophanic character, those in which the divine presence was manifested directly. This meant as a rule either the *Traditio legis*, in which the Law is consigned to the apostles (plates 108–110), or the *Maiestas Domini*, where Christ is enthroned in majesty (plate 107). At a later period, though, the preference went to specifically symbolic motifs such as the cross, the monogram of Christ, sheep, deer, peacocks, palms, grapevines, and the like (plates 114–16).

A special characteristic of Ravenna sarcophagi was the presentation of scenes or symbols one right next to the other without any break, thereby creating an uninterrupted progression which makes the composition appear to be a continuous frieze. Against that impression, however, is the fact that the background may consist of no more than a series of aedicules often vaulted by a shell (as in plates 106, 111, 113) or else be perfectly plain and smooth, the result of both of these being that each figure or symbol seems to stand out in and for itself, with no reciprocal relationships and as if divorced from any definable spatial entity (plates 108, 110). This is rather like what one finds in the mosaics of a later time whose uniform gold backgrounds relegate the composition to a plane beyond space and time and reality where only transcendental and metaphysical values matter.

The figures are never numerous or shown in groups. They have a calculated elegance of pose and treatment of drapery and at times reveal the influence of Antique sculpture in the way they are made to stand out in high relief and, through the use of graduated planes, to take on almost a pictorial coloring.

It was particularly in the last decades of the fourth century that sculpture began to develop in earnest in Ravenna, and it flourished there throughout the fifth century and remained vital still during the first decades of the sixth. While this was a period in which sculpture on sarcophagi was in decline or even moribund in Rome, Ravenna was able to develop a style of its own out of the example of Byzantium. This is plain to see in the close analogies between the reliefs on the Ravenna sarcophagi and those on the base of the Obelisk of Theodosius in Istanbul, the so-called Sarcophagus of a Prince, the fragment of a sarcophagus from Psamatia (now in Berlin), or the marble fonts unearthed not long ago in the brickwork sepulchers at Topkapi and in a district in present-day Istanbul, which in ancient times was still within the walls erected by Theodosius II.

From the middle of the fifth century on, sculpture in Ravenna tended more and more to resolve into purely musical cadences, skillful caesuras between full and empty areas, and carefully balanced symmetries between the various symbolic elements that became its principal thematic material. Before then, however, it had utilized figures of Christ, the apostles, and other Biblical personages. At first, as for example in the sarcophagi now in the church of San Francesco, the figures were kept somewhat apart from each other (plate 111) although not without a certain bond and interconnection, however slight. Faces were organically structured and revealed an intimate human rapport (plate 112) and a classical serenity (plate 113).

Later, however—and the evidence for this is, in particular, the so-called Sarcophagus of Saint Barbatianus in the cathedral of Ravenna (plate 107)—the figures became rigidly static and immobile and the faces no longer conveyed that subtle, tremulous vibration of living humans that, in art, gives rise to a truly lyrical expressiveness. Instead there is a deliberate austerity, and this is the sign that the expressiveness has been turned inward. The eyes no longer give out a true spark of life but only a fixed, penetrating concentration on a world of extreme spiritual sensibility, a world beyond time, where man's chief activity would seem to be the contemplation of the divine beatitude.

Behind this new artistic language—ineluctable sign of an age in travail—one senses a profound change in thought and spirituality. The transition between Late Antiquity and the Middle Ages is already well under way.

on the following pages:

*106   The Sarcophagus of Rinaldo Concoreggio. Second quarter of the fifth century. Cathedral*

The urn takes its name from the fact that it was used again in 1321 for the remains of the archbishop of Ravenna who died in that year.

*107   The Sarcophagus of Saint Barbatianus. Around the middle of the fifth century. Cathedral*

Saint Barbatianus lived in the first half of the fifth century and was counselor and confessor to Galla Placidia in Ravenna.

*108   The Sarcophagus of the Twelve Apostles. Second quarter of the fifth century. Sant'Apollinare in Classe*

This sarcophagus has the characteristic semicylindrical lid decorated with monograms of Christ. The entire group of the apostles is depicted together with Christ on the front and the narrow sides.

*109   The Sarcophagus of the Twelve Apostles (detail). Sant'Apollinare in Classe*

These are two of the three apostles who occupy the left side of the coffer.

*110   The Sarcophagus of Peter the Sinner (Pietro Peccatore). Detail. Beginning of the fifth century. Santa Maria in Porto Fuori*

Here we have a representation of the *Traditio legis*, the consignment of the Law to Paul by Christ. This sarcophagus was used again in the twelfth century for the remains of Pietro degli Onesti, who, in Dante's *Paradiso* (XXI, 122–23), is identified with this very church: "And I, Peter the Sinner, was in the house of Our Lady on the Adriatic shore."

*111   Christ enthroned, from the middle niche of a sarcophagus in the left side aisle in San Francesco. End of the fourth century*

*112   Head of an apostle, from the left side of the Sarcophagus of Liberius, now used as the main altar in San Francesco. End of the fourth century*

*113   Apostle (detail), from the left side of the Sarcophagus of Liberius*

*114   The Sarcophagus of Theodore. Third quarter of the fifth century. Sant'Apollinare in Classe*

This urn of two centuries earlier was utilized again in the seventh century for Bishop Theodore.

*115   Sarcophagus of the Lambs. Beginning of the sixth century. Sant'Apollinare in Classe*

*116   Niche on the back of a sarcophagus. First decades of the sixth century. Sant'Apollinare in Classe*

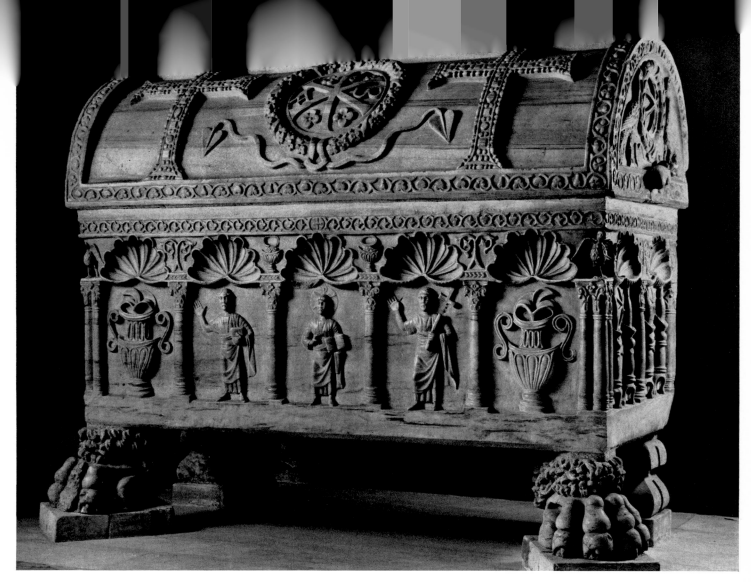

106

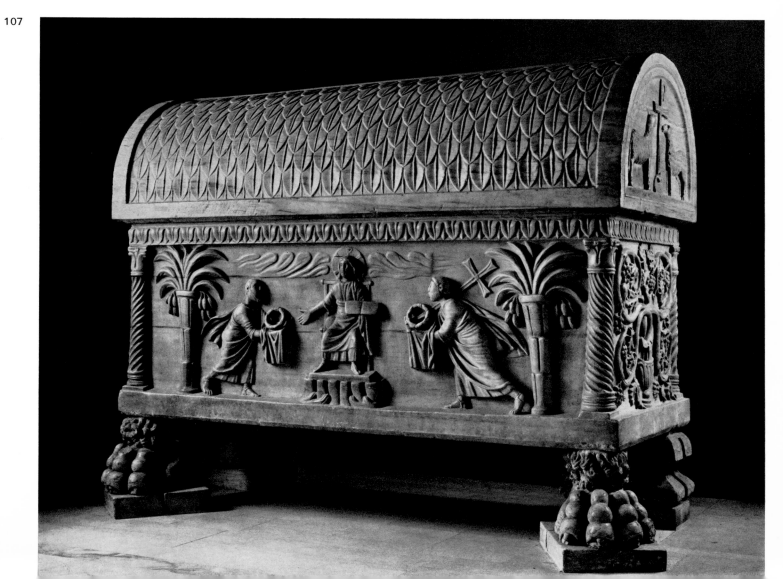

107

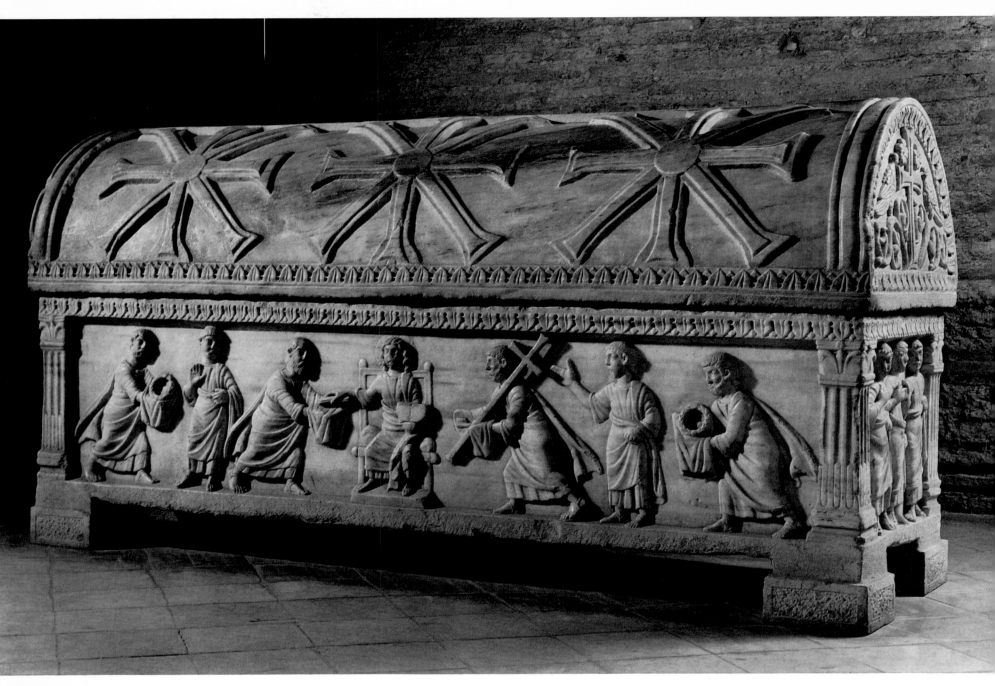

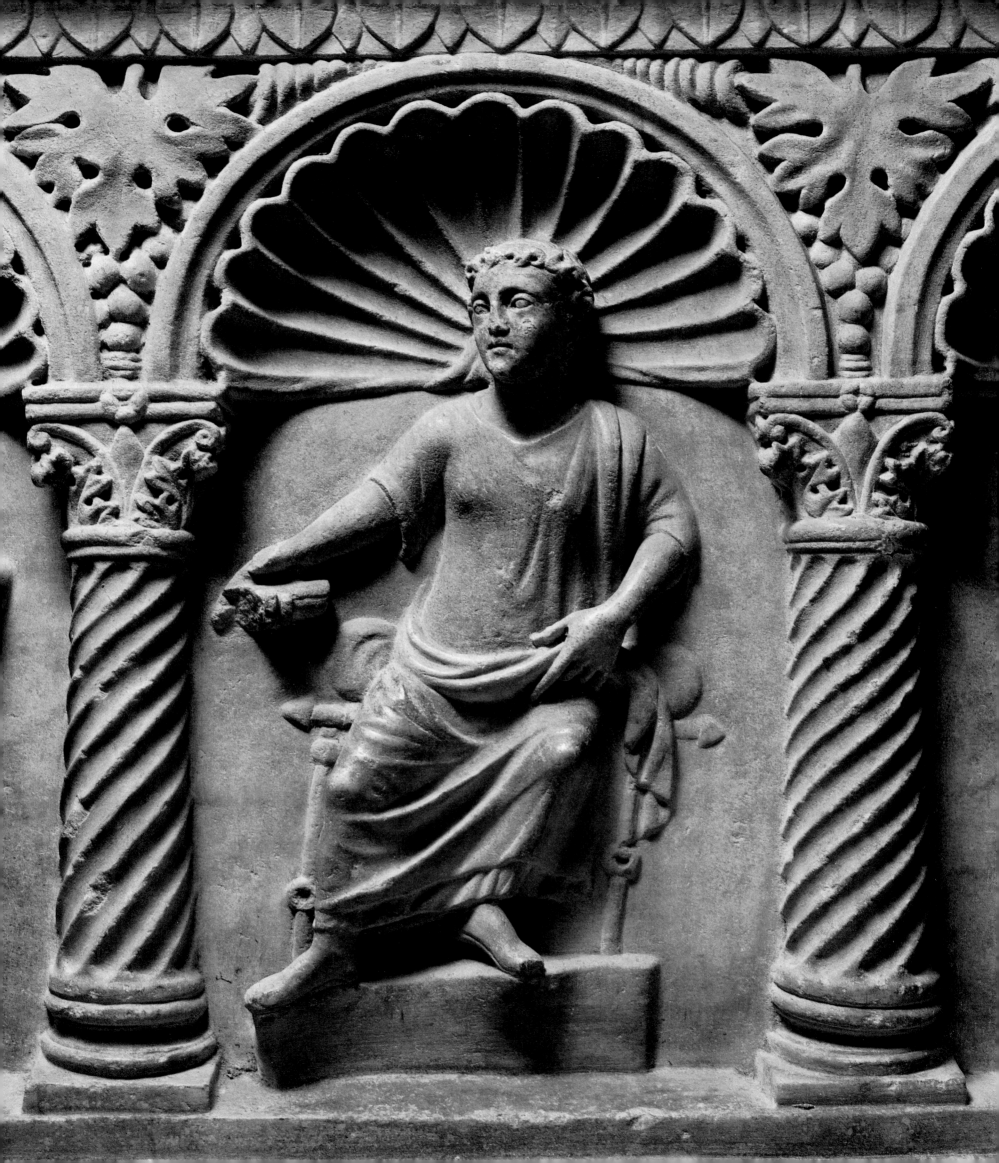

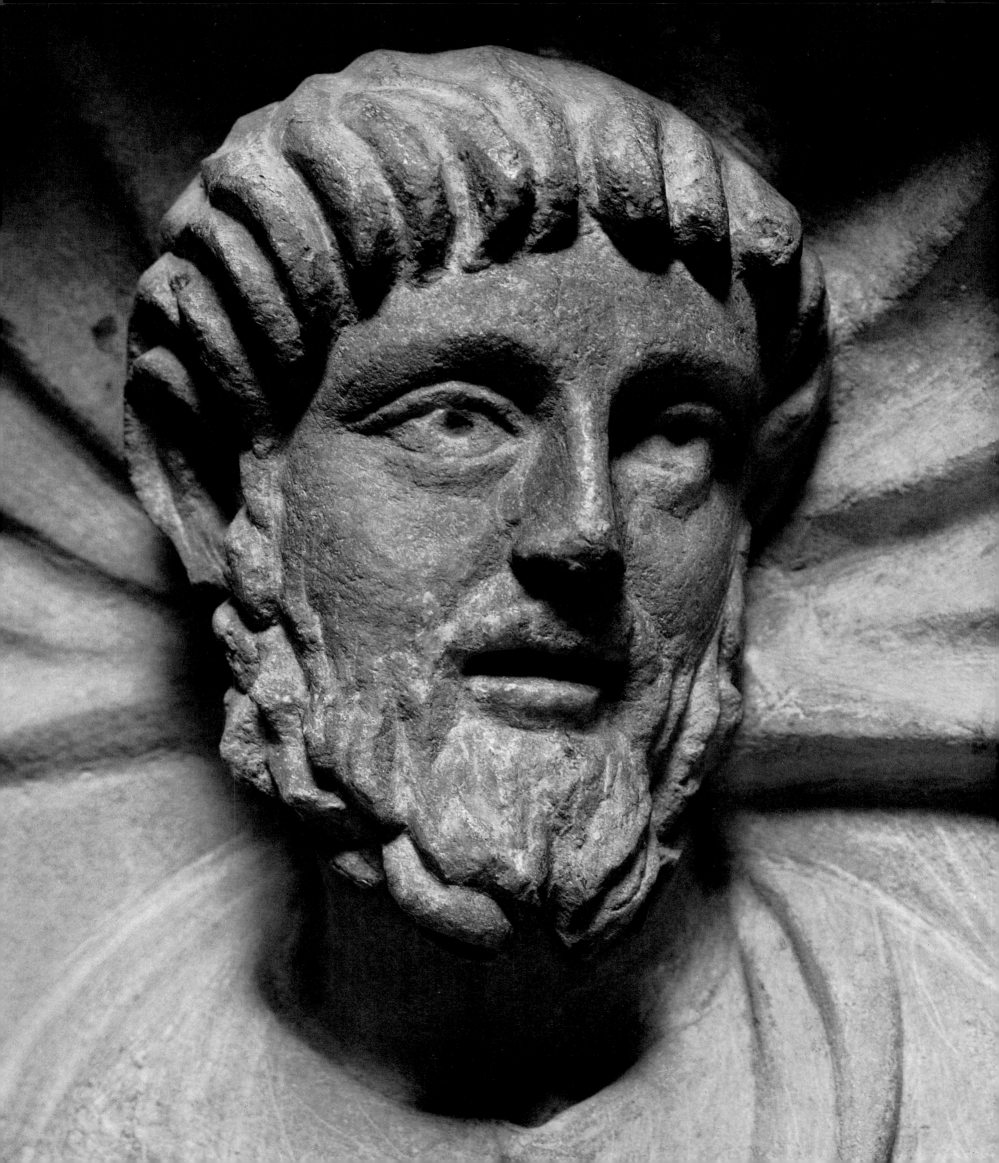

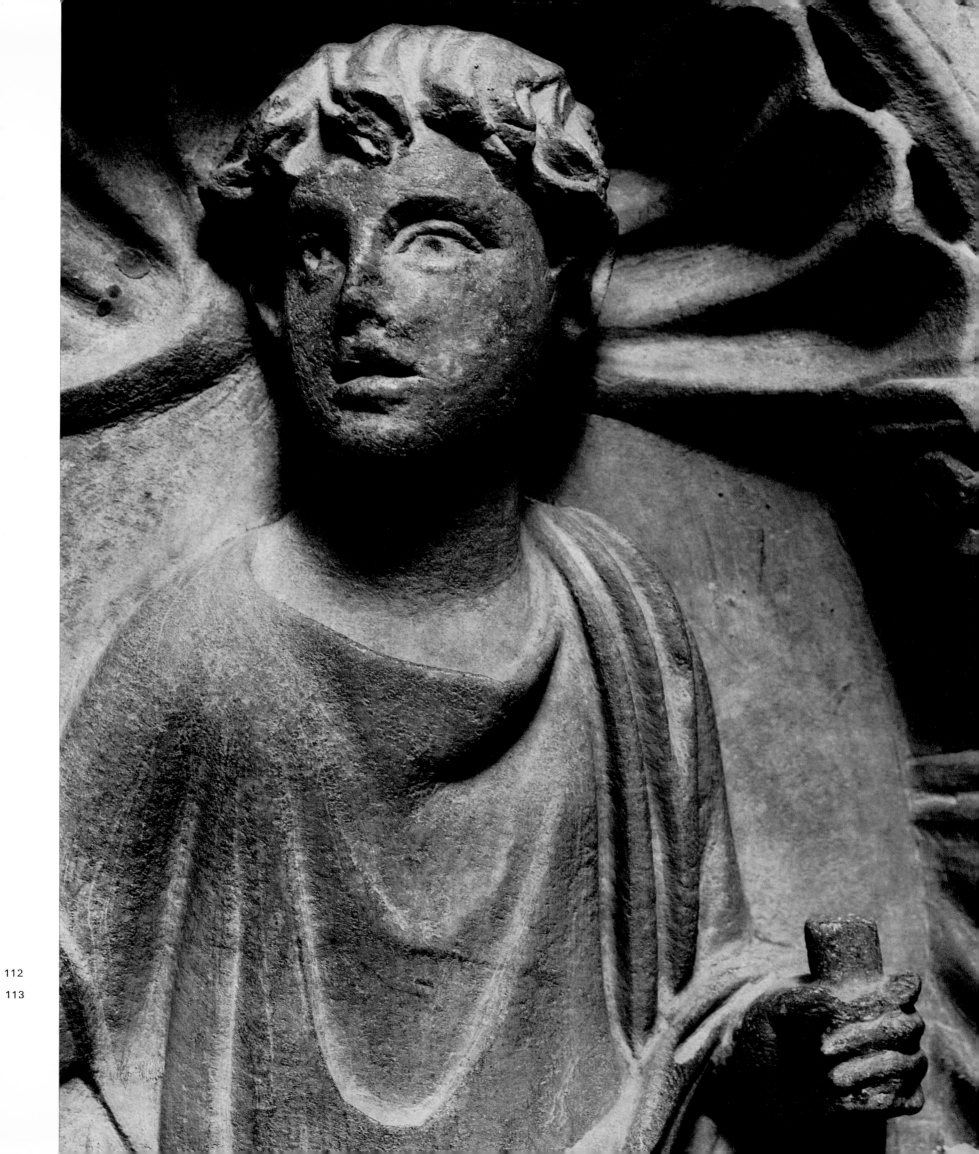

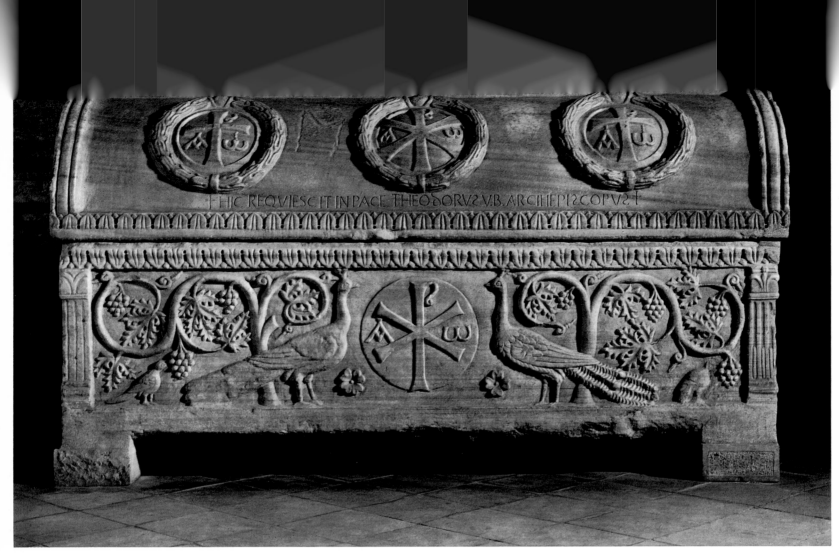

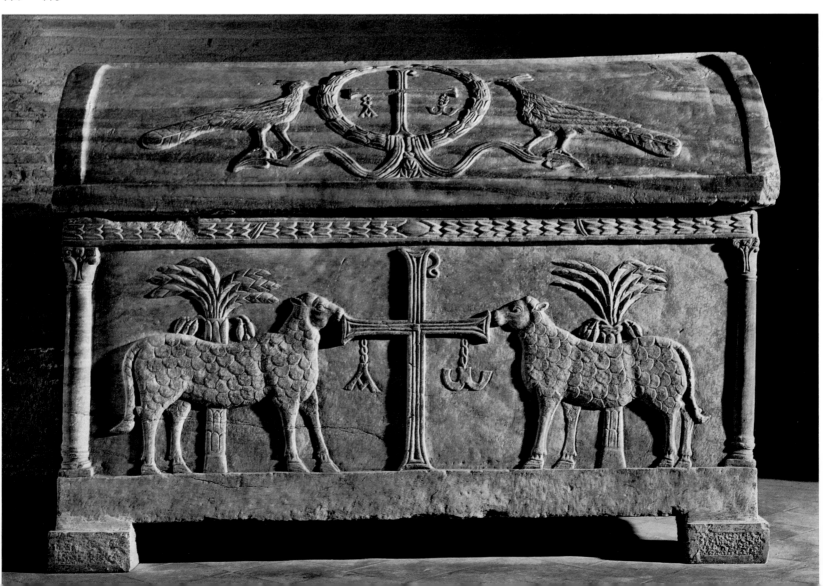

117    118

In his *Liber pontificalis ecclesiae Ravennatis* Andreas Agnellus occasionally reported the provenance of the marble used for the columns in certain churches. From him we learn that the mid-sixth-century Archbishop Maximian replaced the old walnut wood columns in the church dedicated to Saint Andrew with new ones in marble brought from the workshops on the island of Proconnesus. Unfortunately he gives no such information about architectonic elements such as capitals and pulvins or imposts or about the columns in the three finest churches of Ravenna, Sant'Apollinare Nuovo, San Vitale, and Sant'Apollinare in Classe. Yet, since there was no local source of the stone in Ravenna or its hinterland, we can be sure that all the marble used in those basilicas was brought in by the very convenient sea route. If proof is needed, we can point to the quality of the stone and, in the case of the capitals in Sant'Apollinare Nuovo (plate 122), to the initials in Greek characters incised into them to identify the workshop that produced them. In any case, certain elements must have been imported from the East already carved and finished. Many capitals in San Vitale, those in the presbytery in particular (plates 72, 74, 119), have as design an intricate web of marble which is entirely alien not only to the local Roman tradition but also to that of Italy as a whole. In those particular capitals the sixth-century *marmorarii* gave free rein to their lively imaginations. Bordered by strips with a continuous pattern of a thorny-leafed trailer, the four faces seem more woven than carved, completely covered as they are by a web made from a ribbon of marble twisting and turning to give rise to small disks, five of which unite to make a cross inside and outside of which palmettos, twigs, and flowers twine and intertwine. These complex ribbons of marble stand out in high relief against the darker hollowed-out areas to bring about virtually painterly effects of chiaroscuro. Nor was the artist content merely to alternate his white ribbons and vegetable forms against the dark shadow of the hollows behind them. He chose to emphasize and enrich the stylized marble plaitwork with touches of color, sometimes glistening gold, sometimes dark purple. Those same colors and green are also used on the pulvins or imposts surmounting the capitals. These imposts are, in their turn, carved with plantlike arabesques and, in rather flaccid low relief, with sheep, palms, and crosses.

It is not unlikely that the capitals and the inverted truncated pyramids of the pulvins were enhanced with color as a kind of gradual transition to the more vivid chromaticism of the mosaics on the walls above them.

The capitals in Sant'Apollinare in Classe are of quite different character. They are large, and below the carved and clearly profiled abacus two wreaths of acanthus leaves are seemingly tossed by the wind and twist around the capital. The uppermost leaf projects

*◁ 117, 118 Two faces of a marble reliquary shrine. Shortly before the middle of the fifth century. Museo Arcivescovile*

This rectangular reliquary shrine is quite small ($7^7/_8 \times 20^1/_8 \times 15''$) and has representational reliefs on all four sides. Here we see the Three Kings from the East bringing their gifts to the Christ Child. Below, we have the Ascension of Christ, who supports a tall cross on His shoulder and is about to be drawn up into Heaven by the hand of God. Half-kneeling alongside the tomb are the Holy Marys, and the construction at the right is an allusion to the walls of Jerusalem.

farther, and the fronds are combined into pairs twisting respectively one to the left and one to the right, so that each pair looks rather like a butterfly with wings unfurled. Besides this, the median ribbing of each leaf is marked by a continuous perforation (like a dotted line) obtained by fine drilling, and the contours of the leaves are decidedly spiny and spiky, both of which characteristics serve to enhance the pictorial, almost painterly chiaroscuro arising from the contrast of solid areas and hollows. A somewhat similar type of capital is found also in Constantinople and Salonika and had been used in Ravenna some decades earlier, in the church of Sant'Andrea dei Goti, built in the time of Theodoric.

To that same period belong two pilaster capitals (plate 121) where the symbols of the evangelists appear above a wreath of acanthus leaves rather drastically bent and furled back. On the abacus an inscription refers to a bishop named Peter, most likely Peter II (494–519).

The ambo or primitive pulpit in the cathedral (plate 123) comes from the time of Archbishop Agnellus (557–70) as we know from the inscription on its upper border. It belongs to the type known as *pyrgos* which resembles a small turret reached by a few steps at either side. Both front and back are divided by bands into small squares framing various symbolic animals. Reading from top to bottom these are sheep, peacocks, deer, doves, drakes, and fish. Stylistically no attempt whatsoever is made at three-dimensionality and modeling, with the result that the animals stand out not by reason of high relief but rather because of their sharply defined contours which make it seem as if the marble had been not so much carved as incised.

Similar traits, but less artistry, can be noted in the ambo once in the church of Santi Giovanni e Paolo (plate 124) whose inscription, similarly strung along the upper border, places it in the year 596 or 597, during the episcopate of Marinianus.

In contrast, one finds a truly miraculous sculptural technique in the openwork screens or transennae (plates 125, 126). Their marble lacework is given dramatic emphasis by the strong contrast between light and shade, between white marble and dark hollows.

The solid counterpart of the transenna, the large slab of marble used as a partition in early churches and known as the pluteus (plate 128), may evince a rather delicate pictorial feeling—an obvious though late persistence of the Hellenistic tradition—as one finds it in the example still in Sant'Apollinare Nuovo (plate 127) from a date as late as around the middle of the sixth century. On its front two peacocks, symbols of immortality, are disposed on two symmetrical grapevines emerging from either side of a vase in the shape of a Greek kantharos.

*119   Columns, capitals, and pulvins in the presbytery of San Vitale. Second quarter of the sixth century*   ▷

All the marble utilized in San Vitale came from Eastern workshops. The capitals are quite unique in that their four faces are framed by bands through which a trailer of thorny leaves winds deftly and, on the faces themselves, the marble is carved away completely behind the surface to leave an open lacework of remarkable pictorial effect. As for the pulvins or impost blocks above the capitals, the face they turn toward the presbytery bears in each case a cross, two sheep, and two palms, all of them carved in exceptionally low relief.

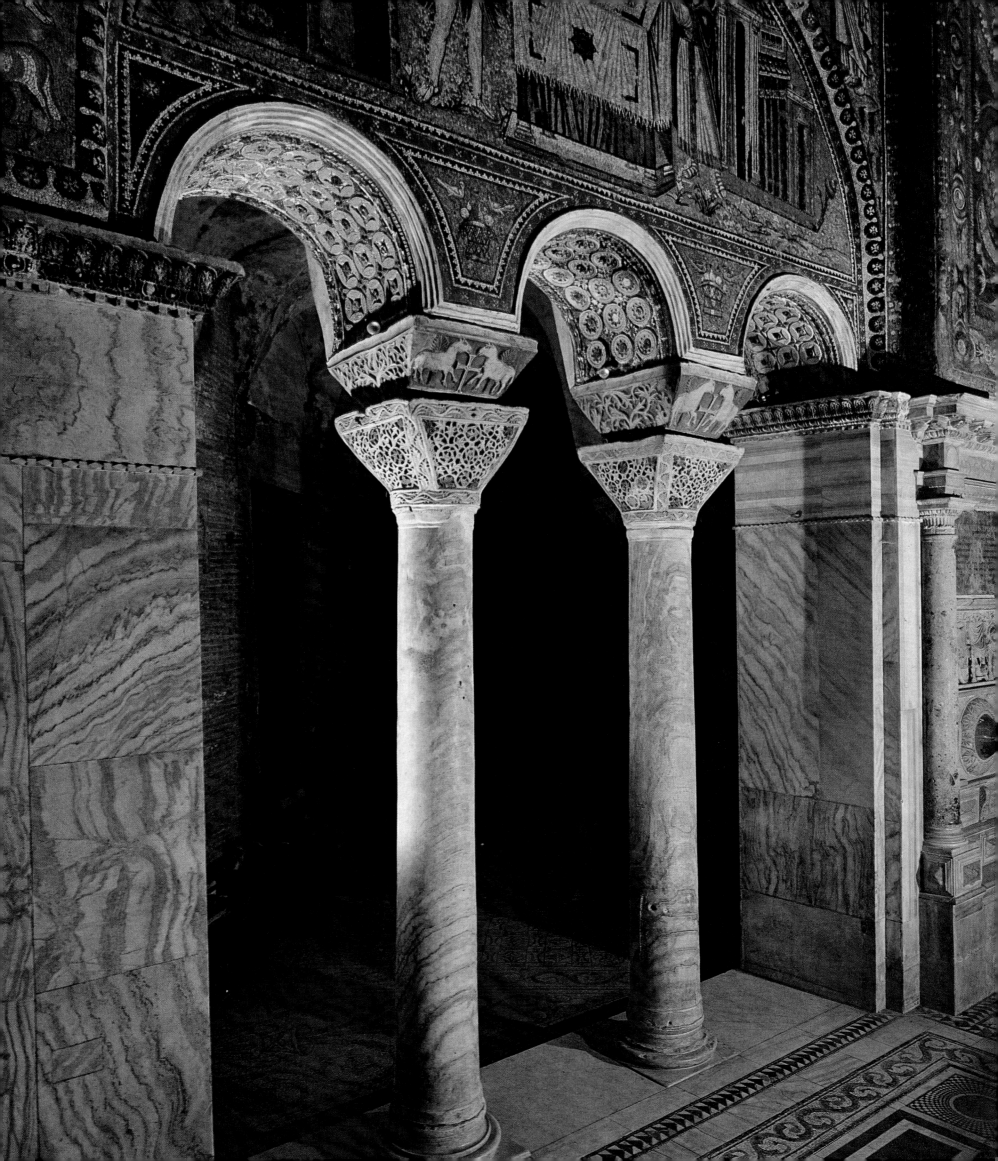

on the following pages:

*120    Capitals in the nave of Sant'Apollinare in Classe. Second quarter of the sixth century*

The capitals of the twenty-four columns which, in two rows, divide the church into three areas are all of the same type. It is as if a wind whirls about inside the capital and blows the large acanthus leaves outward so forcefully as to bend their tips backwards, and as they open out and curve back they strike one as wings of huge butterflies. Typical of these capitals also are the many tiny holes drilled into the leaves to accent their veining.

*121    Detail of a pilaster capital. End of the fifth or beginning of the sixth century. Museo Arcivescovile*

An inscription on the abacus alludes to a *Petrus episcopus*, in all probability Bishop Peter II. The capital belongs to a type characterized by two distinct zones, the lower one with windblown acanthus leaves, the upper one with two symbols of the evangelists, in this instance the winged man typifying Saint Matthew.

*122    Columns and ambo in the nave of Sant'Apollinare Nuovo. First quarter of the sixth century*

All the capitals and pulvins of the twenty-four columns in this basilica were brought from the East, as the initials in Greek characters would seem to indicate. In the center of each face, between the four large leaves that make up the capital, there is a motif somewhat resembling a lyre.

The ambo mounted on columns is of the turret-like *pyrgos* type, as is also that in the old Cathedral of the Arians, the present Spirito Santo.

*123    Ambo of Archbishop Agnellus (557–70). Cathedral*

*124    Ambo formerly in the church of Santi Giovanni e Paolo. 596/97. Museo Arcivescovile*

*125    Marble transenna from the old Cathedral of the Orthodox (the so-called Basilica Ursiana). Third quarter of the sixth century. Museo Arcivescovile*

*126    Marble transenna from San Vitale. Shortly before the middle of the sixth century. Museo Nazionale*

*127    Detail of the front of a pluteus. Around the middle of the sixth century. Sant'Apollinare Nuovo*

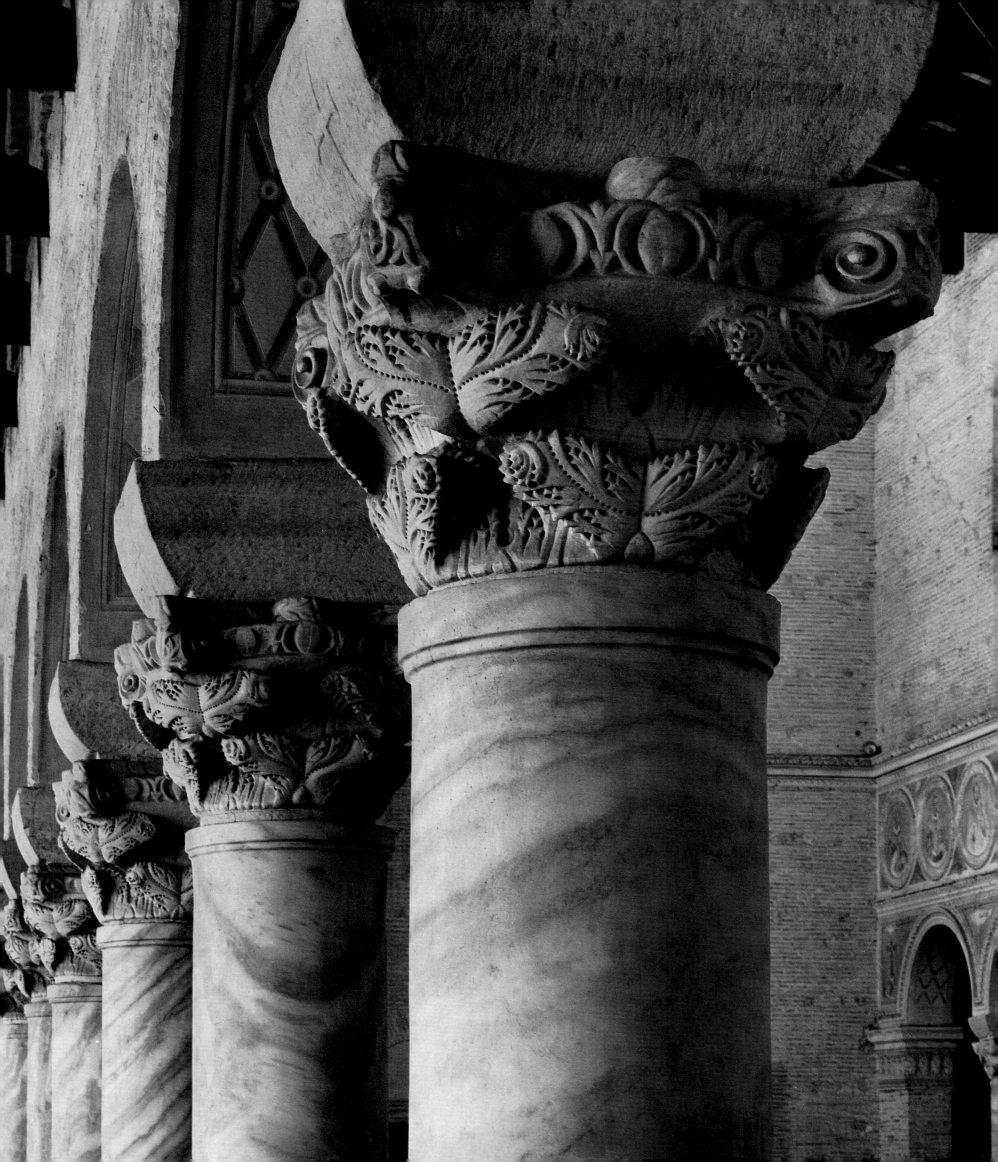

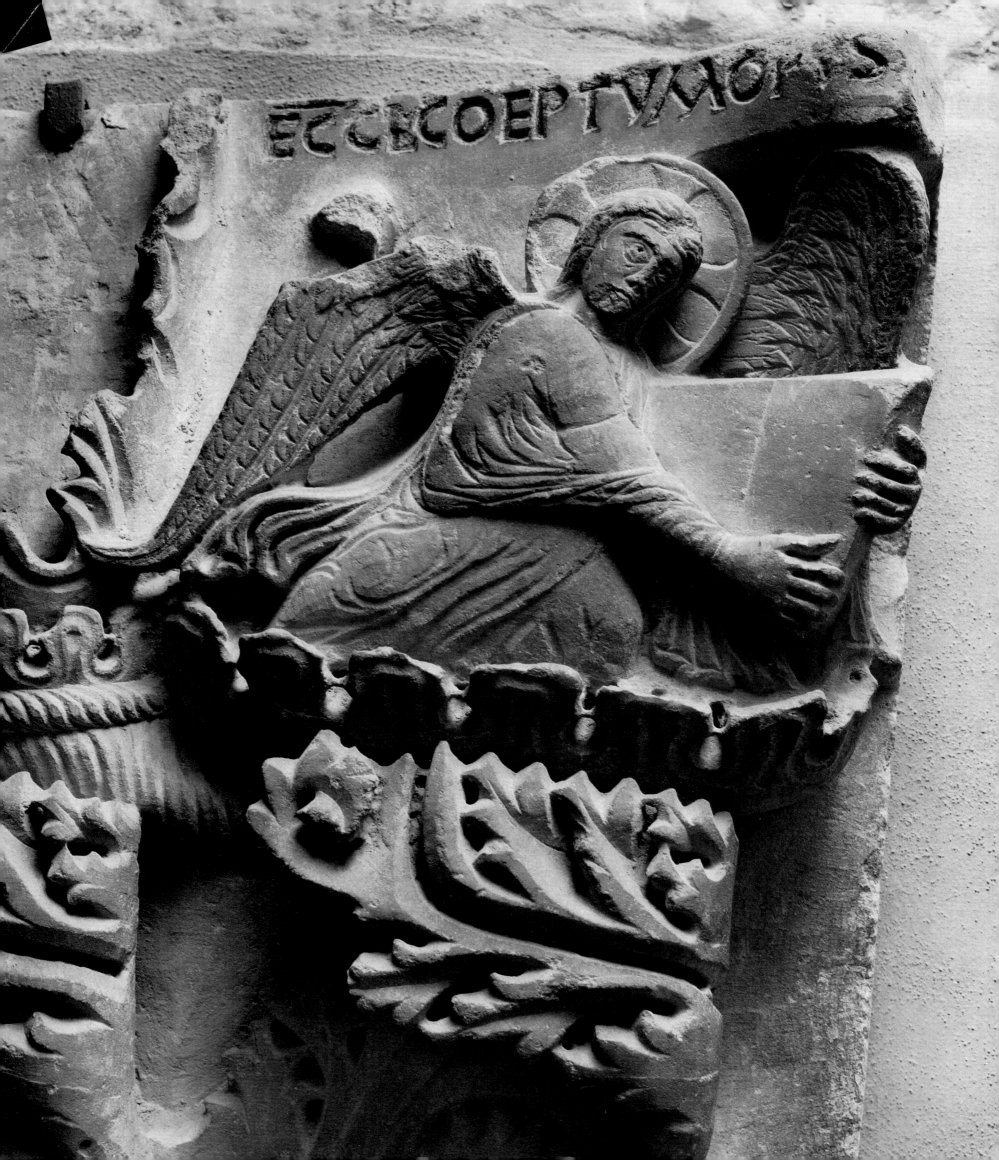

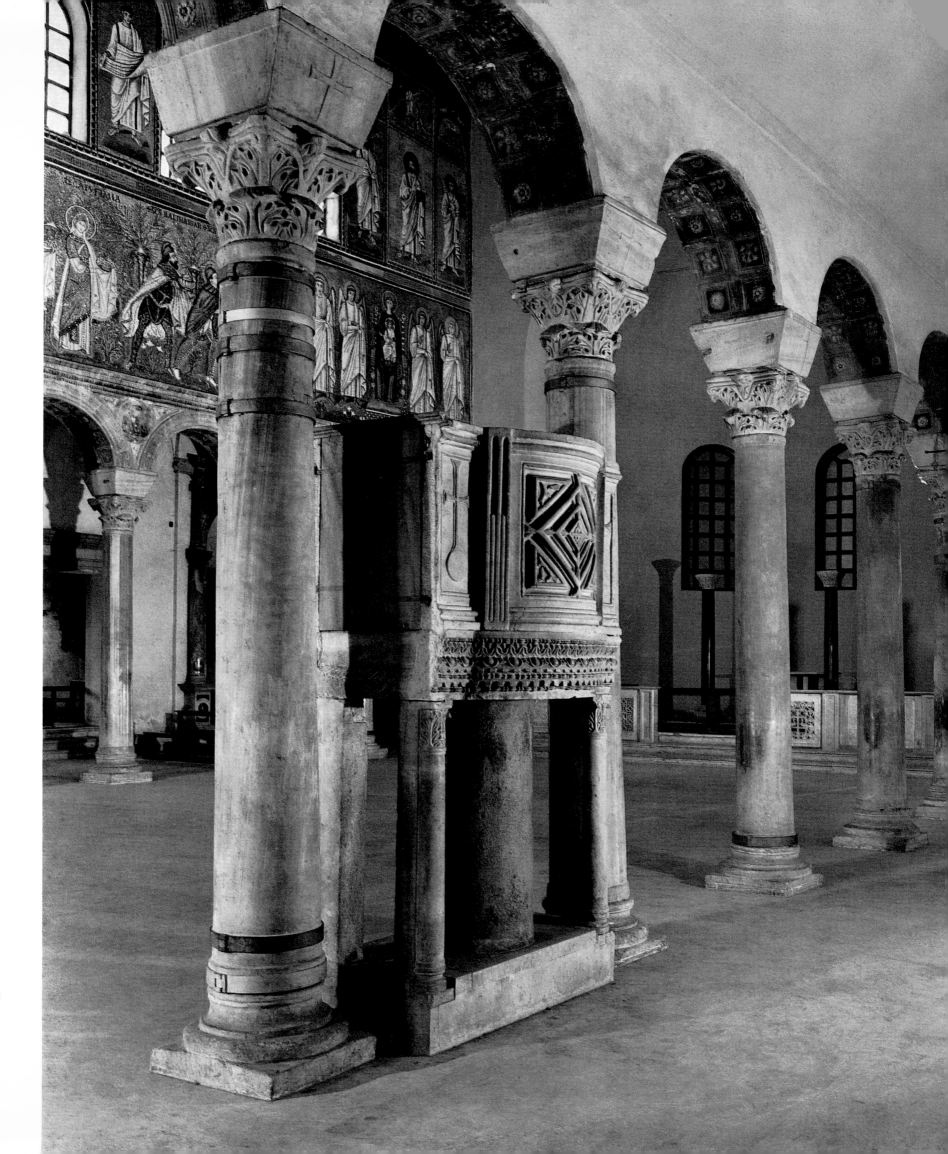

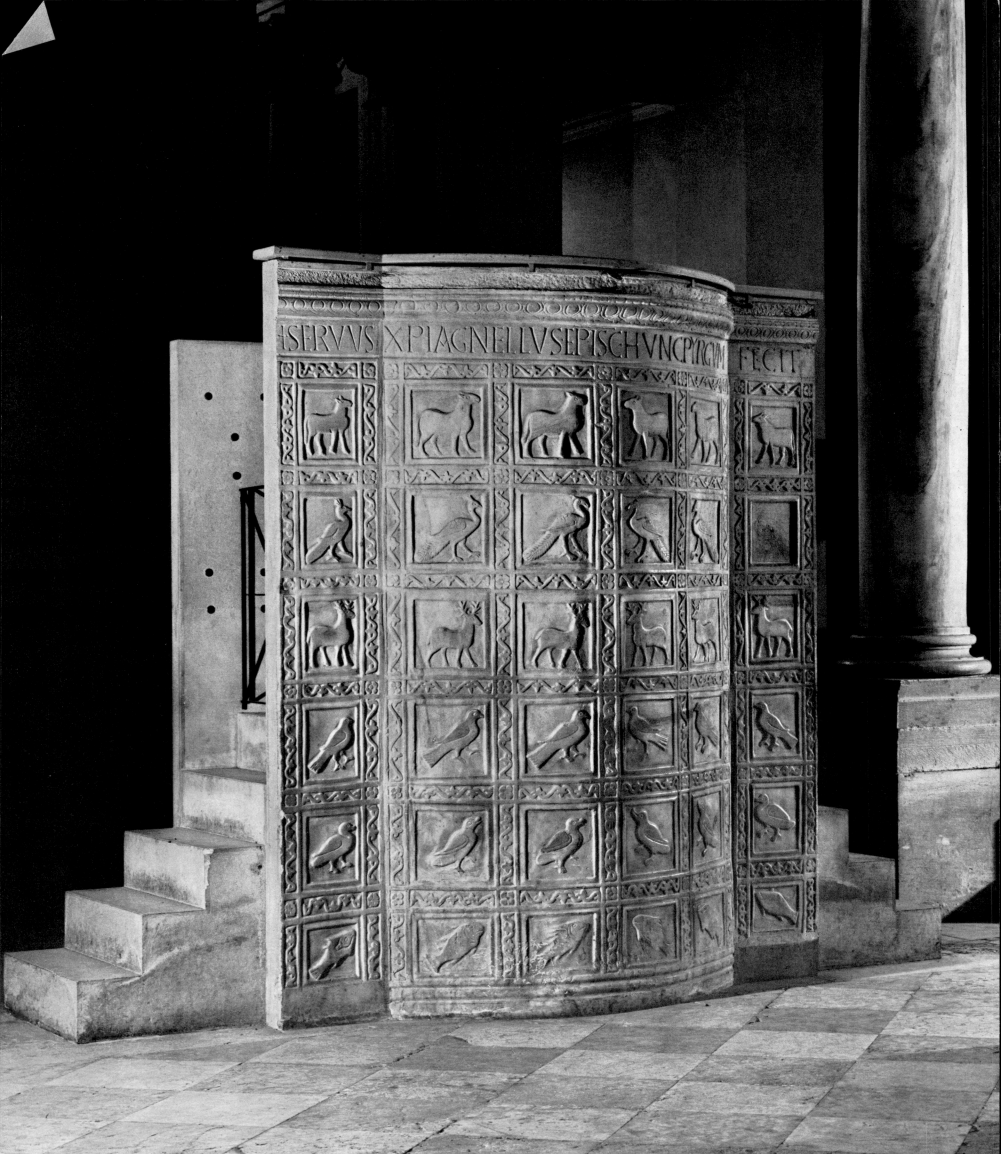

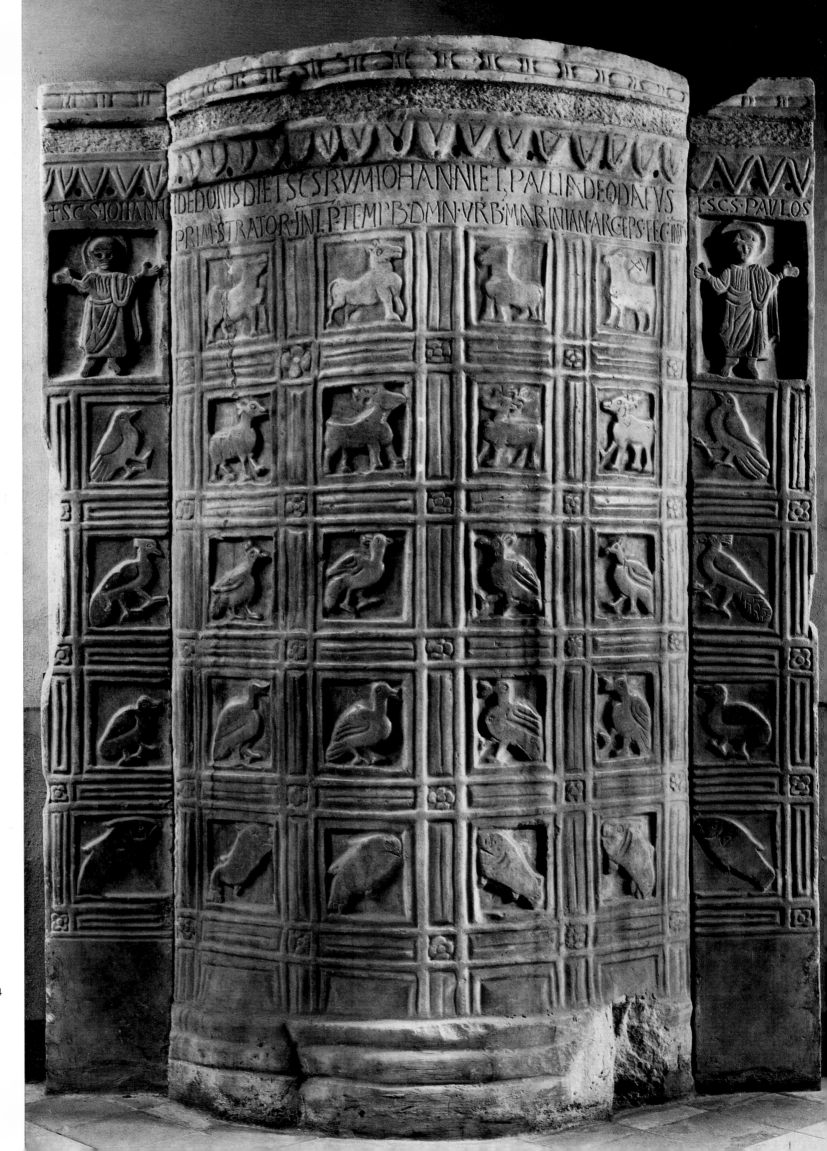

123 124

125

126

127 ▷

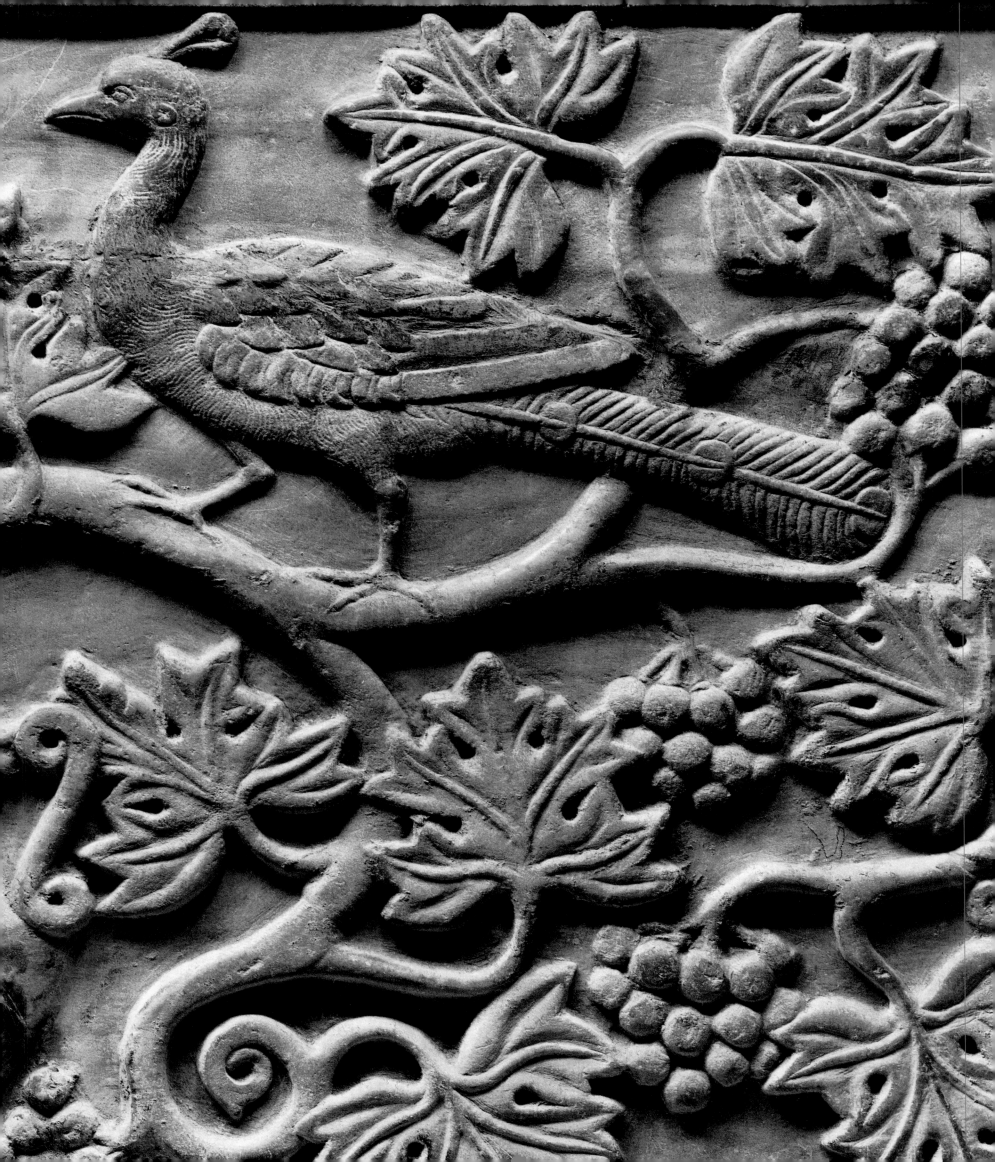

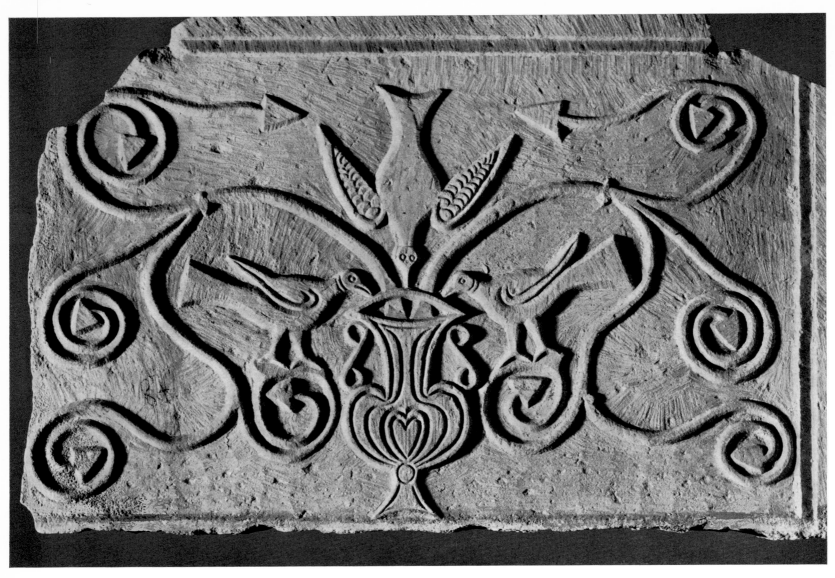

128

*Monogram of Archbishop Maximian*

*middle of the sixth century*

Almost five feet tall and just under two feet in width, this renowned episcopal throne is splendidly preserved considering that it is made entirely of ivory. Minor repairs and replacements have had to be made, but they are well integrated with the original material. A few figured plaques have been lost and have been substituted with wood carvings which were covered with parchment to help blend with the ivory, and the framework, originally wood, was replaced with transparent plexiglass in 1956.

What we have here is a throne or, more specifically, a cathedra, symbol of the dignity and authority of the bishop and explicit allusion to the task of teaching, of guidance, assumed in the name of the Divine Master by a fully ordained priest charged with the cure of souls of the flock entrusted to him. In form, the throne is entirely similar to the others that survive from Early Christian times.

In the center of the upper part of the front panel, flanked by purely decorative motifs, there is a monogram that has given scholars much difficulty. Some have decoded it as MAXIMVS SALONE EP(i)S(copus), which would refer to either Maximus I (326–46) or Maximus II (594–602) of the church of Salona, while others claim to read IOANNES EP(iscopus) AL(exandrinus), which would connect it with Saint John the Almsgiver, Bishop of Alexandria, who lived around the beginning of the seventh century.

But these are isolated aberrant interpretations, and all other archaeologists and historians of art agree in reading the monogram as MAXIMIANVS EPISCOPVS and associating it with the celebrated prelate who was a native of Pola in Istria, was ordained bishop in Patras in Greece, and governed the Church of Ravenna for a decade beginning in 546.

With his skill and diplomacy Maximian proved to be one of the most sagacious bishops in Ravenna's history. It was given to him to consecrate two of the most renowned churches in the city, San Vitale, where one can still admire a very expressive mosaic portrait of him, and Sant'Apollinare in Classe.

It should be mentioned that the attribution to Maximian of the monogram on the throne is further confirmed by the fact that this same monogram form appears on other works of art in Ravenna which are unquestionably from the middle of the sixth century and hence contemporaneous with him.

In 550, four years after being ordained bishop, Maximian was promoted to *Archiepiscopus*. This means that if the monogram stands only for MAXIMIANVS EPISCOPVS with no indication of the more exalted title, then the cathedra must be assigned to the first years of his episcopate, specifically to some date between 546 and 550.

Oddly enough there is no mention whatsoever of the throne in the *Liber pontificalis ecclesiae Ravennatis* in which Agnellus recorded

the most detailed information about so many works of art in Ravenna up to about the middle of the ninth century. On the other hand, it does seem to be the work described in the Venetian chronicles of John the Deacon as an artistically carved cathedra which Doge Pietro Orseolo II gave in 1001 to Emperor Otto III, who, it so happened, was in Ravenna at the time. In itself this is no proof that that was the throne we know today, but nothing rules out that it may be. Indeed, Bettini has even proposed that the doge bestowed it as a gift on the emperor precisely because he may have found it in the basilica of Santa Maria Formosa in Pola, which Maximian himself had founded.

As we see the chair now, there are nine small plaques missing from its back. Three of these were carved on both sides so that there are twelve episodes in all lost. Luckily, thanks to the drawings and the epigraphs noted by Bacchini and Muratori, we know at least the subjects of some of them: the Meeting of Elizabeth and the Virgin, the Adoration of the Magi, the Flight into Egypt, and the Marriage Feast at Cana.

There are a number of hypotheses concerning the original disposition and the subjects of the other missing plaques. However, it is very difficult to speculate as to which Biblical episodes were actually illustrated since, among those plaques that have survived, certain events are depicted in two distinct episodes on two separate plaques while other plaques synthesize two quite diverse scenes into one.

In the 1890s and early 1900s four long-dispersed plaques were recovered and restored to the throne. First, in 1893 and 1894 two that had been recognized by Garrucci as belonging to it were returned. One of them, the scene of Christ and the Samaritan Woman, had been in the museum in Naples, and the other, a double-faced one having on one side the Annunciation and on the other the miracle of the Multiplication of the Loaves and Fishes, came from the Musei Oliveriani of Pesaro. Then in 1903 Count Gregor Stroganoff of Rome returned a plaque in his private collection which had at one time been in the Trivulzio collection in Milan and later had passed to the Trotti di Locate Trivulzio collection. This one likewise was double-faced, with the Nativity on one side and the Entry into Jerusalem on the other, and had been recognized by Bugati as far back as 1700 as

being part of the cathedra. In 1905 a fourth plaque, this one showing the Healing of the Blind Man, having been identified by Westwood, was returned by the Museo Archeologico of Milan, which had acquired it from the Accademia di Belle Arti of the same city.

On the front of the cathedra, between ornamental bands of exuberant grapevines there are five tall panels with Saint John the Baptist and the Four Evangelists.

The front of the backrest, still lacking three of its panels, has scenes from the New Testament and the apocryphal gospels, specifically the Annunciation, the Proof of the Virgin, Joseph's Dream and the Journey to Bethlehem, the Nativity, and the Madonna Enthroned with the Infant Jesus.

On the back of the throne there are sixteen compartments separated by ornamental bands, and of these only seven still have their relief plaques, the surviving subjects being the Baptism of Christ, the Entry into Jerusalem, the Feeding of the Five Thousand, the Multiplication of the Loaves and Fishes, the miracle of the transformation of water into wine at the Marriage Feast at Cana, the Healing of the Blind, and the Samaritan Woman at the Well.

Each of the two sides with the arm rests has five plaques, all of them devoted to scenes from the life of Joseph in the Old Testament.

There is no doubt that all of these reliefs were not executed by a single *magister eburarius*. On the basis of stylistic analysis, four different hands have been singled out. One must have executed the figures of Saint John the Baptist and the Four Evangelists on the front of the seat. To a second are ascribed the quite flatly modeled scenes from the Gospels on the front and back of the backrest. A third, this one of high artistic talents and possessing a marked feeling for plastic relief, must have done the ten plaques with episodes from the life of Joseph, while a fourth hand is probably responsible for the beautiful ornamental bands with their remarkable effects of chiaroscuro.

As to where the throne was likely to have been executed, there are many opinions. Some propose Alexandria or even Antioch, others Constantinople, and still others hold out for Ravenna itself, though that seems the least probable. For our part we think that this work could have come only from Constantinople.

129   *The Ivory Throne of Archbishop Maximian. Museo Arcivescovile*
▷

202

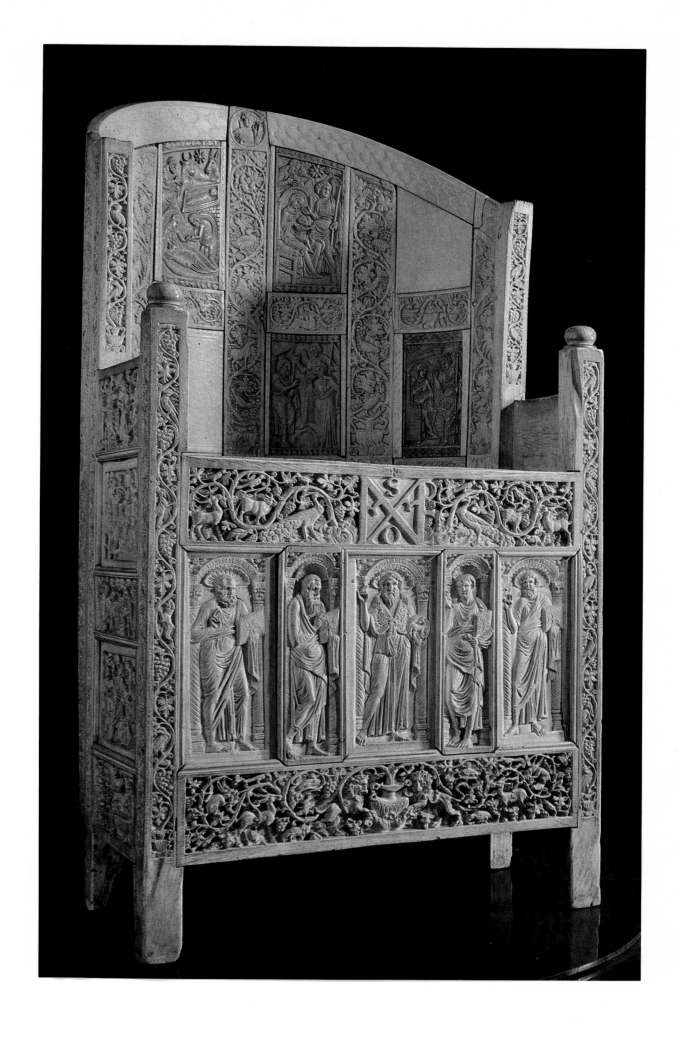

*130–38   The ten plaques on the sides of the throne depict fourteen
episodes from the story of Joseph recounted in the book of Genesis.
These plaques are shown here and on the following pages.*

130   Exterior of the left arm rest. *Lower plaque:* On the right the
young Joseph is cast into a cistern by two of his brothers while
a third, Reuben, looks on in sorrow. A large star shines above the
head of Joseph, who is probably to be understood here as a
prefiguration of Christ. On the left, one brother slaughters a goat,
another dips Joseph's coat of many colors into the blood to
deceive their father into believing his favorite son to be dead,
and two other brothers watch from behind. *Upper plaque:* Three
of the brothers show Jacob the blood-stained coat. The despairing
father recognizes it as Joseph's and clasps his hands over his head
in a gesture of grief. Alongside him are the boy Benjamin and
Bilhah, Jacob's second wife and the stepmother of Joseph.

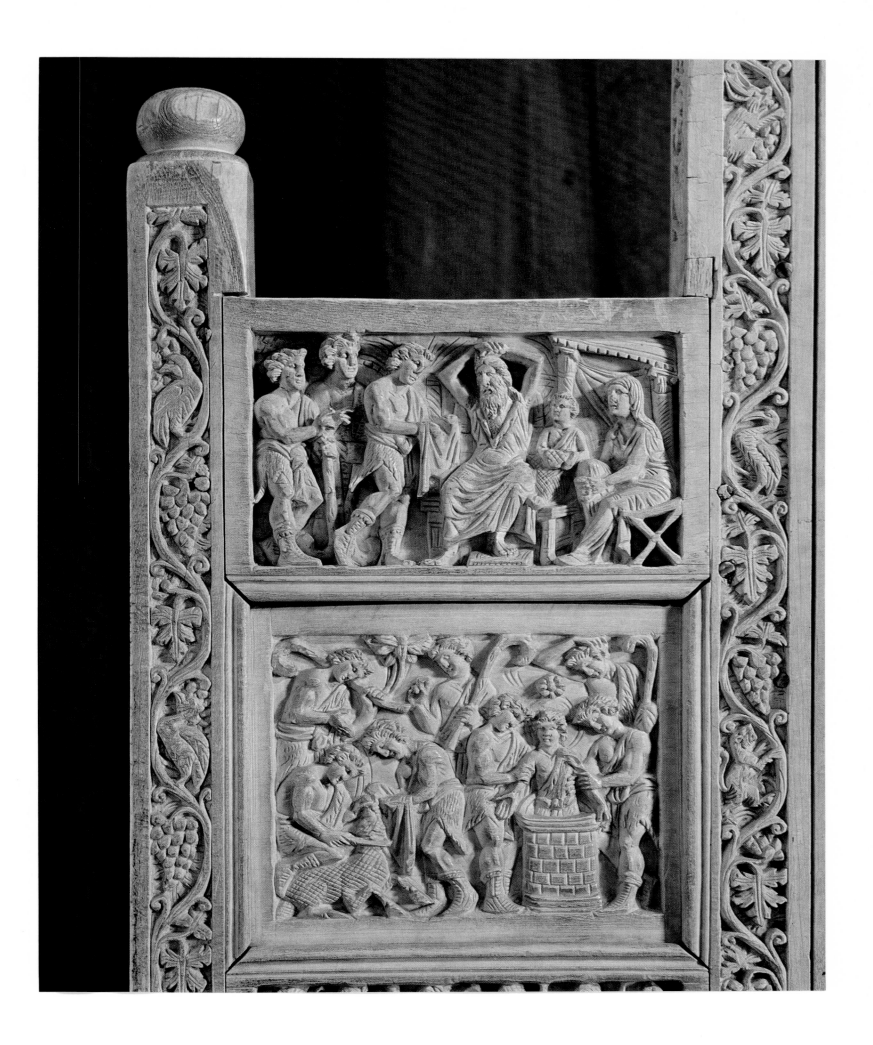

131   Joseph, the tiny boy in the center here, is being sold by his brothers to the Ishmeelite traders from Midian. The brothers are at the left, each clutching a *pedum*, a heavy club with curved handle. The long-haired traders are at the right with two camels; one of them is handing a sack of money to one of the brothers.

132   The Ishmeelite traders convey Joseph to Egypt on the back of a camel. There they sell him as a slave to Potiphar, captain of the guard, who is seen here paying the sum agreed on while behind him, in the doorway of his house, stand his wife and another person.

133   Here, from left to right, there are three episodes. First Potiphar's wife, a prey of blind passion, attempts literally to drag Joseph into her chamber, but the young man resists. Then, falsely accused by the frustrated woman, Joseph's hands are tied behind his back and he is delivered over to justice. Finally we see the prisoner staring sadly out of a window while his jailer sits nodding in the doorway below.

134   Pharaoh lies sleeping on his couch. A winged graybeard holding a burning torch approaches the bed: the spirit of sleep and dreams. And there, behind this allegorical personage, we can see Pharaoh's dream: "seven well favoured kine and fatfleshed" on a riverbank and then another seven cattle, but these "ill favoured and leanfleshed," which are shown here one group above the other.

135   The young Hebrew has been brought from the dungeon into Pharaoh's presence, where we see him interpreting the monarch's dream. Pharaoh is seated on his throne and is watched over by two guards armed with swords. On the left there are other soldiers and two elderly men dressed like ancient philosophers, the soothsayers who had been unable to explain the dream.

136   Joseph has been made governor of all Egypt. Here, enthroned and surrounded by his guards, without disclosing his identity he interrogates his brothers, who have come from Canaan, now in the throes of famine, to buy food. Joseph consents to their request but insists on holding the young Simeon as hostage.

137   From his throne Joseph looks on while the brothers' sacks are being filled with corn. The Egyptian *dispensator* keeps tally of how much is being bought and supplied. It is during this operation that the money and Joseph's silver cup are adroitly concealed in the sacks.

138   Now all of Joseph's devious maneuvers have their explanation and happy ending. He reveals himself to his aged father and duly repentant brothers: "and he fell on his [father's] neck, and wept on his neck a good while. And Israel said unto Joseph, Now let me die, since I have seen thy face, because thou art yet alive" (Gen. 46:29–30).

131

135

136

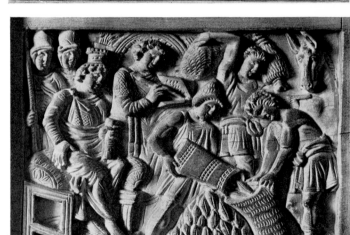

132

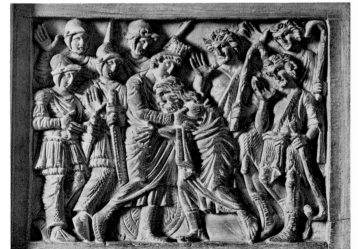

133

137

134

138

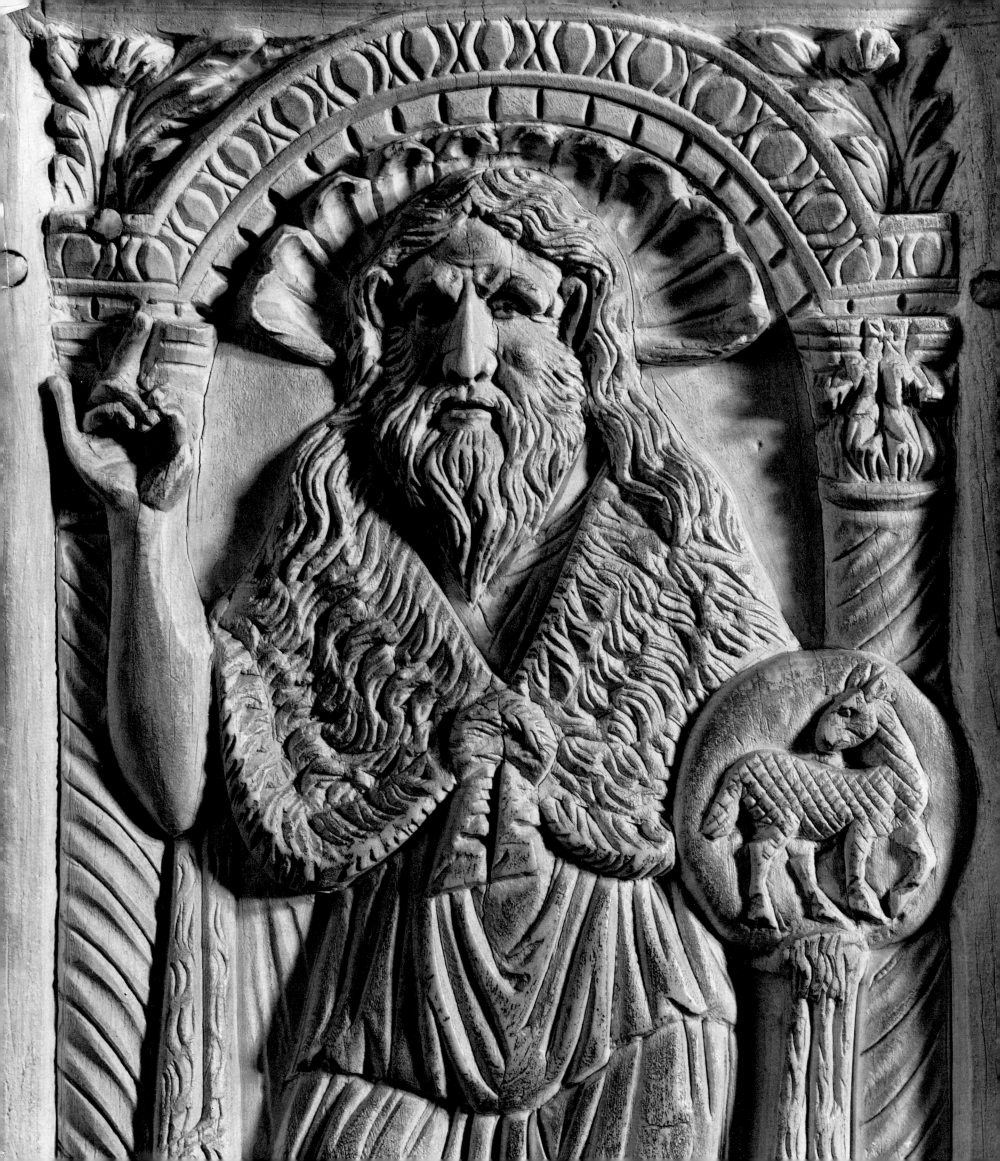

*139   Saint John the Baptist (detail of a plaque on the Ivory Throne of Archbishop Maximian). Museo Arcivescovile*

# Historical Chart

| Emperors of the West | | Emperors of the East | |
|---|---|---|---|
| 379–95 | Theodosius I | | |
| 395–423 | Honorius | 395–408 | Arcadius |
| [423–25 | Galla Placidia, regent] | 408–50 | Theodosius II |
| 425–55 | Valentinian III | 450–57 | Marcian |
| 455 | Petronius Maximus | | |
| 455–56 | Avitus | | |
| 457–61 | Majorian | 457–74 | Leo I |
| 461–65 | Livius Severus | | |
| 467–72 | Anthemius | | |
| 472 | Olybrius | | |
| 473–74 | Glycerius | | |
| 474–75 | Julius Nepos | 474–75 | Leo II and Zeno |
| 475–76 | Romulus Augustulus | 475–76 | Basiliscus |

## Barbarian Kings

| | | | |
|---|---|---|---|
| 476–93 | Odoacer | 476–91 | Zeno |
| 493–526 | Theodoric | 491–518 | Anastasius I |
| | | 518–27 | Justin I |
| 526–34 | Athalaric | 527–65 | Justinian I |
| 534–36 | Theodat | | |
| 536–39 | Vitiges | | |
| 540–41 | Ildibald | | |
| 541 | Heraric | | |
| 541–52 | Totila | | |
| 552–53 | Teias | | |

## Lombard Kings

| | | | |
|---|---|---|---|
| 565–72 | Alboin | 565–78 | Justin II |
| 572–74 | Cleph | | |
| 575–84 | Interregnum of the Dukes | 578–82 | Tiberius II |
| 584–90 | Authari | 582–602 | Maurice |
| 590–615 | Agilulf | | |

| Popes | | Bishops of Ravenna | | Architectural Monuments |
|---|---|---|---|---|
| 384–98 | Siricius | | | |
| 398–401 | Anastasius I | 398–424(?) | Ursus | Cathedral of the Orthodox |
| 402–17 | Innocent I | | | Baptistery of the Orthodox |
| 417–18 | Zosimus | | | |
| 418–22 | Boniface I | | | |
| 422–32 | Celestine I | 429–49 | Peter I | San Giovanni Evangelista |
| 432–40 | Sixtus III | | | Mausoleum of Galla Placidia |
| 440–61 | Leo I the Great | 449–75 | Neon | Basilica Apostolorum (San Francesco) |
| 461–68 | Hilarius | | | |
| 468–83 | Simplicius | | | |
| | | 475–77 | Exuperantius | |
| 483–92 | Felix III | 478–94 | John II | |
| 492–96 | Gelasius I | 494–519 | Peter II | Anastasis Gothorum (Spirito Santo) |
| 496–98 | Anastasius II | | | Baptistery of the Arians |
| 498–514 | Symmachus | | | Archiepiscopal Chapel |
| 514–23 | Hormisdas | 519–21 | Aurelianus | Sant'Apollinare Nuovo |
| 523–26 | John I | 521–32 | Ecclesius | Mausoleum of Theodoric |
| 526–30 | Felix IV | | | |
| 530–32 | Boniface II | | | |
| 533–35 | John II | 532–36 | Ursicinus | |
| 535–36 | Agapetus | | | |
| 536–37 | Silverius | | | |
| 538–55 | Vigilius | 538–45 | Victor | |
| | | 546–56 | Maximian | San Vitale |
| | | | | Sant'Apollinare in Classe |
| 556–61 | Pelagius I | 557–70 | Agnellus | |
| 561–74 | John III | 570–78 | Peter III | |
| 575–79 | Benedict I | | | |
| 579–90 | Pelagius II | 578–95 | John II | |
| 590–604 | Gregory I the Great | 595–606 | Marinianus | |

# Selected Bibliography

## Sources

The most important historical-literary source concerning Ravenna in Late Antique and early medieval times is the *Liber pontificalis ecclesiae Ravennatis* by the ninth-century chronicler Andreas Agnellus, of which there exist two convenient modern editions. One, edited by O. HOLDER-EGGER, is in the *Monumenta Germaniae historica: scriptores rerum italicarum et longobardicarum*, Impensis bibliopolii Hahniani, Hanover, 1878, pp. 265–391. The other, edited and with valuable commentary by A. TESTI-RASPONI, is in the *Rerum Italicarum Scriptores*, 2nd ed., N. Zanichelli, Bologna, 1924, but it is incomplete and does not go beyond the biography of Bishop Marinianus.

## History

SPRETI, D., *De urbis Ravennae amplitude, vastatione et instauratione*, Venice, 1489; RUBEI, H. [ROSSI, G.], *Historiarum Ravennatum libri decem*, Paulus Manutius, Venice, 1572; TOMAI, T., *Istoria della città di Ravenna*, Appresso Aloisio Giglio, Pesaro, 1574; FABRI, G., *Ravenna ricercata ovvero compendio storico delle cose notabili dell'antica città di Ravenna*, Bologna, 1678; PASOLINI, P. D., *Ravenna e le sue grandi memorie*, Ermanno Loescher, Ravenna, 1912; HUTTON, E., *Ravenna*, J. M. Dent & Sons, Ltd., London, 1913; TORRE, A., *Ravenna, Storia di 3000 anni*, Edizioni del girasole, Ravenna, 1967. An invaluable and fascinating source for the English-speaking reader remains EDWARD GIBBON, *The Decline and Fall of the Roman Empire*, available in many modern editions.

## Art in general

RAHN, J. R., *Ravenna; Eine kunstgeschichtliche Studie*, Leipzig, 1869; GOETZ, W., *Ravenna* ("Berühmte Kunststätten" series), E. A. Seemann, Leipzig-Berlin, 1901; DIEHL, C., *Ravenne* ("Les Villes d'art célèbres" series), Renouard, Paris, 1907; RICCI, C., *Ravenna*, Istituto italiano d'arti grafiche, Bergamo, 1909; MOREY, C. R., *Early Christian Art*, Princeton University Press, Princeton, N. J., 1953; BOVINI, G., *Chiese di Ravenna*, Istituto geografico de Agostini, Novara, 1957; VOLBACH, W. F., *Early Christian Art*, Abrams, New York, 1961; BOVINI, G., *Ravenna, an art city*, Edizioni A.

Longo, *Ravenna*, 1969; DEICHMANN, F. W., *Ravenna, Geschichte und Monumente*, Franz Steiner, Wiesbaden, 1969 (complemented with the richly illustrated album *Frühchristliche Bauten und Mosaiken von Ravenna*, B. Grimm, Baden-Baden, 1958, which has 14 color and 413 black-and-white plates).

## Architecture

VON QUAST, A. F., *Die altchristlichen Bauwerke von Ravenne*, Berlin, 1842; ZIRARDINI, A., *De antiquis sacris Ravennae aedificiis* (18th-century text), Ravenna, 1908–9; BIRNBAUM, V., *Ravennská Architektura*, Ceská akad. věd a umění, Prague, Vol. I, 1916, Vol. II, 1921; DE ANGELIS D'OSSAT, G., *Studi ravennati; Problemi di architettura paleocristiana*, Edizioni "Dante" di A. Longo, Ravenna, 1962; BOVINI, G., *Storia e architettura degli edifici paleocristiani di culto di Ravenna*, R. Pàtron, Bologna, 1964; MARTINELLI, P., *Caratteristiche architettoniche degli edifici paleocristiani di Ravenna*, Edizioni A. Longo, Ravenna, 1964; BOVINI, G., *Edifici di culto d'età paleocristiana nel territorio ravennate di Classe*, R. Pàtron, Bologna, 1969; BOVINI, G., *Edifici di culto di Ravenna preteodoriciana*, R. Pàtron, Bologna, 1969; BOVINI, G., *Edifici di culto d'età teodoriciana e giustinianea a Ravenna*, R. Pàtron, Bologna, 1970.

## Mosaics

RICHTER, J. P., *Die Mosaiken von Ravenna; Beitrag zu einer kritischen Geschichte der altchristlichen Malerei*, Wilhelm Braumüller, Vienna, 1878; KURTH, J., *Die Wandmosaiken von Ravenna*, 2nd ed., Piper, Munich, 1912; RICCI, C., *Monumenti; tavole storiche dei musaici di Ravenna*, 8 Vols., Istituto poligrafico dello stato, Rome, 1930–37; UEHLI, E., *Die Mosaiken von Ravenna*, Heitz, Strassburg, 1935; DEMUS, O., *Byzantine Mosaic Decoration*, Kegan Paul Trench Trubner & Co., Ltd., London, 1948; VON SIMSON, O., *The Sacred Fortress*, University of Chicago Press, Chicago, 1948; GALASSI, G., *Roma o Bisanzio*, Vol. I: *I musaici di Ravenna e le origini dell'arte italiana*, 2nd ed., Libreria dello stato, Rome, 1953; NORDSTRÖM, C. O., *Ravennastudien*, Almquist & Wiksell, Stockholm, 1953; BOVINI, G., *Ravenna Mosaics*, New York Graphic Society, Greenwich, Conn., 1956; RICE, D. TALBOT, *The Art of Byzantium*,

Thames & Hudson, London, 1959; BOVINI, G., *Ravenna und seine Mosaiken*, Hirmer Verlag, Munich, 1962; ANTHONY, E. W., *A History of Mosaics*, reprint, Hacker, New York, 1968; RICE, D. TALBOT, *Byzantine Art*, rev. and exp. ed., Penguin, Harmondsworth, 1968.

## Baptistery of the Orthodox

BETTINI, S., "Il Battistero della Cattedrale," in *Felix Ravenna*, Ravenna, 52, 1950, pp. 41–59; WESSEL, K., "Zur Interpretation der Kuppelmosaiken des Baptisteriums der Orthodoxen," in *Corsi di cultura sull'arte ravennate e bizantina*, Bologna, 1957, fasc. 1, pp. 77–81; CASALONE, C., "Ricerche sul Battistero della Cattedrale di Ravenna," in *Corsi di cultura...*, 1960, fasc. 2, pp. 7–12; MAZZOTTI, M., "Il Battistero della Cattedrale di Ravenna, problemi architettonici e vicende del monumento," in *Corsi di cultura...*, 1961, pp. 255–78; GHEZZO, A., "Il Battistero degli Ortodossi di Ravenna, problemi ed aspetti architettonico-strutturali e decorativi," in *Felix Ravenna*, 86, 1962, pp. 5–73; KOSTOF, S., *The Orthodox Baptistery of Ravenna*, Yale University Press, New Haven, 1965; KASPERSEN, S., "La decorazione musive del Battistero degli Ortodossi di Ravenna," in *Felix Ravenna*, 96, 1967, pp. 33–53.

## San Giovanni Evangelista

SCEVOLA, L., "La Basilica di S. Giovanni Evangelista a Ravenna," in *Felix Ravenna*, 87, 1963, pp. 5–107; GROSSMANN, P., "Zum Narthex von S. Giovanni Evangelista in Ravenna," in *Römische Mitteilungen*, Berlin, 71, 1964, pp. 206–28; BOVINI, G., "S. Giovanni Evangelista di Ravenna, Il problema della sua forma nel primo edificio placidiano," in *Corsi di cultura...*, 1967, pp. 63–80; BOVINI, G., "Note sulla cronologia e sulla funzione della polifora absidiale di S. Giovanni Evangelista di Ravenna," in *Rivista di Archeologia Cristiana*, Rome, 42, nos. 1–4, 1966 (1968), pp. 41–55; OLIVIERI FARIOLI, R., "I mosaici pavimentali della chiesa di S. Giovanni Evangelista di Ravenna," in *Felix Ravenna*, series 4, no. 1 (CI), 1970.

## Mausoleum of Galla Placidia

RICCI, C., "Il sepolcro di Galla Placidia in Ravenna," in *Bolletino d'arte*, Rome, 11, 1913, pp. 389–418 and 12, 1914, pp. 429–44; BOVINI, G., *Il cosidetto Mausoleo di Galla Placidia in Ravenna*, Società Amici delle Catacombe, Vatican City, 1950; BOTTARI, S., "Mausoleo di Galla Placidia," in *Tesori d'arte cristiana*, Bologna, no. 3, 1966, pp. 57–84; ZOVATTO, P. L., *Il Mausoleo de Galla Placidia*, Edizioni A. Longo, Ravenna, 1968.

## Basilica Apostolorum (San Francesco)

MESINI, G., "La chiesa di S. Francesco," in *VI Centenario Dantesco*, Ravenna, I, 1914, no. 1; MAZZOTTI, M., "La 'Basilica Apostolorum' in Ravenna," in *Corsi di cultura...*, 1959, fasc. 2, pp. 137–56; BOVINI, G., *La "Basilica Apostolorum" attuale chiesa di S. Francesco di Ravenna*, Edizioni "Dante" di A. Longo, Ravenna, 1964.

## Anastasis Gothorum (Cathedral of the Arians)

MAZZOTTI, M., "La 'Anastasis Gothorum' di Ravenna ed il suo Battistero," in *Felix Ravenna*, 75, 1957, pp. 25–62; BRESCHI, M. G., *La Cattedrale degli Ariani ed il suo Battistero*, Edizioni A. Longo, Ravenna, 1965.

## Baptistery of the Arians

GEROLA, G., "Il restauro del Battistero degli Ariani," in *Studien zur Kunst des Ostens*, Leipzig, 1923, pp. 112–29; BOVINI, G., "Note sulla successione delle antiche fasi di lavoro nella decorazione musiva del Battistero degli Ariani," in *Felix Ravenna*, 75, 1957, pp. 5–24; BRUNO, A., "Il Battistero degli Ariani a Ravenna," in *Felix Ravenna*, 88, 1963, pp. 5–82.

## Archiepiscopal Chapel (Monasterium Sancti Andreae Apostoli)

GEROLA, G., "Il ripristino della Cappella di S. Andrea nel Palazzo Vescovile di Ravenna," in *Felix Ravenna*, 51, 1932, pp. 71–132; OTTOLENGHI, L. B., "La Cappella Arcivescovile di Ravenna," in *Felix Ravenna*, 73, 1957, pp. 5–32.

## Sant'Apollinare Nuovo

BOVINI, G., *Mosaici di S. Apollinare Nuovo di Ravenna: il ciclo cristologico*, Arnaud, Florence, 1958; BOVINI, G., *Sant'Apollinare Nuovo di Ravenna*, Silvana, Milan, 1961.

## Mausoleum of Theodoric

HAUPT, A., "Das Grabmal Theoderichs des Grossen zu Ravenna," in *Monumenta Germaniae Architectonica*, Leipzig, I, 1913; HEIDENREICH, R., "Das Grabmal Theoderichs zu Ravenna," in *Kriegsvorträge der Rheinländischen Friedrich-Wilhelms Universität*, Bonn, 102, 1943; GUBERTI, V., "Il Mausoleo di Teodorico detto anche 'Rotonda,'" in *Felix Ravenna*, 68, 1952, pp. 5–71; GOTSMICH,

A., "Das Grabmal Theoderichs in Ravenna," in *Universitas*, Stuttgart, XII, 1957, 11, pp. 1183–94; WESSEL, K., "Das Grabmal Theoderichs des Grossen," in *Das Altertum*, Berlin, IV, 1958, 4, pp. 229–48; BOVINI, G., *Il Mausoleo di Teodorico a Ravenna*, Edizioni Fratelli Lega, Faenza, 1959; DE ANGELIS D'OSSAT, G., "Un enigma risolto, Il completamento del Mausoleo teodoriciano," in *Felix Ravenna*, 85, 1962, pp. 5–39; BORGHERO, N., "Il Mausoleo di Teodorico a Ravenna," in *Felix Ravenna*, 92, 1965, pp. 5–68.

## San Vitale

JONESCU, G., "Il problema planimetrico della chiesa di S. Vitale a Ravenna," in *Felix Ravenna*, 43, 1934, pp. 37–57; TOESCA, P., *S. Vitale di Ravenna: I mosaici*, Sidera, Milan, 1952; BOVINI, G., *San Vitale, Ravenna*, 3rd ed., Silvana, Milan, 1957; BOTTARI, S., "Basilica di S. Vitale," in *Tesori d'arte cristiana*, no. 4, 1966, pp. 113–40.

## Sant'Apollinare in Classe

MAZZOTTI, M., *La basilica di S. Apollinare in Classe*, Pontificio Istituto di Archeologia Cristiana, Vatican City, 1954; DINKLER, E., *Das Apsismosaik von S. Apollinare in Classe*, Westdeutscher Verlag, Cologne-Opladen, 1964; PELÀ, M. C., *La decorazione musiva della basilica ravennate di S. Apollinare in Classe*, R. Pàtron, Bologna, 1970.

## Sarcophagi

GOLDMANN, K., *Die Ravennatischen Sarkophage*, J. E. H. Heitz, Strassburg, 1906; LAWRENCE, M., *The Sarcophagi of Ravenna*, College Art Association Monographs, 2, New York, 1945; BOVINI, G., *Sarcofagi paleocristiani di Ravenna: Tentativo di classificazione cronologica*, Società Amici delle Catacombe, Vatican City, 1954; KOLLWITZ, J., *Die Sarkophage Ravennas*, Schulz Verlag, Freiburg im Breisgau, 1956; DE FRANCOVICH, G., "Studi sulla scultura ravennate," in *Felix Ravenna*, 77–78, 1958, pp. 5–172 and 79, 1959, pp. 5–175; GERKE, F., "La scultura ravennate," in *Corsi di cultura...*, 1959, fasc. 2, pp. 109–21; VALENTI ZUCCHINI, G., and BUCCI, M., *I sarcofagi a figure e a carattere simbolico* (*Corpus della scultura paleocristiana, bizantina ed altomediovale di Ravenna*, II), Edizioni De Luca, Rome, 1968.

## Columns, Capitals, Pulvins, Ambos, Screens

ANGIOLINI MARTINELLI, P., "Ambini ravennati," in *Felix Ravenna*, 93, 1966, pp. 361–73; OLIVIERI FARIOLI, R., "Capitelli bizantini di Ravenna," in *Atti del Primo Congresso Nazionale di Studi Bizantini*, Ravenna, 1966, pp. 153–62; ANGIOLINI MARTINELLI, P., *Altari, amboni, cibori, cornici, plutei con figure di animali e con intrecci, transenne e frammenti vari* (*Corpus della scultura paleocristiana, bizantina ed altomedioevale di Ravenna*, I), Edizioni De Luca, Rome, 1968; OLIVIERI FARIOLI, R., *La scultura architettonica: Basi, capitelli, pietre d'imposta, pilastri e pilastrini, plutei, pulvini* (*Corpus della scultura paleocristiana, bizantina ed altomedioevale di Ravenna*, III), Edizioni De Luca, Rome, 1969.

## The Ivory Throne of Archbishop Maximian

CECCHELLI, C., *La Cattedra di Massimiano ed altri avorii romani-orientali*, R. Istituto di archeologia e storia dell'arte, Rome, 1938; MORATH, G. W., *Die Maximianskathedra in Ravenna* ("Freiburger theologische Studien" series, 54), Freiburg im Breisgau, 1940; BOVINI, G., *La cattedra eburnea del vescovo Massimiano di Ravenna*, Edizioni Fratelli Lega, Faenza, 1957; WESSEL, K., "La cattedra eburnea di Massimiano e la sua scuola," in *Corsi di cultura...*, 1958, fasc. 1, pp. 145–60.

More extensive bibliographical references can be found in G. BOVINI, *Saggio di bibliografia su Ravenna antica*, R. Pàtron, Bologna, 1968.